Maternal Regret

Resistances, Renunciations, and Reflections

Edited by Andrea O'Reilly

DEMETER

Maternal Regret

Resistances, Renunciations, and Reflections

Edited by Andrea O'Reilly

Copyright © 2022 Demeter Press

Demeter Press
PO Box 197
Coe Hill, Ontario
Canada
K0L 1P0
Tel: 289-383-0134
Email: info@demeterpress.org
Website: www.demeterpress.org

Demeter Press logo based on the sculpture "Demeter" by Maria-Luise Bodirsky www.keramik-atelier.bodirsky.de

Printed and Bound in Canada

Cover design and typesetting: Michelle Pirovich
Proof reading: Jena Woodhouse

Library and Archives Canada Cataloguing in Publication
Title: Maternal regret : resistances, renunciations, and reflections / edited by Andrea O'Reilly.
Names: O'Reilly, Andrea, 1961- editor.
Description: Includes bibliographical references.
Identifiers: Canadiana 20210363592 | ISBN 9781772583793 (softcover)
Subjects: LCSH: Regret. | LCSH: Mothers. | LCSH: Motherhood. | LCSH: Mothers—Psychology. | LCSH: Motherhood—Psychological aspects.
Classification: LCC HQ759 .M38 2022 | DDC 155.6/463—dc23

Contents

Introduction

Maternal Regret: Resistances, Renunciations, and Reflections

Andrea O'Reilly

Sarah Treleaven's *Marie Claire* magazine article "Inside the Growing Movement of Women Who Wish They'd Never Had Kids" opens with this assertion: "It's unthinkable and it's definitely unspeakable, but women all over the world are coming forward to say it: I regret having children." Although maternal regret remains, in Kingston's words, a "huge taboo," she argues that a growing number of mothers are confessing that they wish they never had children. The movement began, Treleaven argues, in 2008 with the publication of Corinne Maier's *No Kids: 40 Reasons Not to Have Children*, and it gained momentum in 2013, with the publication of Isabella Dutton's article 'The Mother Who Says Having These Two Children Is the Biggest Regret of Her Life" in the *Daily Mail*. The author, who was fifty-seven with two adult children when she wrote the article, states that when her first born son was five-days old, a "realization hit me like a physical blow: having a child had been the biggest mistake of my life" (Dutton). She writes that she "would have been happier not having children," that she "felt oppressed by [her] constant responsibility for them," and that she "hated the idea of motherhood." She describes her children as parasitical: "Both my children would continue to take from me and [give] nothing meaningful back in return." She did everything a good mother is supposed to and is confident that her children "would agree that they always felt secure and loved." Dutton concludes by saying: "I

7

would cut off my right arm if my children needed it ... and that, maybe is the paradox. I am a conscientious and caring parent—yet perhaps I would have resented my children less had I not been."

However, by 2018, writers such as Dutton and Maier were no longer regarded, in the words of Kingston, as "freakish outliers"; "parental regret or the last parenting taboo as it is dubbed in the media is now being covered by everyone." Indeed, today the controversial topic of maternal regret is now being discussed in chat rooms across the Internet as well as in various Facebook communities, including the nine-thousand-member Facebook group called "I Regret Having Children" as well as a Facebook community founded by Canadian mother Lauren Byrne with 2,600 members. However, most mothers who admit to maternal regret do so in private and in closed social media forums or in anonymity. All the mothers interviewed for the *Marie Claire* article requested anonymity because they were "deeply concerned about both stigma and the potential impact of their statements on their children" (Treleaven). Mothers who do publicly convey maternal regret are regarded as de facto bad mothers and are deemed unnatural and abusive. One reader of Dutton's column called her "an utterly miserable, cold-hearted and selfish woman" (Dutton) and Orna Donath who authored a book on maternal regret has been savaged for her research. One critic suggested "she be burned alive" (Kingston). Society's decisive discomfort with regretful mothers, Treleaven argues, "gets at a larger discomfort with women overall—that we won't do our fundamental jobs." More pointedly, Kingston contends that maternal regret is "an affront to the sanctity of motherhood and the entrenched belief that maternal instinct is innate and unconditional." Indeed, maternal regret is an affront to patriarchal motherhood precisely because it dislodges its bedrock mandates of essentialization, naturalization, and idealization—the assumptions that women desire motherhood, that maternal ability is innate to all mothers, and that mothers find purpose and joy in mothering.

To date, there has been only one scholarly book published on the topic of maternal regret: Donath's 2017 book *Regretting Motherhood: A Study*. Donath's book is based on interviews with Israeli women and seeks "to make room for the unspoken topic of maternal regret" (xvii). Donath argues that when maternal regret or ambivalence is considered, the discussion is limited to the early years of mothering when women

transition to motherhood. This approach suggests that any maternal ambivalence or regret experienced by mothers is temporary and will recede as mothers adjust to motherhood. There has been little discussion on the experiences of mothers with older children and certainly none that focuses on maternal regret in mothers' retrospective accounts of raising children. Indeed, as Donath remarks, "It seems that even in feminist theorization about the topic, there is no room for re-evaluation let alone regret" (xv). Whereas Donath's book is a study of mothers who regret motherhood, this book seeks to enrich, enlarge, and expand upon Donath's study by looking at the larger concept of maternal regret across diverse themes, perspectives, and genres. This collection considers how maternal regret—as it is conveyed in remorse, resentment, dissatisfaction, and disappointment—troubles the assumptions and mandates of normative motherhood and how it is explored and critiqued in creative nonfiction, film, literature, and social media. In this collection, maternal regret is also examined in relation to the estrangement of mother and child and the remorse and grief felt by both mothers and children caused by the abandonment of mother or child. Finally, the collection explores how regret opens the space for maternal erudition, enlightenment, and evolution as well as makes possible maternal empowerment. The book is organized in three sections. The first, "Resistances," examines how maternal regret as conveyed in remorse, disillusionment, and resentment counters and corrects normative motherhood. The second. "Renunciations," looks at how regret is experienced in mother-child abandonment, and the third, "Reflections," explores how regret may be an opportunity for maternal knowledge and power.

In the opening chapter of the first section, "'Out of Bounds': Maternal Regret and the Reframing of Normative Motherhood," I explore how the emergence of the topic of maternal regret has given rise to a reframing of contemporary mothering to offer a formidable critique of, and corrective to, normative motherhood. It first examines how maternal regret exposes the normative scripts and the oppressive conditions of patriarchal motherhood and then goes on to consider how maternal regret subverts and disrupts normative motherhood and how maternal regret debunks the dictates of patriarchal motherhood and enacts authentic mothering. Finally, the chapter examines how maternal regret defies and disrupts the mandate of compulsory motherhood.

Lorin Basden Arnold's chapter "'I Know I Am Not Supposed to Say These Things. It Is Very Not Maternal of Me': Confessional Rhetoric of Maternal Resentment" examines the ways in which mothers discuss maternal resentment in online venues as well as the ramifications of that rhetorical frame. She argues that through the seven prominent themes that are present in this maternal resentment discourse, we can see confessional rhetoric that provides both an admission of transgression as well as a vehicle for redemption. Her analysis supports our understanding of how mothers position their transgressive behaviours and how that discourse may function for mothers as both rhetors and readers.

In their chapter "'Reimagining What Might Have Been': A Comparative Analysis of Abortion and Maternal Regret," Alesha E. Doan and J. Shoshanna Ehrlich engage in a comparative study of abortion and maternal regret narratives. They begin by situating these narratives in a brief history, tracing the origins of each. Using content analysis, they compare publicly available regret narratives from the antiabortion website *Silent No More Awareness Campaign* and from the Facebook group "I Regret Having Children." Twenty-four subthemes emerged from the motherhood regret narratives and nineteen from the abortion regret ones. These subthemes coalesced into two broad themes: diminished wellbeing and loss. Across both sets of narratives, women express a longing for a reimagined life, unburdened by their reproductive decision. In the conclusion, they argue that although the antiabortion movement has weaponized abortion regret narratives for political gain, the reproductive rights movement has missed an opportunity to use maternal regret narratives to combat hegemonic ideals of motherhood and to challenge the essentialized construction of patriarchal motherhood.

Ideals of motherly love as natural do not fit the actual lived experiences of motherhood. That is to say, motherhood as an institution, as a gender expectation, and as a norm and role do not fit the variety of experiences of motherhood. In her chapter "Shocking Readers and Shaking Taboos: Maternal Body and Affects in Itō Hiromi's Work," Juliana Buriticá Alzate argues that a large number of Japanese authors, including Itō herself, have written texts that resist these ideals. The chapter first presents an overview of the representations of motherhood in Japanese literature as a background to Itō's work and then introduces

a selection of Ito's works that can be considered attempts to free more maternal bodies. It concludes by discussing the ways in which Itō's work has shaped current understandings of mothering from a feminist perspective.

In "'It's Not Enough for Me': Maternal Regret in HBO's *Big Little Lies*," Rachel Williamson analyses the show's representation of mothers who may initially appear to "have it all" but who, in reality, experience maternity as a source of shameful disappointment and regret. Although the characters' experiences of regret vary, it is not by accident that many of the show's mothers can be seen grappling with this cultural taboo, thus suggesting it is perhaps a far more common experience than its almost total absence in representational form and discourse would otherwise imply. However, although the appearance of these dissatisfied, unhappy mothers is potentially transgressive and startling, the chapter argues that the show is simultaneously unable to fully escape the ideologies of intensive mothering and neoliberalism, which prop up idealized maternity and render maternal regret abject and unspeakable. As such, although maternal regret is, to some extent, normalized by *Big Little Lies*, it is also paradoxically positioned as the purview of the so-called bad mother, thereby highlighting just how controversial and challenging maternal regret remains to longstanding, conventional understandings of maternity.

The final chapter of the section, "'Yes, My First and Only': Dealing with Assumptions of Regret about Family Size" by Karla Knutson, argues that mothers who choose to have only one child, or who appear to have chosen only one child, are viewed by a pronatalist American culture as selfish. Knutson suggests that the rhetoric surrounding only children and their mothers employs the spectre of maternal regret as a threat, leading mothers who may not desire more than one child to believe that this family structure is somehow harmful to their child, to them, and to their family. The chapter analyzes how this pronatalist threat of potential regret is expressed in studies of the mothers of only children, of family size, and of maternal regret. It also suggests strategies for resisting this damaging rhetoric by refuting stereotypes of only children and their mothers by employing the frameworks of matricentric feminism and feminist parenting.

The second section of the book, "Renunciations," opens with Laurie Kruk's chapter "The Children Leave: Maternal Abandonment in Two

Alice Munro Stories'" In each story, the mature mother faces estrangement from, and abandonment by an adult child, a daughter, and a son. As each mother struggles to adjust, Kruk argues that she has to confront the spectre of the "bad mother" in herself and regrets how her parenting career has turned out. Motherhood is, thus, deidealized, as ambivalence takes its place. In these two disturbing stories, Kruk argues, Munro disrupts the "daughter-centric" voice of much contemporary feminist criticism and invites us to witness the mother's trauma from her children's abandonment.

The estrangement of mother and child is likewise a theme in Jane Turo's creative nonfiction piece "Love and Longing Buried under Silence and Strife." The chapter is a recollection written under a weight of grief and longing for the child whom this mother lovingly brought up in a foreign culture that prioritized different values and interactions. In this patriarchal culture, the mother was left without moral support. Even as she was loved, her husband failed to support her efforts to control her powerfully feisty daughter. Her in-laws slandered her, and family frictions shattered their early bliss. Holding her mother responsible for the conflicts in her upbringing, the mother remains separated from her beloved daughter, even as she appears to have succeeded in her mother's western culture.

The final chapter of the section, "My Mother's Story" by Kanchan Tripathi, tells the story of her mother—an Indian woman, immigrant, (former) wife, singer, person living with disability, and survivor of domestic violence—and the loss of a child, who is on a path to self-enlightenment. The author aims to tell her mother's experience of maternal regret as her daughter—the child her mother regrets having. The stories told in this creative nonfiction piece are a collection and recollection of memories, past journal entries, voice messages, and conversations between the author, her sister, mother, and family.

Martha Satz's chapter, "Pernicious Narratives of Maternal Regret: Adoption and Disability Chronicles That Coarsen and Corrupt Their Readers," opens the third section, "Reflections." The chapter considers two works, one a work of fiction and the other a memoir, which explore both maternal regret and more sweeping philosophical issues. Both works explore the lives of children whom the mother deems unacceptable and whose nurturing threatens the wellbeing of other healthy children within the family. Their portrayal raises the spectre of some

children's problem being so intransigent that they are beyond the hope of remediation and, in fact, suggests that they not merit the ethical claims of other human beings. Satz boldly argues that these narratives are philosophically harmful to their readers, coarsening their moral thinking.

Jessica Jennrich's creative nonfiction chapter, "Time Machine," finds the author pondering the question of what advice she might have given her twenty-year-old self one winter night as she plays a game with her children. During which, the author revisits the violence of the twenty-year marriage she had finally ended and ponders its effects on her children. In this chapter, Jennrich ruminates on regret and in doing so takes the reader on a jagged tour of the silent brutality that made up much of her life.

In "From Mourning to Greeting: The Predicament and Possibilities of Maternal Regret," BettyAnn Martin and Michelann Parr explore the threshold between experience and research as they explore regret. Throughout their exploration, they understand regret as the inner work of memory, as unmet societal and cultural expectations that linger in our minds, as well as a space for healing and resonance. In the end, they invite mothers of the world to join them in their quest to under-stand regret as a dwelling place of introspection and mourning, a place of greeting, and a threshold to meet possibility with empathy for others, for children, for mothers, and for themselves

In Anishinaabeg cultural traditions, as Renee E. Mazinegiizhigoo-kwe Bedard explains in her chapter, "Minjinaweziwin: Anishinaabeg Women's Teachings on Maternal Regret," maternal regret is considered a natural part of Anishinaabeg life. The chapter shares Anishinaabeg teachings on the origin and contexts of maternal regret through an Anishinaabeg women's centered paradigm. The chapter examines the Anishinaabemowin term "minjinaweziwin" as an intellectual anchor for understanding Anishinaabe-kwewag (Anishinaabeg women) ethics, philosophies, and cosmological teachings about the complex nature of maternal regret within the lives of women. It also explores how Anishinaabeg beliefs of maternal regret are recognized as a natural state of being and as a site of both Indigenous women's agency and self-governance. The chapter offers a traditional sacred story as the origin of the knowledge the author carries and how she contextualizes that sacred knowledge as instructions related to the ways Anishinaabeg

women view, embody and utilize the embedded teachings to navigate contemporary maternal realities. The chapter concludes with a poem by the author to convey her own positionality on maternal regret as an Anishinaabe-kwe (Anishinaabe woman).

The section's final chapter "'(How) Can We Speak of This?' Opening into the Dark Spaces of Maternal Regret, Choice, and the Unknowable" by May Friedman and Jacqui Gingras, asks what choices would they make if we were not worried about risk and accountability. How do these questions fit into a broader politic of gendered, raced, classed, and heteronormative expectations? Put differently, why do we do what we do and how do we know what we know as mothers, scholars, and queer ciswomen, and how do these truths factor into discussions of maternal regret? Through dialogue, and collective auto/biography, the authors call to each other with an ethic of care while considering the epistemology of choice: What decisions have led them to live as mothers in the present day, and what complications and considerations have brought them to be the specific mothers they have come to be? As mother-scholars from working-class roots, they seek to interrogate the complexities of both maternity and regret, leaning into the messiness of their varying subject positions, and they consider the intersectional implications of their lived experiences through queerness, racialization, class, and beyond. In the context of an iterative reflexive script, the chapter aims to foreground both their individual experiences and the complicated truths that live in the space between their words as they come together to expose this hidden and painful terrain.

In its resistances, renunciations, and reflections, this collection explores maternal regret beyond the regret of motherhood to show how it may be both a critique of the assumptions and expectations of normative motherhood as well as a lament when mothering does not go as planned. And perhaps paradoxically, regret—as it bespeaks resentment and rage and marks mourning and loss—also makes possible maternal enlightenment and empowerment. In this, maternal regret moves beyond regretting motherhood to new and transformative possibilities for living and learning from the longings and losses of mothering.

Works Cited

Donath, O. *Regretting Motherhood: A Study.* North Atlantic, 2017.

Dutton, Isabella. "The Mother Who Says Having These Two Children Is the Biggest Regret of Her Life." *Daily Mail*, 2013, www.dailymail. co.uk/femail/article-2303588/The-mother-says-having-children-biggest-regret-life.html. Accessed 14 Apr. 2022.

Kingston, A. "I Regret Having Children" *Maclean's*, 2018, www. macleans.ca/regretful-mothers. Accessed 14 Apr. 2022.

Treleaven, S. "Inside the Growing Movement of Women Who Wish They'd Never Had Kids." *Marie Claire*, 2016. www.marieclaire.com/ culture/a22189/i-regret-having-kids. Accessed 14 Apr. 2022.

Section I
Resistances

"the alarm"

Tracy Royce

we had this long
snaky-shaped house
kitchen on one end
and bedrooms on the other
all my mother's domain
while father was out

valedictorian with a free ride at Temple
long before Roe v. Wade
she always said they would've married anyway
she continued to write
until she got lost somewhere
between the bedroom and the kitchen

father liked grapefruit for breakfast
serrated spoon in hand
he'd rend the tender flesh
and my childish laughter filled the room
when he spit seeds like a machine gunner
(guess who picked them up)

mother worked while we ate
always in motion
laundry basket balanced
against one well-padded hip
she set the oven timer—
a chrome dial mounted just inches away
from where father wrestled with his breakfast—
then whisked her crisp sheets off to the bedroom

when the timer sounded
noxious, piercing
I watched as my father
who could have silenced the alarm without rising
an easy arm's length between us and peace
instead did nothing
but continue his vigorous breakfast dissection

and at the other end of the house
once again mother dropped everything
and navigated a new course
back to the kitchen

I never laughed at his seed spitting again

An earlier version of "the alarm" appeared in *Affilia* 2009, volume 24, issue 1, pages 97-98.

Chapter 1

"Out of Bounds": Maternal Regret and the Reframing of Normative Motherhood

Andrea O'Reilly

Central to patriarchal motherhood are the beliefs that all women want to become mothers, that mothering comes naturally to all women, and that women experience mothering as fulfilling and gratifying. I have termed these assumptions essentialization, naturalization, and idealization. In patriarchal motherhood, it is assumed (and expected) that all women want to be mothers (essentialization), that maternal ability and motherlove are innate to all mothers (naturalization), and that all mothers find joy and purpose in motherhood (idealization) (O'Reilly, *Matricentric Feminism*). Over the last few years, these dictates of normative motherhood have been countered and challenged by the emergence of what has been termed "the last parenting taboo" (Kingston)—that is, maternal regret (Kingston). From recent magazine articles to scholarly works, such as *Regretting Motherhood: A Study* (Donath), mothers "are challenging an explosive taboo and pushing the boundaries of accepted maternal response; and reframing motherhood in the process" (Kingston). Indeed, as author Lionel Shriver commented in reference to her acclaimed 2003 novel, *We Need to Talk about Kevin*, in which maternal regret is a central theme: "While we may have taken the lid off sex, it is still out of bounds to say that you do not like your own kids, that the sacrifices they have demanded of you are unbearable, or perish the thought, you wish you never had them." Or as journalist Sarah

Treleaven notes: "Despite the fact that we have officially entered the age of oversharing—documenting anything and everything on social media from children's births to family deaths—there are still things women are not supposed to feel, and certainly not to openly discuss. Regretting motherhood is the biggest to date."

Building on Shriver's and Kingston's words, this chapter will explore how the emergence of the out-of-bounds topic of maternal regret has given rise to a reframing of contemporary mothering to offer a formidable critique of, and corrective to, normative motherhood. The chapter first examines how maternal regret exposes the normative scripts and the oppressive conditions of patriarchal condition. It goes on to consider how maternal regret subverts and disrupts normative motherhood and how maternal regret debunks the dictates of patriarchal motherhood and enacts authentic mothering. Finally, the chapter examines how maternal regret defies and disrupts the mandate of compulsory motherhood.

Maternal Regret as Critique of Normative Motherhood

In *Regretting Motherhood: A Study*, which is still the only scholarly work on the topic of maternal regret, Donath describes the purpose of her book as "to make room for this unspoken topic" (xvii). She argues that when maternal regret or ambivalence is considered, the discussion is limited to the early years of mothering when women transition to motherhood. This approach suggests that any maternal ambivalence or regret experienced by mothers is temporary and will recede as mothers adjust to motherhood. There has been little discussion, however, on the experiences of mothers with older children and certainly none that focuses on maternal regret in mothers' retrospective accounts of raising children. Indeed, as Donath remarks, "It seems that even in feminist theorization about the topic, there is no room for re-evaluation let alone regret" (xv). The purpose of this section is to consider what we discover and learn about patriarchal motherhood when we make room for the unspoken topic of maternal regret.

"I Did It Automatically": Maternal Regret and the Normative Dictate of Essentialization

Donath argues that the reproductive potential of women obligates them to become mothers; she argues that women "are passively ruled by a fatalist command that leaves us *no other choice*" (3). This mandate—that all women will become mothers—is what I have termed "essentialization," and it is simultaneously and paradoxically interfaced with the neoliberal assumption of choice: Women freely choose motherhood. Under this assumption, as Donath explains, "Women actively, sensibly and rationally turn to the path of motherhood of [their] own, liberated will" (3). Any complaints about motherhood, let alone confessions of maternal regret, are dismissed, in Donath's words, as "whining" because "it was your choice, now live with it" (3-4). Biological determinism, or the neoliberal concept of choice, however, cannot explain why most women become mothers, as biology is certainly not destiny and individual choice is largely illusory. Rather most women become mothers simply because this is the normative trajectory of womanhood, as it is "inconceivable that a woman who is purportedly healthy and sane, and who is able to choose her own trajectory in life would decide against motherhood" (7). Moreover, as the normative script positions motherhood as woman's purpose and fulfilment, it simultaneously and unsurprisingly delineates nonmotherhood as meaninglessness. Donath introduces the concept of "the colonisation of our imagination," through which "women absorb the notion that motherhood is the only path to the point that women cannot conceive of other available options" (10). Many of the mothers in Donath's study describe motherhood as something that happened to them: "I thought it was the right thing to do ... I didn't know what it actually meant"; "It was the norm, and it wasn't thought about either. There was no option to think in that direction. It was not in my conscious mind"; "I did it automatically, without understanding there was room for thought or deliberation"; "It was moving forward along life's course" (11-15). These sentiments signify what Donath describes as "passive decision making" and emerge from "heteronormative cultural logics that instil in both women and men that life is fundamentally a series of progressive stages—that is, a roadmap every person must follow, with milestones such as school, work, coupledom, marriage, and parenthood" (15). To

be a nonmother is, thus, to go off script with no story to be told. Simultaneously, normative motherhood renders maternal regret as inconceivable and unimaginable. How can you regret something that is naturally ordained, freely chosen, and simply meant to be? Maternal regret subverts and disrupts normative motherhood and, in particular, its mandate of essentialization, for if motherhood was truly natural, chosen, and supposed to happen, there could not be regret.

"I Can't Even Fake It": Maternal Regret and the Normative Dictates of Naturalization and Idealization

Not only does Donath's study reveal how the mandate of essentialization gives rise to maternal regret by designing motherhood as the only life trajectory for women, but it also illuminates how the dictates of naturalization and idealization cause regret in mothers by creating a normative model of motherhood that is impossible for mothers to achieve. Mothers today must perform what Sharon Hays defines as "intensive mothering," which is characterized by three central themes: first, "the mother is the central caregiver"; second, "mothering is regarded as more important than paid employment"; and third, "mothering requires lavishing copious amounts of time, energy, and material resources on the child" (8). Indeed, as Bonnie Fox has remarked:

> Expectations about the work needed to raise a child successfully have escalated at a dizzy rate; the bar is now sky high. Aside from the weighty prescriptions about the nutrition essential to babies' and children's physical health, and the sensitivity required for their emotional health, warnings about the need for intellectual stimulation necessary for developmental progress are directed at mothers. (237)

The mothers in Donath's study seek "to impersonate the 'right' maternal feelings and emotional behaviours of 'good' motherhood" (37). Her participants said the following: "I do this pose of family, all this theatre—but it's not me. I don't relate to it"; "I do normative things"; and "I try to put [on] some kind of show, but it's not [real]. I can't even fake it" (36-38). These mothers, as Donath explains, "describe their performance of mimicking normative maternal feelings

and behaviors out of sense of duty while feeling completely at odds with what is expected of them as mothers" (37).

In this performativity, the mother seeks to deny and repress her maternal regret by wearing what Susan Maushart has termed the "mask of motherhood." The mask of motherhood, Maushart explains, is an "assemblage of fronts – mostly brave, serene, and all knowing – that we use to disguise the chaos and complexity of our lived experience" (2). To be masked, Maushart continues, is "to deny and repress what we experience, to misrepresent it, even to ourselves" (1-2). Normative motherhood confers an idealized and, hence, unattainable image of motherhood that causes mothers, such as those in Donath's study, to feel guilt, resentment, and anxiety about their own messy and muddled experiences of motherhood. This tension between the mothers' lived experiences of motherhood and the social discourses of mothering, which relentlessly seek to claim and control them, can cause the mothers to camouflage the tabooed emotion of maternal regret.

Significantly, most mothers in Donath's study emphasize what they regret is motherhood and not their children: Said one participant: "I am not sorry [my son] is here. The regret is due to the parenthood aspect" (32). Other participants echoed this sentiment: "[My children] are lovely people ... [my regret] has nothing to do with that. [Being a mother] is not where I want to be"; "I love [my son]. I just don't like being a mother"; "He is a wonderful son. [My regret] has nothing to do with that. It is completely unrelated"; "It's really paradoxical. I regret having had children and becoming a mother, but I love the children that I've got"; and "I try to do my best.... But still I *hate* being a mother. I *hate* being a mother. I hate this role.... I hate the lack of freedom, the lack of spontaneity. The fact that it restricts me" (72–75).

This paradox of women loving their children but hating motherhood may be explained through the crucial distinction Adrienne Rich makes in *Of Woman Born* "between two meanings of motherhood, one superimposed on the other: the potential relationship of any woman to her powers of reproduction and to children; and the institution—which aims at ensuring that that potential—and all women—shall remain under male control" (7). The term "motherhood" refers to the patriarchal institution of motherhood, which is male defined and controlled and is deeply oppressive to women, whereas the word

"mothering" refers to women's experiences of mothering and is female defined and centred and potentially empowering to women. The reality of patriarchal motherhood, thus, must be distinguished from the possibility or potentiality of empowered mothering. In other words, whereas motherhood operates as a patriarchal institution to constrain, regulate, and dominate women and their mothering, mothers' own experiences of mothering can, nonetheless, be a site of empowerment. I would suggest that the maternal regret experienced by the women of Donath's study is specifically and explicitly caused and created by the patriarchal institution of motherhood

Donath organizes the explanations for the women's maternal regret under several themes: who I was and who I am; motherhood as traumatic experience; bonds and fetters of maternal love; obligated to care; being a mother and a never-ending story. Under the first three themes, the mothers speak about the profound loss of self in motherhood: "It is consuming me ... I do not have room for anything else"; "After giving birth to my daughters, I felt I was not realizing myself at all"; and "It is very painful when a person loses his life and is living-dead" (102-108). The following themes examine the experiences of mothers who do not, or cannot, perceive or practice maternal love as innate, all giving, and forever, as patriarchal motherhood requires it to be. As the mothers explained: "What I lack is the mother gene: Of course I love my children. But to put it blankly, from the very beginning I didn't know what to do with them"; "I don't want anything bad to happen to them. But on the other hand, [motherhood] does not sit well with me"; "The intensive caretaking they needed. I suffered and I cried [but] I did it"; "There's nothing you can do about it. I brought him into the world—it is my responsibility to take care of him ... even though it takes its toll"; "The bottom line is that I don't like [taking care of children]. I mainly do these things because I feel obligated"; and "There is something that is very difficult for me, and that is my responsibility for the children, even though they are grown up. It won't come off" (110-23). Donath argues that the idea of "maternal love has become a form of oppression because it dictates specific requirements that engineer women's emotional worlds and mother's relationships with their children; they must feel unconditional love toward their children and they must exhibit this love in a 'proper' manner" (117).

This proper manner means and necessitates the negation of the

mother's selfhood as required by normative motherhood and as evidenced in the mothers' words in Donath's study. Elsewhere, I have argued that normative motherhood is characterized by four central themes. The first defines mothering as natural to women and essential to their being. In this essentialist belief, as Pamela Courtenay Hall notes, "Women are naturally mothers ... they are born with a built-in set of capacities, dispositions, and desires to nurture children ... [and that this] engagement of love and instinct is utterly distant from the world of paid work" (60). Second, the mother is to be the central caregiver of her biological children. Third, children require full-time mothering, and if the mother must work outside the home, the children must always come before the job. And finally, mothers must lavish excessive amounts of time, energy, and money in the rearing of their children (O'Reilly, *Matricentric Feminism*). These requisites, in turn, require that maternal love be unconditional, that mothering be provided 24/7, that mothers be fully satisfied, fulfilled, completed, and composed in motherhood, and that over the lifetime of their children, mothers always put children's needs before their own. The words of the mothers in Donath's study suggest that what causes maternal regret is not, reminiscent of Rich's distinction, mothering but patriarchal motherhood, which defines, constrains, and regulates how women should perceive and practice mothering.

"It Is Motherhood Itself That Is Intolerable": Maternal Regret and Compulsory Motherhood

Significantly, however, for the mothers in Donath's study, maternal regret is not always or solely caused by the specific conditions of motherhood: "It is quite often implied that because women ... are naturally equipped with a set of characteristics that promise serenity in motherhood, all that society needs to do is to make sure that women's natural tendencies are not interrupted by unjust conditions" (194). In other words, it is assumed that maternal regret is caused not by women's dislike of motherhood per se but by adverse societal conditions that prevent women from experiencing the joy and purpose of motherhood. Significantly, this assumption continues to uphold and reinforce the patriarchal dictates of normative motherhood— essentialization, naturalization, and idealization—by implying that all

women would enjoy motherhood if the societal circumstances were right. As sociologist Barbara Katz Rothman reflects:

> I can afford to love mothering, afford it in every sense of the term: I have the middle class services and environment that make it doable, let alone lovable. And I haven't had to do it alone. I've shared the mothering of my children, mostly with their father but also with grandparents and friends and even with "hired help".... Women like me who are well placed can afford the costs and enjoy our mothering enormously. Women who are not so well placed—women who are poor, or very young or not well educated or of minority status or all of the above—suffer greatly in their mothering. (10)

Rothman's words suggest that women's suffering in motherhood is caused solely by deleterious elements extraneous to the mother and that if these mothers had the same supports that she enjoyed, they too would find mothering "doable" and "lovable." Or in the words of a blogger quoted by Donath: "In an ideal world the burden of having a child would not be so heavy that parents regretted it" (195).

Donath argues, however, that for the women in her study, maternal satisfaction is not only a matter of social conditions. Regardless of the diverse contexts of the mothers in her study—poor, economically prosperous, single, with an involved partner, living apart from their children, or living with young and adult children—they all expressed maternal regret. As Donath explains: "Even though there are conditions that can alleviate the hardships of motherhood, this does not necessarily mean that the difficult conditions accompanying motherhood, or the rigid social dictates determining how women must mother, can completely account for suffering or lack of satisfaction in motherhood" (196). Indeed, as I have argued elsewhere, and as cited in Donath's book, while I remain convinced that patriarchal motherhood is oppressive to mothers, I do not think that mothers' oppression can only be reduced to the institution/ideology of motherhood: "Aspects of mother love and mother work remain arduous, if not oppressive, regardless whether they take place within, outside, or against patriarchal motherhood. Empowered mothering may ameliorate many/most of the adversities of patriarchal motherhood; it cannot however, eliminate all of them. (O'Reilly, *Rocking the Cradle* 14).

For the mothers in Donath's study, improving the conditions of their motherhood would not necessarily eradicate regret because "it is motherhood itself that they find intolerable" (203). Some mothers describe motherhood as a foreign entity: "I can't even imagine myself enjoying motherhood"; and "When the child calls 'Mom' I look around to see who they're talking to ... I could never connect to the idea, the position, the repercussions of, the responsibility and commitment. I couldn't relate to that" (203-04). Similar responses were received in an online forum moderated by Donath in which she asked whether there were conditions under which they would consider motherhood. One woman commented as follows: "The reluctance to have children is not rooted in the thought that it would be hard to take care of them. It's plain reluctance period.... Even if I lived in a world in which others help or even raise the children instead of me, it wouldn't change the fact that I don't want children simply because I don't feel the urge or desire to have them" (208-09). Donath concludes:

> Women's lives would indeed improve if we provided adequate support and conditions to nurture children. But although some women would feel relieved by such conditions and thus encouraged to have children, there are also women for whom it would be irrelevant, as they fundamentally do not want to be mothers— whether they are currently [mothers] or not. (209-10)

For the mothers in Donath's study, maternal regret is not just the result of the specific normative dictates of essentialization, naturalization, and idealization, or even the societal conditions of the patriarchal institution of motherhood. It is also the result of some women simply not wanting to become mothers. Thus, not only does maternal regret denote and enact a critique of patriarchal motherhood and its normative dictates, but it also, and more profoundly, signals an unmitigated and unreserved repudiation of motherhood in itself.

Maternal Regret as a Corrective to Normative Motherhood

In her 2018 book *Modern Motherhood and Women's Dual Identities: Rewriting the Sexual Contract*, Petra Bueskens theorizes how "strategic absence" by mothers beyond the standard workday or outside standard

work hours reconstructs gendered dynamics in the home. Specifically, she examines how women are in the "default position" in normative families and how leaving—or what she calls "revolving absence"—essentially mandates the contributions of fathers, partners, and others. In her interviews with fifteen "revolving mothers," she finds evidence that fathers gain valuable childcare and domestic skills when they are solely responsible for extended periods of time and that mothers, in turn, negate the effects of the "second shift" when they leave their family. In her research, this was for periods of three days to three months. Interestingly, many of the mothers preferred periods of intensive work combined with periods of intensive mothering, although all of them benefited from the greater domestic contributions made by partners (and for the single mothers, other carers), which loosened the hold of the default position. All the mothers report, Bueskens explains, "that leaving offers a break from the normative allocations of labour and leisure in the home, allowing them time for reflection, creativity, career investment otherwise foreclosed by the standard allocation of family and work" (261).

Thus, "periodic maternal absences," as Bueskens further elucidates, "shifts the balance of power in (heterosexual) relationships away from sanctioned inequality towards innovative patterns of equality" (278). Bueskens concludes that while "a small group of atypical mothers cannot speak for the majority, they can offer valuable insights into processes of social change" (301). I mention Bueskens's research on revolving mothers because it provides a useful framework to consider how maternal regret may likewise provide valuable insights into how normative motherhood may be challenged and changed. Periodic maternal absences expose the gendered inequality of parenting and seek to reform it. Similarly, maternal regret reveals that the normative mandates of essentialization, naturalization, and idealization are only ideological constructions that dictate how motherhood should be perceived and practised—they are not reflective of women's actual and lived experiences of mothering. In this, regretful mothers flip the script of normative motherhood: they speak truth to power.

Maternal Regret and Empowered Mothering: Flipping the Script and Maternal Authenticity

Elsewhere I have developed a theory of empowered mothering as a counternarrative to resist and reform patriarchal motherhood (O'Reilly, *Matricentric Feminism*). Empowered mothering signifies a theory and practice of mothering; it challenges the dominant discourse of motherhood and transforms the various ways that the lived experience of patriarchal motherhood is limiting or oppressive to women. In *Of Woman Born*, Rich writes, "We do not think of the power stolen from us and the power withheld from us in the name of the institution of motherhood" (275). The aim of empowered mothering is, thus, to reclaim that power for mothers and to imagine and implement a mode of mothering that mitigates the many ways that patriarchal motherhood, both discursively and materially, regulates and restrains mothers and their mothering. A theory of empowered mothering begins by positioning mothers as "outlaws from the institution of motherhood" (Rich) to imagine and implement a maternal practice beyond patriarchal categorization and regulation. I suggest that maternal regret can play a central role in creating empowered mothering to challenge and change patriarchal motherhood.

Central to a practice of empowered mothering is the enactment of maternal authenticity. Authenticity, as Elizabeth Butterfield explains, "is an ethical term that denotes being true to oneself, as in making decisions that are consistent with one's own beliefs and values [whereas] inauthenticity is generally understood to be an abdication of one's own authority and a loss of integrity" (701). In the context of empowered mothering, maternal authenticity draws on Ruddick's concept of the "conscientious mother" as well as my model of the "authentic feminist mother"; it refers to "independence of mind and the courage to stand up to dominant values" and to "being truthful about motherhood and remaining true to oneself in motherhood" (Butterfield 701). Regretful mothers are the quintessential mother outlaws; in their acknowledgement and articulation of maternal regret, they flip the patriarchal script of normative motherhood to expose that maternal desire, ability, and fulfilment are not innate to women; rather, they are constructed to regulate women's and mothers' lives. As well, in their refusal to mother in accordance with the patriarchal dictates of normative motherhood,

they enact maternal authenticity. In both, regretful mothers open up space for resistance to, and reformation of, normative motherhood.

Maternal Regret and the Repudiation of Compulsory Motherhood

In her 2013 blog post "Compulsory Motherhood," Meghan Brinson argues that compulsory motherhood functions in a manner similar to Rich's concept of "compulsory heterosexuality." Substituting motherhood for heterosexuality in Rich's article "Compulsory Heterosexuality and Lesbian Existence," Brinson writes the following: "The bias of compulsory motherhood, through which non-mothering experience is perceived on a scale ranging from deviant to abhorrent, or simply rendered invisible." While insisting that heterosexuality and motherhood are not interchangeable, Brinson maintains the following:

> Heterosexuality [functions] as a default position, [to] exert certain pressures on women to set aside their misgivings and conform. Motherhood also seems like a default position in our culture, and the narrative of childlessness is often attended by a similar spectrum of reception as lesbianism, ranging from sympathy for the infertile as tragically damaged to portrayals of the childless-by-choice as unnatural or even monstrous.

The mandate of compulsory motherhood dictates that all women will be mothers and that all mothers will perceive and position motherhood as the focal purpose of their lives. Indeed, in patriarchal societies, motherhood is the default position for all women, regardless of whether they desire children or are fulfilled in motherhood. The mothers of Donath's study resist and refuse compulsory motherhood. The women who were not mothers state that they have no desire to have children, and those with children convey regret in having them. Arguably, this may be the most radical and controversial conclusion of Donath's study and its most formidable and wounding assault on normative motherhood. In their unequivocal rejection of motherhood, the women of Donath's study, as both nonmothers and mothers, attest and affirm that motherhood is neither obligatory in women's lives nor necessary for their identities. The repudiation of compulsory motherhood permits and affords women the right to create lives and identities

not defined by or limited to motherhood.

Conclusion

In the epilogue to her book, Donath asks the following questions: "What are the consequences of silencing regret over motherhood? Who pays the price when we try to pretend it does not exist?" Donath provides an answer:

> I insist that it is not a single group who pays this price. Silencing regret impacts women who do not want to be mothers (both those who have children and those who do not): women who *do* want to be mothers (and who may or may not have children); and children—all of them suffer the actual consequences of those social orders that make *them*, that make *us*, the bearers of arrangements that purportedly care for us but are in fact instruments of our oppression. (221)

Indeed, not only does the acknowledgement of maternal regret empower women who do not desire children or regret motherhood by voicing and validating experiences of maternal regret and by sanctioning a life beyond motherhood, but it also empowers all women by exposing the normative dictates of essentialization, naturalization, and idealization as well as the oppressive societal conditions of patriarchal motherhood that regulate and restrain women's mothering. In so doing, maternal regret makes possible transformative empowered mothering. In *Of Woman Born*, Rich writes, "The words are being spoken now, are being written down; the taboos are being broken, the masks of motherhood are cracking through" (25). As one mother in Donath's study commented, "It was initially hard for me to say that having children was a mistake.... It took me a long time to be able to say those words" (47). As regretful mothers voice and validate their regret, they debunk and destroy the final taboo of normative motherhood. Mothers voicing regret, Kingston writes, "signals a large groundswell of maternal reckoning, [one that] has been compared to the #MeToo campaign." Indeed, this groundswell of maternal reckoning has made possible a formidable critique of, and corrective to, normative motherhood.

Works Cited

Brinson, M. "Compulsory Motherhood." *Medusa's Head 2013: Feminism, Poetry, Poetics*, 2013, transletics.blogspot.com/2013/04/compulsory-motherhood.html. Accessed 15 Apr. 2022.

Bueskens, P. *Modern Motherhood and Women's Dual Identities: Rewriting the Sexual Contract.* Routledge, 2018.

Butterfield, A. "Maternal Authenticity" *Encyclopedia of Motherhood*, edited by A. O'Reilly, Sage Press, 2010, pp. 700-01.

Donath, O. *Regretting Motherhood: A Study.* North Atlantic Books, 2017.

Fisher, Sarah. *Myth of Mothering Joy: Regretting Motherhood—Why I Would Rather Be a Father.* Lugwig Press, 2016.

Fox, B. "Motherhood as a Class Act: The Many Ways in which 'Intensive Mothering' Is Entangled with Social Class." *Social reproduction: Feminist Political Economy Challenges Neo-Liberalism*, edited by K. Bezanson and M. Luxtion, McGill-Queens University Press, 2006, pp. 231-62.

Hall, P. C. "Mothering Mythology in the Late Twentieth Century: Science, Gender Lore, and Celebratory Narrative." *Canadian Woman Studies*, vol. 18, no. 1-2, 1998, pp. 59-63.

Hays, S. *The Cultural Contradictions of Motherhood.* Yale University Press, 1996.

Kingston, A. "I Regret Having Children." *Maclean's*, 2018, www.macleans.ca/regretful-mothers. Accessed 15 Apr. 2022.

Maushart, S. *The Mask of Motherhood: How Mothering Changes Everything and Why We Pretend It Doesn't.* Vintage Books, 1997.

O'Reilly, A. *Matricentric Feminism: Theory, Activism, and Practice.* Demeter Press, 2016.

O'Reilly, A. *Rocking the Cradle: Thoughts on Motherhood, Feminism, and the Possibility of Empowered Mothering.* Demeter Press, 2006.

Rich, A. *Of Woman Born: Motherhood as Experience and Institution.* W. W. Norton, 1986.

Rothman, B. K. *Recreating Motherhood.* Rutgers University Press, 2000.

Ruddick, S. *Maternal Thinking: Toward a Politics of Peace.* Beacon Press, 1989.

Shriver, L. "Why Ruin Your Life?" *The Guardian*, 2005, www.the
 guardian.com/world/2005/feb/18/gender.uk1. Accessed 15 Apr.
 2022.

Treleaven, S. "Inside the Growing Movement of Women Who Wish
 They'd Never Had Kids." *Marie Claire*, 2016, www.marieclaire.com/
 culture/a22189/i-regret-having-kids/ Accessed 15 Apr. 2022.

Chapter 2

"I Know I Am Not Supposed to Say These Things. It Is Very Not Maternal of Me": Confessional Rhetoric of Maternal Resentment

Lorin Basden Arnold

In this chapter, I consider the way in which mothers, and those who judge them, frame and discuss maternal resentment in online blogs and discussion boards as well as the ramifications of that rhetorical frame. I argue that most maternal discourse regarding resentment can be understood as carefully constructed confessional rhetoric that carries within it both the admission of transgression and the vehicle for redemption. In developing this argument, I will discuss basic concepts of intensive mothering, the methodology utilized for this analysis, seven themes of mothers' rhetoric of resentment, and how this rhetoric may function for mothers. Through this analysis, I attempt to understand how mothers position their own transgressive behaviours of resentment, how others respond to those narratives, and what this sort of discourse may do for, or to, mothers as rhetors and readers.

Intensive Mothering

The meanings of maternal transgression must be located within the cultural understanding of motherhood as a natural and all-consuming

role for women. This view of motherhood has come to be understood in our scholarly lives as "intensive mothering" or "the new momism" (Douglas and Michaels) and in the online community as "attachment parenting." In *The Cultural Contradictions of Motherhood*, Sharon Hays examines the dominant conception of mothering in North America, which she terms "intensive mothering," that promotes the idea that the creation of a happy child is an obligation of mothers to ensure a successful life for their children. Thus, mothers must continually provide emotional and physical caretaking for the child, ignoring their own desires and needs.

Although not every mother understands or enacts this type of motherhood in the same way, a variety of scholars (e.g., Arnold; Johnston and Swanson; and Huisman and Joy) have found that they do recognize the demands of intensive mothering, including the mother as the crucial player in the child's development, the importance of making the child's needs primary, and the preciousness and innocence of children. Due to the pervasiveness of the intensive model of mothering, we see it replicated across communicative forms, including in online discourse. We also see mothers, and others, call out behaviour that violates these standards. Given the view of the child, and of mothering, as wondrous, it is no surprise that expressions of resentment would be seen as a violation. As Orna Dornath notes regarding the current model of motherhood:

> Although there is no one, single emotion that children inspire in mothers, and although a mother's feelings might vary over the course of a day and certainly over time, depending on the behavior of her children and the time, space, and assistance available to her, the expectation is that all mothers will feel the same—and consistently—if they wish to be perceived as "good mothers." The "good mother" must love each of her children without question or condition ... and feel pleasure in being a mother—and if a mother's path is not adorned with roses, her challenge is to enjoy the suffering that her situation entails. (33)

Yet Dornath, Patrice DiQuinzio, Joan Raphael-Leff, Shari Thurer, and others argue persuasively, and with evidence, that mothers' feelings are not so singular or so untroubled. As DiQuinzio states, "Many mothers report that mothering is a deeply ambivalent experience in

which, at one time or another, they feel exaltation, despair, and many other emotions in between" (viii).

Methodology

In order to better understand how mothers express the challenging— and challenged—feeling of resentment, I analyzed thirty blog and bloglike discussion forum posts that included significant discourse regarding resenting motherhood or resenting children as well as hundreds of responses of other rhetors, mostly also mothers, to those posts. This included blog sites such as *Filter Free Parents* and *Her View from Home*, blog columns of online publications, such as *Medium* and *Christian Living*, and discussion boards posts located on sites such as *Reddit* and *Mumsnet*.[1] In the rhetoric examined, I located six themes that were most prominent: characterizations of feelings of maternal resentment; love for the child/children; resentment of motherhood but not of the child/children; resentment of motherhood or children with mitigating factors that reduce blame; resentment as psychological issue or wrongdoing; and ways to reclaim the status of good mother by redeeming resentment. A seventh theme, resentment as natural and reasonable, was far less prominent but contained a pointed underlying critique of the cultural standards of intensive mothering.

Rhetoric of Resentment

Resentment Feels Like...

I ought to have known that this new life would give me little time for my husband and no time to do the things I enjoyed. But experiencing that reality filled me with thoughts of escaping it. Many nights, as I cradled my baby close and whispered into her ear that I loved her, my heart ached to be released from caring for her.

—Bryna Singh

Many of these mothers, like Bryna Singh, speak expressively and poignantly about how they experience resentment and what it feels like in their minds and bodies. They express pain and anger as well as sorrow and numbness. Anonymous Panda states, "I can't remember

the last day that I didn't cry," and Amother writes, "I can't keep going on like this. I'm a basketcase." Most of the mothers make clear that the feelings of resentment they are experiencing are not just one day's frustrations but the additive effect of anger and stress. Kristina articulates the range of feelings and indicates that she has reached a real breaking point:

> I don't want to be a mom anymore. I'm done. My nerves are shot, my fuses are short-circuiting, and my brain has backfired on cold, stale coffee for the very last time. The lone spark plug of sanity keeping me out of the loony bin has finally fizzled out. The mounting pressure has become too much for me to bear another tantrum-filled moment of motherhood. This mom is burnt the fuck out.

In addition to their experiences of these emotions, the mothers write about feeling that there is no appropriate place to express them; no one wants to listen to them talking about their struggle, and no place exists where mothering resentment will not be heard as inappropriate. As Lola Augustine Brown clarifies: "When we do complain, we do it in the most socially acceptable way, through memes declaring 'the struggle is real' or by talking about how much wine we need to get through this. We joke, but it doesn't feel very funny. It feels like bits of me, the fun bits, mostly, are dying from a lack of attention." Experiencing this intensity of emotion, with no way to express or relieve it, is clearly a pivot point in the sensation of being trapped by motherhood.

I Resent but Love My Child

Regardless of the content or length of the post, most of the mothers take some care to clarify their love for their children, regardless of feelings of resentment. In a comment response to an anonymous post on *Any Other Woman* ("Behind Closed Doors") Basketcase notes: "I do love my baby, he is wonderful. But he is also damned hard work and is everything I didn't want in a baby. I had such hopes of enjoying motherhood, and instead I hate it, and if I could go back in time, I would simply not get pregnant." Elizabeth Richards says that she loves her son "fiercely, as only a mother can," and Anonymous Panda states, "I adore my daughter, and I'm fully aware that one day, she'll be my

best friend." Inhiding foregrounds her love for her child and her commitment to him before she expresses her resentment: "First, I should note and emphasize that I love my son and would NEVER do anything to harm him in any way. Including showing him any sort of resentment. He's an incredible little human, and I strive every day to be the best mother I can be despite my feelings about motherhood."

This theme is replicated in instances of interaction between mothers, as well. Veryprivate[1]—whose initial writing expresses regret about having a child, a desire to run away, a belief that her spouse manipulated her into pregnancy, and a feeling that her daughter deserves a mother who "actually wants her 100%"—receives replies to her post suggesting that she leave both husband and child and let her spouse deal with it, as he was the one who sought the pregnancy. To this advice, she responds: "To everyone saying divorce my husband and leave my child/give her up for adoption. I can't do that. I don't want to do that. I love her, and yes, she drives me crazy and to the point of insanity, but I love her. And I will give her the best life I can without her growing up knowing I resented/hated her." For the majority of the mothers whose writings I analyzed, statements of resentment are paired with reassurances that the child is loved, whether the resentment is directed at the child or at the institution of motherhood.

I Resent Motherhood, Not My Child

"I hate to admit this and I'm hesitant and nervous in saying this, but I have been resenting motherhood lately." This is how Sarah opens her writing—by indicating the locus of her resentment. She goes on to further clarify that the resentment is not directed at her children, who are "good, amazing kids." This distinction between resenting the child and resenting the role is another common feature of the discourse I examined.

Like Sarah, the anonymous writer who tells her story in "Behind Closed Doors: Resenting Your Baby" clearly indicates that it is the expectations of the mothering role that are the origins of her resentment: "I resent being the only person that can feed her, who can calm her. I resent constantly being on call." Jenny Albers similarly notes: "Motherhood involves a lot of bending down. Backbreaking, repetitive bending down. And so much of the time, in all the bending down, I can feel resentment building up."

It is not surprising that this rhetorical positioning is common in the discussion of resentment. In her study of maternal regret, Donath also found it common for respondents to distinguish between motherhood and the children: "The distinction most of the women in my study make to clarify they regret motherhood, rather than the existence of their children in the world, suggests that they relate to their children as separate and independent human beings who have the right to live; at the same time, they regret becoming their mothers and being responsible for their lives" (75). Mothers in her study, like the mothers quoted above, wish not for the erasure of the children that they love but for the connection between them not to be one of mother and child.

At times, the mothers whose narratives I examined discuss their resentment in a manner that implies, or states, that what they feel is resentment of the child. In some of these instances, respondents stepped in to clarify that the writer's feelings are actually directed at the strain of the mothering role, not at the children. In response to AnonymousMom, who is the mother of a child with severe physical disabilities, Calsag declares: "You don't resent your child. You hate watching her suffer and badly want it to end."

For mothers who do state that they resent the child, they may be corrected or castigated by respondents. After Divinepoet states her resentment and general dislike for her baby, Maisieowens pleads in response: "Please, please, don't say you resent your baby ... that is a gift from God, and he chose [you] as his mommy." When challenged by another respondent to explain why she made this plea, Maisieowens explains:

> I have an eight-year-old and was a single parent to her until she was four, and I have a five [month] old baby and [dear husband] helps me to a point, and I do need to tell him he has to help me more. I live in NY; my entire family lives in FL. I don't have anyone here to talk to. I do feel alone A LOT of the times, BUT you will never [hear] me say I resent my children or crap like that. People like that make me sick.

Mothers, it appears, are on much safer rhetorical ground when they resent the institution of motherhood than they are if they specifically resent the child. Even so, as Alexis Barad-Culter puts it: "I know I am not supposed to say these things. It is very not maternal of me. And

when I have said this out loud to people, the response I usually get is 'No, you don't really mean that.' But yes, I do. The feelings sometimes are so real and so overwhelming. And confusing." Barad-Culter, and other mothers, recognize that feelings of resentment do not match the view of intensive maternity, which is deeply embedded in the culture, and they struggle not just despite of, but because of, this knowledge.

My Resentment Is a Special Case

In addition to creating some distance from censure by invoking love of the child or clarifying the direction of resentment, mothers in the discourse that I examined make claims regarding the special circumstances that they face, which make motherhood more difficult and resentment more understandable. These special circumstances include challenging family compositions (single mothers or mothers with partners who will not participate), limited access to help (often due to distance from family), and particular child characteristics (primarily physical or psychological disability).

In her response to Kristina's post regarding a desire to stop mothering, Andrea—a widow with a child who has attention deficit hyperactivity disorder, anxiety disorder, and Oppositional Defiance Disorder—describes her situation and goes on to say: "I have been miserable ever since I've been having to do this alone. I resent that I can't get a moment to breathe let alone remember who I was as a person before she came along.... I love my child, but I truly hate motherhood." In a similar example, AnonymousMom, mother to a child with severe physical disabilities says on Reddit (a venue not always known for kind responses): "She literally can't do anything, and either me, my husband, or her home nurse (she has a nurse that comes in at night) [has] to do everything for her. Some days, I feel helpless and almost wish that I had just let her go all those years ago. Sometimes, I wish she'd just die so she wouldn't have to go through all of this pain." In reply to this post, the vast majority of responses show sympathy and understanding and praise the writer for her bravery.

Although the degree to which individual mothers view their lives as different from "normal" motherhood varies, in these examples, the specific special circumstances are carefully articulated by the writers, which often invoke responses from others, who frequently provide absolution. Responding to Bothofus, the mother to a child with

psychological disabilities, AllDressedUp states: "Nobody with any decency and empathy will judge you OP. I'm so sorry. Stop being brave. You and your other child's health and wellbeing should not be sacrificed completely for your disabled child." In this theme of the discourse, it appears that mothers who successfully articulate the particularly onerous nature of their mothering experience are given greater latitude by respondents. The rhetorical decision to frame statements of resentment within these special circumstances may reflect mothers' awareness of potential negative reaction as well as their own internal attempts to explain their problematic feelings.

Resentment as Abnormal

Whereas some writers and respondents suggest that feeling resentment, particularly toward the institution of motherhood, is not unusual, others make clear that such feelings are not normal. Calling her own feelings selfish and intolerant, Sarah says: "Having this shameful thought that I resent motherhood and I don't like being a stay at home mom? It's one of the worst things I've done/thought of for the last seven years." Selfishness is invoked as an inappropriate characteristic by these mothers, which reflects the intensive mothering standard. Catherine Wilson writes, "Oftentimes our anger is simply ignited by sin, selfishness or an over-sensitivity that finds fault when none was intended." In a similar exchange, Delta-01 responds to Inhiding's statements regarding her lack of enjoyment in mothering by saying: "When a life is in your hands, things like 'I'm hoping I just don't like the job of parenting babies' shouldn't be expressed. You're in full control, know yourself because this is the biggest responsibility you could have ... it's 100 per cent selfish."

Feelings of resentment are also characterized as psychologically abnormal and are commonly paired with suggestions that they may reflect postpartum depression (PPD). Englass7 tells Divinepoet: "I'm sure you realise this isn't quite 'normal,' and you should probably talk to your doctor." Kimberly Zapata states that it was resentment that made her realize she had PPD. Similarly, many respondents to KelsieMama suggest that she may be experiencing PPD. Such responses suggest that resentment is not a normal, or an appropriate, part of the mothering experience.

Reclaiming Good Motherhood by Transcending Resentment

As resentment is often characterized as abnormal or problematic, suggestions for how to transcend feelings of resentment are not uncommon in this discourse. In addition to seeking medical or psychological help for the emotions and physical help for the tasks of motherhood, writers and respondents suggest that resentment can, and should, be overcome by redirecting attention.

Andrei suggests that repenting and feeling "filled by the abundance instead of drained by the responsibility" is a solution. Likewise, Courtney Reissig reminds mothers of the following: "Motherhood is a call to death. You may find fulfillment in it, but it won't come in the ways the world talks about fulfillment. Fulfillment in motherhood is found in following the way of the cross, in laying down your life so another may live."

Writers not invoking religious perspectives also argue that a change of focus is needed. Bryna Singh says she overcame most of her resentment when she "stopped trying to wish my old life back and started to celebrate the life of my fast-developing baby." Jelise Ballon states that focusing on love is the solution because if the "heart is full of love, real love (patience, kindness, without envy or pride, free from self-seeking), then there cannot be room for resentment or bitterness." Fiona, in her reply to Youllhateme, argues, "you see him as work rather than a beautiful little person you've created. Entirely understandable, but you need to start building a loving bond with him as mum and son rather than carer and baby." Thus, the abnormal and problematic feeling of resentment can be resolved through seeking help or changing perspective.

Resentment Is a Normal Part of Motherhood

Resentment is never something you want to feel toward your kids, but you would be hard pressed to find a parent who hasn't experienced this emotion. We resent our kids for what they do to our bodies. We resent them for the loss of our free time. We resent them for the strain they put on our marriage. We resent them for the missed nights out. We resent them for not being what we expected. We resent them for revealing our shortcomings as parents.

—Gail Hoffer-Loibl

In these narratives, mothers or respondents who argue that feelings of resentment are completely natural and normal are the exception. Those who do still indicate that regardless of the normalcy, such feelings are associated with guilt and shame. As Ellen Braaten says: "Like many parents and caregivers, I sometimes felt overwhelmed and resentful. We don't often talk about those feelings. They can make us feel guilty and ashamed—and alone—even though these feelings are normal and universal." The Well-Adjusted Adult, responding to Kristina, similarly states: "We all often feel this way and wonder what people will think and fear if people will equate us to the ones that tragically drown their kids in the bathtub. We aren't! We are human beings being pulled thin. We are parenting in a society that expects much more from us as parents than any other generation before us, and that shit is hard."

Although these writers do not engage in an extended discussion of the issues inherent in our current model of motherhood, they point to the expectations, rather than the mothers, as the source of the problem. It is not that mothers are bad to be resentful. It is that the realities of motherhood and the expectations held by the society are unpleasant and unreasonable and create a situation where one would have to be superhuman to avoid resentment. Yet most mothers—even those who can see the issues with the expectations—report guilt and shame regarding resentment.

Functions of Maternal Rhetoric of Resentment

Regardless of the theme of the discourse, the ideas of intensive mothering form an unstated lens through which these mothers see their own behaviour. In falling short of the intensive model, mothers experience guilt, censure, or both. This can be clearly seen in these online narratives of resentment. In this section, I consider how maternal narratives of resentment, across the present themes, function as confessional and therefore redemptive rhetoric.

The standard established by intensive mothering asks the mother not only to maintain the happiness of the child but also to always keep their own needs and desires secondary (or tertiary, as they may also need to come after those of the spouse) to the needs and desires of the child. In the themes in the discourse of maternal resentment, we can see women confessing their own needs for privacy, time alone, a social

life, career success, romance, or even sleep while they simultaneously indicate that their feelings of resentment related to those needs are inappropriate. Maternal needs or desires can be positioned as acceptable only if they can be framed as existing within the intensive mothering model. This framing occurs most commonly in responses related to the mother's need for sleep. Replying to Amother's tale of anger and exhaustion, many respondents encourage her to find a way to get some rest. As WriterMom said: "You need to be able to function during the day, both for your sake and the baby's, and for any other children you have." Desiring sleep is spoken of as appropriate because it is ultimately for the good of the children. Desiring a wild night out or a personal getaway, in contrast, is not framed as acceptable, precisely because it benefits the mother as a standalone person but is not necessary for the wellbeing of the child.

In the discourse of these mothers, we can see them confessing a yearning to get away from the child or family, even though they believe—and resent—that such behavior is not permitted to them. The feeling of being trapped is common and intense, as Youllhateme writes, "I never seem to physically get away from him, let alone mentally get away from him." Inhiding expresses her resentment at being treated as a constantly available servant and adds the following: "I know how selfish and bitter this sounds. I HATE that I feel this way." In response, many respondents encourage her to persevere through this challenge as a difficult part of early mothering, but others are far less tolerant. As one respondent puts it: "I detest people that have kids and then regret it. Man the fuck up, stop bitching, and become a parent. It's not about you anymore." Whether suggesting that the struggle of constant accessibility is normal in early mothering or berating a mother for even wanting some freedom, respondents did not explicitly validate the feelings of resentment.

Throughout the themes of the resentment rhetoric, the resentment is rarely exhibited through maternal behaviour. Far more often, mothers were confessing that they were not reflecting the appropriate emotional responses of mothers. Mothers strongly and negatively evaluated themselves when they did not feel the way they "should" about mothering or their children.

Although we understand, culturally, that there are parts of mothering that might be stressful (e.g., worrying about the health and

wellbeing of the baby and taking care of multiple children at one time) or unpleasant (e.g., getting up throughout the night, changing diapers, and cleaning vomit), there are limits to the amount of annoyance or anger that a mother is expected or permitted to feel. In the narratives of resentment here, mothers make the claim that by feeling the level of anger and resentment they do, they have exceeded appropriate levels. As Andrei states, "When I feel the resentment, I know it's wrong." Inhiding and Julie characterize themselves as selfish. Gail Hoffer-Loibl explicitly notes that resentment causes guilt and the anonymous writer that led to Ellen Brattan sharing her story states her shame at even admitting resentment.

Not expressing negative emotions, such as resentment, however, is not enough. Motherhood, in the intensive model, is viewed as ultimately joyful and rewarding. Mothers are understood to enjoy their children and the experience, even with its stresses and unpleasant tasks, and find fulfillment in motherhood. For the mothers whose voices we hear in this discourse, their failure to feel as fulfilled by motherhood as they believe they should is seen as a personal failure. As such, even when mothers express their resentment as a special case, or as resentment of the role and not the child, they feel failure. As Inhiding says: "I wish I could love motherhood. Everyone talks about how special and magical and precious it is, and I'm just not feeling it." Nice&Shy similarly reports: "The realization that the magical unicorn mother-child soul bond that everyone promised I'd have would never come for me and that I regretted not getting the abortion I wanted was probably one of the hardest moments of my life." Living up to "magical" is much to ask of such a challenging role, yet these mothers are ashamed to feel that their motherhood has not reached that bar.

With the complexity of the feelings expressed in these narratives, including shame and a belief that such stories will be heard negatively, we might wonder why mothers would ever write publicly about resentment, even anonymously. I argue that this confessional rhetoric provides mothers with the opportunity to confess their carefully selected failures and seek forgiveness from a jury of their peers. Additionally, the public nature of the rhetoric allows non-confessing mothers to actually or vicariously be part of the community experience of confession and exoneration and thus obtain forgiveness for their own transgressions of resentment.

In the multivolume *The History of Sexuality*, Michel Foucault describes the prominence of confession as truth production in Western cultures. Foucault notes that in this confessing society, we do (or must) confess "whatever is most difficult to tell" (58). Foucault, in his published lectures ("Wrong-Doing, Truth-telling"), indicates that we do this because the confession itself—the avowal of the problematic act or feeling—causes us to search our conscience and then speak our sins, which produces shame and is therefore the beginning of purification. These confessions may happen in institutional settings (such as the church or the jail) or in our closest relationships, but they also may occur in public. The confessor only requires someone to hear the confession who is capable of judging it and either prescribing our punishment or forgiving our transgressions. Because this can occur in a virtual space, the listener need not be physically present or even guaranteed to exist; the act of confession remains powerful. As Foucault (62) remarks, "It purifies [the sinner] and promises him salvation" (62). And as Chandra Wells notes, enacting this process within the context of a blog (or discussion forum), where aliases are common, allows for the expression of these complex emotions outside of our personal and professional real-world relationships, which makes blogs or discussion forums a prime place for confessional rhetoric.

For mothers, failure of maternal devotion is a sin that is certainly "most difficult" to express. The rhetorical choices reflected in the themes of this discourse suggest that these mothers are making careful selections in their confessional acts. The sins of resentment they confess are largely limited to emotional failures (rather than behavioural actions that might be seen as dangerous to the child), are directed less at the child(ren) than at the institution of motherhood, and are mitigated by being paired with discussions of special circumstances and deep love. The confessions need not be of the most serious maternal sins of commission, as the lesser and mitigated failures of omission stand as a proxy for all resentment-related violations of the maternal role.

As rhetors engage in confessional rhetoric, they call upon societal standards of behaviour. After all, if we are not violating some standard, we would have little to confess; if it was only our own standards we had violated, there would be no utility in public discussion. For these mothers, the yardstick by which they are measuring themselves, and which then becomes the frame of reference for judgment by readers, is

intensive mothering.

Implicitly and explicitly, in these narratives, mothers invoke the selflessness and devotion of intensive mothering. They call themselves selfish for wanting such things as "physical autonomy and wide-open mental space for ideas and accomplishments and order" (Julie). They note that they have to help themselves by celebrating and focusing on their children. They call up the notion of the overwhelming strength of maternal love that cannot be replaced by other caregivers. They call mother love "fierce" and unique to mothers, saying that they love their children more than they could ever express and "more than life itself" (Kristina). And they call it, as Lola Augustine Brown does, a "deep, burning love" that "eclipses everything I have ever felt."

Even among the few mothers that claim the normalcy of resentment in motherhood, there is an implication that it is a problem that should be fixed by the mother, and the belief that motherhood is a natural part of being for women remains. As Sarah Lou Warren notes, "We are 100% responsible for our feelings of resentment" and need to see them as a warning sign that something must change. We must find time for more rest, ask for more help, see the doctor, celebrate the child, be patient as we wait for the infant phase to pass, consider our diets, worship and emulate our lord, and understand that the fulfillment of motherhood is different than other kinds of fulfillment. In the end, although a limited number of mothers do note that some of the resentment arises from the unreasonable responsibilities of motherhood, the responsibility for resolving the resentment remains the mother's. As WisWoman1 tells Divinepoet, "Only you can get yourself out of this rut." Many responses advise seeking professional help for mothers whose feelings exceeded what the respondent felt appropriate. This trend parallels the findings of Sarah Pedersen and Deborah Lupton, who in their analysis of *Mumsnet* posts related to maternal feelings find that mothers often indicate negative maternal feelings, but when those feelings exceed a perceived boundary, professional care is recommended.

In these narrative exchanges, mothers hold the responsibility of bearing witness for each other's confessions and serving as the arbiters and helpers as others seek to be better. In the conversation regarding Divinepoet's post, RubyDoll states that a mother should be encouraged to share her feelings: "She can feel better and look for ways to improve

her situation and other people can see that they are not alone. It may not be 'normal' to resent your child, but it happens and with the love and support we can show her and all the other moms who feel the same way, the better these women can get." Thus, in rhetoric of maternal resentment, mothers use the intensive mothering model as the standard by which they judge themselves and find themselves to be sinners, the frame for selecting and composing the confession, the yardstick by which others may assess the confession, and the tool by which mothers can be offered advice for the redemptive efforts they must undertake. Although some mothers point to the problem of the current model of motherhood, those examples are limited and embedded within discussions that continue to reaffirm the glory of mothering.

The discourse I examined certainly does not represent the entirety of mothering experience or discourse online. Motherhood is significantly impacted by cultural, individual, and socioeconomic factors that encourage or discourage participation in online discussions of personal experiences. However, these examples do provide a view of a common pattern of discussion of resentment in motherhood. A quarter century after the publication of Hays' text, the intensive model of mothering is still powerful, and motherhood remains embedded in cultural contradictions. Mothers are still judged not only for their mothering behaviour but also for their individual feelings, and they still evaluate themselves severely for failing to feel the way they believe that they should. Their lives as individuals remain circumscribed by expectations of motherhood.

Regardless of the specific rhetorical choices made in their discussions, these mothers position resentment as a transgression and seek forgiveness and redemption through carefully constructed confession. Underlying all of this discourse is the model of intensive mothering, from which the standards are drawn for mothering evaluation. Evaluated through this impossible lens, resentment is a failure of a motherhood in need of redemption.

By stating this, am I saying that it is good for mothers to feel resentful? No, but neither am I saying it is wrong or bad. Resentment is a normal human emotion. It is as much a part of us as joy and wonder. Mothers are asked to suppress too many emotions that are seen as negative or as not nurturing. We are not to be angry, bitter, or loud. Even our sadness should be kept under wraps if it impinges on the joy

of others. What woman has not been told that she should smile more by a passing stranger? What mother has not been told by a friend or family member that she should enjoy the time of raising children because it passes so quickly? If a woman's feelings of resentment cause her trauma, it should be addressed for her wellbeing. If a woman engages in dangerous behaviour towards others as a result of her resentment, that should be addressed for the wellbeing of those who are being hurt. But mothers should not have to feel that simply having these feelings is behaving in a way that makes them bad women or bad mothers. As Ellen Braaten notes, parenthood (and I would say particularly motherhood) is an all-consuming job: "You're always needed, and you're never done." And that is too much for anyone to manage.

Endnotes

1. Blog posts and similar discussions were gathered utilizing multiple online search programs and certain search terms, including "resent," "resentment," "child," "children," "baby," "toddler," "mother," "motherhood," and "mothering." All discourse examined for this analysis exists in publicly available online venues. Blog posts and blog columns (blogs written for publication in online periodicals) with discourse quoted in this paper have been cited in the bibliography, as they were directly written for public consumption. Discussion board posts were gathered only from discussion forums that required no registration; thus, no privacy was violated. However, as individuals may, at times, post on such forums without fully considering their public nature, I have not provided a bibliographic citation for that material and have altered usernames. Where discourse is presented here, I provide it in largely unedited format. With only edits required for comprehension, the language choices and typographical choices of the authors have been preserved, such that we might more fully examine the rhetorical choices made by these mothers and respondents.

Works Cited

Andrei. "Dealing with Resentment as a Christian Mom." *Missionary Mom*, 16 May 2018, www.missionarymom.net/resentment/. Accessed 17 June 2020.

Albers, Jenny. "Replacing Resentment with Humility When Motherhood is Overwhelming." *A Beautifully Burdened Life*, 7 Oct. 2018, https://abeautifullyburdenedlife.com/all-blog-posts/replacing-resentment-humility-motherhood-overwhelming/. Accessed 21 April, 2022.

Amother. "So Exhausted that I Resent My Baby. I Need Help." *ImAMother*, 1 Sept. 2009, https://www.imamother.com/forum/viewtopic.php?t=90767. Accessed 20 April 2022.

Anonymous Panda. "I Love My Daughter, but I Hate Being Her Mom." *Medium*, 11 May 2019, https://medium.com/@anonymous_panda/i-love-my-daughter-but-i-hate-being-her-mom-ff74345a7886. Accessed 21 April 2022.

Arnold, Lorin B. "I Don't Know Where I End and You Begin: Challenging Boundaries of Self and Intensive Mothering." *Intensive Mothering: The Cultural Contradictions of Modern Motherhood*, edited by Linda Ennis, Demeter Press, 2014, pp. 47-65.

Ballon, Jelise. "The Ugly Truth of an Overwhelmed Mom and Resentful Wife." *Her View From Home*, https://herviewfromhome.com/the-ugly-truth-of-an-overwhelmed-mom-and-resentful-wife/. Accessed 21 April 2022.

Barad-Cutler, Alexis. "Sometimes I Hate My Toddler." *Going Beyond Movement*, https://goingbeyondmovement.com/sometimes-hate-toddler/. Accessed 21 April, 2022.

"Behind Closed Doors: Resenting Your Baby." *Any Other Woman*, 3 Sept. 2013, http://anyotherwoman.com/resenting-your-baby/. Accessed 17 June 2020.

Braaten, Ellen. "Sometimes I Resent My Child. Is That Normal?" *Understood*, https://www.understood.org/en/articles/sometimes-i-resent-my-child-is-that-normal*. Accessed 21 April 2022.

Brown, Lola Augustine. "Regretting Motherhood: What Have I Done to My Life?" *Today's Parent*, 8 June 2017, https://www.todaysparent.com/family/parenting/i-regret-motherhood/. Web. 21 April 2022.

DiQuinzio, Patrice. *The Impossiblity of Motherhood: Feminism, Individualism and the Problem of Mothering*. Routledge, 1999.

Donath, Orna. *Regretting Motherhood: A Study*. North Atlantic Books, 2017.

Douglas, Susan J., and Merideth W. Michaels. *The Mommy Myth: The Idealization of Motherhood and How It Has Undermined All Women*. The Free Press, 2004.

Ennis, Linda, editor. *Intensive Mothering: The Cultural Contradictions of Modern Motherhood*. Demeter, 2014.

Foucault, Michel. *The History of Sexuality, Volume 1: An Introduction*. Vintage Books, 1978.

Foucault, Michel. *Wrong-Doing, Truth-Telling: The Function of Avowal in Justice*. University of Chicago Press, 2014.

Hays, Sharon. *The Cultural Contradictions of Motherhood*. Yale University Press, 1996.

Hoffer-Loibl, Gail. "Resentment: What I Never Expected to Feel As a Mother." *Filter Free Parents*, 24 July 2017, https://filterfreeparents. com/resentment-what-i-never-expected-to-feel-as-a-mother/. Accessed 21 April 2022.

Huisman, Kim, and Elizabeth Joy. "The Cultural Contradictions of Motherhood Revisited: Continuities and Changes." *Intensive Mothering: The Cultural Contradictions of Modern Motherhood*, edited by Linda Ennis, Demeter, 2014, pp. 83-103.

Johnston, Deirdre D., and Deb H. Swanson. "Constructing the 'Good Mother': The Experience of Mothering Ideologies by Work Status." *Sex Roles*, vol. 54, no. 7-8, 2006, pp. 509-19.

Julie. "Not Regretting Motherhood (but Resenting It a Little)." *These Walls*, 10 Aug. 2017, https://thesewallsblog.com/2017/08/10/not-regretting-motherhood-but-resenting-it-a-little/. Accessed 21 April 2022.

Kristina. "Resenting Motherhood" *The Angrivated Mom*, 18 May 2016, https://angrivatedmom.wordpress.com/2016/05/18/resenting-motherhood/. Accessed 21 April 2022.

Pedersen, Sarah, and Deborah Lupton. "'What Are You Feeling Right Now?' Communities of Maternal Feeling on Mumsnet." *Emotion, Space and Society*, vol. 26, 2018, pp. 57-63.

Raphael-Leff, Joan. "Healthy Maternal Ambivalence." *Studies in the Maternal*, vol. 2, no. 1, 2010, https://doi.org/10.16995/sim.97. Accessed 21 April 2022.

Reissig, Courtney. "When Motherhood Feels Like Death." *Christian*

Living, 6 June 2018 https://www.thegospelcoalition.org/article/motherhood-feels-like-death/. Accessed 21 April 2022.

Richards, Elizabeth. "Being a Stay-At-Home Mom Made Me Miserable." *Mommyish,* 20 June 2011, https://mommyish.com/being-a-stay-at-home-mom-made-me-miserable/. Accessed 21 April, 2022.

Sarah. "I've Been Resenting Motherhood Lately, and I Don't Like Being a Stay at Home Mom. Ooops, I Said It." *Our Life is Beautiful,* 25 Sept. 2014, https://www.ourlifeisbeautiful.com/ive-been-resenting-motherhood-lately/. Accessed 21 April 2022.

Singh, Bryna. "From Excitement to Resentment: Why This New Mum Hated Her Life After Baby." *Young Parents,* 15 Dec. 2106, https://www.youngparents.com.sg/from-excitement-to-resentment/. Accessed 17 June, 2020.

Thurer, Shari L. *The Myths of Motherhood: How Culture Reinvents the Good Mother.* Houghton Mifflin, 1994.

Warren, Sarah Lou. "The Medicine of Maternal Resentment." *Single Mama Magic,* 5 Nov. 2019, https://www.sarahlouwarren.com/blog/the-medicine-of-maternal-resentment. Accessed 21 April 2022.

Wells, Chandra. "The Vagina Posse: Confessional Community in Online Infertility Journals." *Compelling Confessions: The Politics of Personal Disclosure,* edited by Suzanne Diamond, Farleigh Dickenson University Press, 2014, pp. 203-24.

Wilson, Catherine. "Why Moms Who Struggle with Anger Need to Be Brave." *Focus on the Family Canada,* 2015, https://www.focusonthefamily.ca/content/why-moms-who-struggle-with-anger-need-to-be-brave. Accessed 21 April 2022.

Zapata, Kimberly. "How I Realized I Had Postpartum Depression." *Little Things,* 2017, https://www.littlethings.com/realizing-postpartum-depression/. Accessed 21 April 2022.

Chapter 3

"Reimagining What Might Have Been": A Comparative Analysis of Abortion and Maternal Regret

Alesha E. Doan and J. Shoshanna Ehrlich[1]

Introduction

In the mid-1990s, a vocal cohort of antiabortion activists insisted that the movement needed to expand its fetal centric message to include the grieving "post-aborted" mother. Grounded in the gendered belief that motherhood is woman's true calling, they argued that in addition to saving lives, restricting abortion access would benefit women by protecting them from the trauma of repudiating their maternal selves. The resulting abortion regret narratives have since proliferated across multiple platforms in an effort to persuade "abortion-minded" women to embrace their maternal destinies.

More recently, a growing number of women have begun speaking out about their regret at becoming a mother. Unlike with abortion, these narratives have not emerged within the context of an organized social movement but rather stand as the voices of individual women with a shared experience of grief and loss. These narratives of regret have not been put in meaningful conversation with one another.

This chapter engages in a comparative study of abortion and maternal regret narratives. We begin by situating these narratives in a brief history, tracing the origins of each. Using content analysis, we

then compare publicly available regret narratives from the antiabortion website *Silent No More Awareness Campaign*, and from the Facebook group "I Regret Having Children." Twenty-four subthemes emerged from the motherhood regret narratives and nineteen from the abortion regret ones. These subthemes coalesced into two broad themes: diminished wellbeing and loss. Across both sets of narratives, women express a longing for a reimagined life, unburdened by their reproductive decision. In the conclusion, we argue that although the antiabortion movement has weaponized abortion regret narratives for political gain, we contend that the reproductive rights movement has been missing an opportunity to use maternal regret narratives to combat hegemonic ideals of motherhood and challenge the essentialized construction of patriarchal motherhood (O'Reilly).

Situating the Regret Narratives

Emergence of Abortion Regret

The contemporary abortion regret narrative has a direct historical antecedent in nineteenth-century physicians' antiabortion crusade in which they warned of the dire consequences for women who subverted the "end for which they are physiologically constituted and for which they are destined by nature" (Storer 75-76). Characterizing abortion as contrary to "nature and all natural instinct," (74) they declared it woman's "holiest duty ... to bring forth living children" (81) and expressed utter disdain for women who made their bodies "dens of murder" ("Infantiphobia and Infanticide" 212).

In the wake of the Supreme Court's landmark 1973 *Roe* v. *Wade* decision, this essentialized view of women quietly took up residence in the nation's crises pregnancy centres (CPCs). Within the feminized and sanctified spaces of the CPCs, counsellors sought to steer women towards motherhood to protect them from the trauma associated with "child murder." Like the physicians before them, they collapsed womanhood with motherhood.

As the antiabortion movement began faltering in the early 1990s due largely to its increasingly violent tactics aimed at saving the life of the unborn, activist David C. Reardon urged leaders to place the grieving post-aborted woman at the centre of its oppositional message in order to persuade the public that the movement did not just care for

the sanctity of unborn life, but also spoke for the "*authentic* rights" of women (101). Anchoring this "prowoman/prolife" oppositional frame in the divinely inscribed "personal and intimate" bond between mother and child, Reardon insisted it is "impossible to rip a child from the womb of a mother without tearing out a part of the woman herself— a part of her heart, a part of her joy, a part of her maternity" (5).

Subsequently, the "therapeutic ... discourse concerned with informing women's decision making about abortion" (Siegel 1649) was transformed into a potent weapon aimed at shutting down the "abortion industry". Perhaps most famously, Operation Outcry gathered an extensive collection of "legally admissible, written sworn testimonies from women hurt by abortion" in order to expose "the great lie [that] abortion is good and safe for women." These testimonies were relied upon by the Supreme Court in its 2007 *Gonzales* v. *Carhart* decision in which it asserts it is "unexceptional to conclude that some women come to regret their choice to abort the infant life they once created and sustained.... Severe depression and loss of esteem can follow" (159).

The Emergence of Motherhood Regret

In contrast, given the highly stigmatized nature of maternal regret, it is not surprising that there is no direct historical antecedent for its current expression. However, there is a long narrative arc reaching back to at least the antebellum period, which makes it clear that motherhood has long been a freighted experience.[2] As Nora Doyle documents in *Maternal Bodies: Redefining Motherhood in Early America*, "The discomfort, pain, fatigue, and frustration wrought by childbearing and childrearing ... caused [women] to regard motherhood with ambivalence" (203). Rooted in this ambivalence, some turned away "from happily anticipating motherhood to desperately hoping to avoid further suffering" (60). Elaborating on this theme, according to George M. Beard, a prominent neurologist, "The simple act of giving birth opens the door to unnumbered woes ... ending by a life-long slavery to sleeplessness, hysteria, or insanity" (77). His colleague further cautioned that in some women, the common gloom of early pregnancy never lifted, leaving them "under the constant influence of a settled and gloomy anticipation of evil" (Montgomery 42).

Although the professionals were mainly preoccupied with the experiences of white middle-class mothers, Doyle stresses that

maternity was a particularly freighted experience for enslaved women. Although "often welcom[ing] motherhood as a role that helped them resist the worst aspects of slavery," (63) they were forced to endure the "psychological trauma" of having their children sold away by slaveowners cruelly intent upon "sever[ing] maternal-child bonds" (425). Seeking to assuage this trauma, enslaved women commonly "established practices of mourning," into which they poured their grief in an effort "to manage both the loss of a child and the loss of maternal authority" (Webster 428-29).

This historical record notwithstanding, maternal regret has been dubbed the "last parenting taboo" (Kingston). According to Orna Donath, this taboo is rooted in the fear of being met by a reaction of "disbelief and rage" and being "branded as selfish, insane, damaged women and immoral human beings" (xvi). Braving the potential backlash, in a 1992 poignantly titled commentary "Am I the Only Woman Who Regrets Having Children?" in the feminist newspaper *Off Our Backs*, Katie Kronberg wrote the following: "I feel that motherhood has ruined my life, and I may never recover.... What baffles me the most about the situation is that I never hear other women talk about how they may resent or despise being mothers. Surely other women feel the way I do about motherhood, but I feel like women like me do not have a voice. No one talks about this" (17).

However, as evidenced by the title of Sarah Treleaven's ground-breaking 2016 article—"Inside the Growing Movement of Women Who Wish They'd Never Had Kids"—the floodgates have since opened. According to Treleaven, the dam began bursting following the publication of Corine Maire's pithy book *40 Good Reasons Not to Have Children,* in which this mother of two defied social convention to boldly declare, "If I had perceived I wouldn't have conceived" (3). Since then, women have been speaking out (particularly in safe spaces on the internet) about their maternal regret and dreams of a "life unburdened by dependents and free from the needs of others. A do-over" (Treleaven).

The tradition of "locating of motherhood beyond the human experience of regret" (Donath xv) has slowly given way to a "ground-swell of maternal reckoning" (Kingston). The women Donath interviewed in her landmark study on maternal regret "refute the promise that sooner or later every mother will ... reorient her emotional world to

align with the trajectory of motherhood" (71). Instead, their stories feature "death, traumatic effects, and loss as *the essence of their motherhood*" (109).

In contrast to the abortion regret narratives, which have become highly politicized, the voices of women who regret motherhood remain highly individualistic and apolitical. Following our comparative content analysis, we return to this divide to argue that the latter's potential for dismantling the construction of patriarchal motherhood firmly embedded in the abortion regret narratives has yet to be tapped.

Voices of Regret

Seeking to put motherhood and abortion regret narratives in conversation with one another, we analyzed two public and readily available sources of data that catalogue them. Before doing so, an important proviso is in order. For present purposes, we have opted to accept the women's recounting of their experiences at face value. However, it is critical to recognize that a body of evidence-based studies have refuted the idea of abortion regret as a debilitating condition, finding instead that the most important predictors of postabortion mental health difficulties include preexisting psychosocial problems and prior experiences of rape or sexual assault (Robinson et al). Notably, the Turnaway Study, a five-year longitudinal study of comparative pregnancy outcomes found that women "felt more regret, sadness and anger about the pregnancy than about the abortion and felt more relief and happiness about the abortion than about the pregnancy" (Rocca et al. 128). It further reported that five years out, 99 per cent of participants said their abortion was the right decision, including those for whom the decision was difficult (Rocca, "Debunking"). At present, there have not been similar studies that seek to unpack the potential psychological and emotional underpinnings of maternal regret.

Data and Method

The abortion regret narratives came from the website *Silent No More Awareness Campaign*, a nondenominational Christian effort to "[m]ake the public aware of the devastation abortion brings to women and men." It posts narratives written by people "who are ready to break the

silence" by sharing their personal testimonies of abortion regret and document their road to recovery through Christian healing programs. The campaign encourages viewers to share these testimonies of regret with their social networks, specifically Facebook and Twitter. The campaign began on November 11, 2002, and houses nearly three thousand narratives. We selected 164 of the most recently posted narratives; one was written by a father and excluded from the analysis.

The motherhood regret narratives came from the Facebook group "I Regret Having Children." According to the group, the page exists "to let all of the mothers and fathers know that regretting having a kid(s) in not abnormal and shouldn't be a taboo subject." The group was created on July 9, 2012, and was active through December 14, 2018, when it became dormant for two years. Public posts began appearing again in August 2020.[3] Nearly twenty thousand people follow this page. Our analysis was conducted before the group became publicly active again; thus, it only includes posts from this initial active period. All the posts included in our analysis were posted anonymously. We included all narratives posted between 2012 through 2018, which yielded a sample of 164; ten were written by fathers and excluded from the analysis.

Outside of the narrator's sex, demographic information was rarely disclosed on either site. Thus, in the analysis, we were unable to consider potentially relevant intersectional differences in the regret narratives. We coded the motherhood and abortion regret narratives using an open coded, in-vivo format (using the words in the narratives) to catalogue dominant and frequent themes (Charmaz). Although themes were coded separately, they were not expressed discretely; most narratives touched on several themes.

Multiple aspects of regret are infused through and expressed in both sets of narratives. Twenty-four subthemes emerged from the motherhood regret narratives and nineteen from the abortion regret narratives. Our analysis focuses on nine prominent subthemes that coalesced into two broad and often overlapping latent themes that capture women's expressions of diminished wellbeing and sense of loss (see Tables 1 and 2). Below, we include narrative quotes that are representative of these subthemes; pseudonyms are used for all quotes.[4]

Analysis

Comparing narratives of motherhood and abortion regret reveals striking similarities. Although we focus here on the broad themes of diminished wellbeing and loss, as a whole, the narratives are replete with poignant stories of changed lives. Many motherhood regret narratives are imbued with a haunting expression of a longing to undo their decision in favour a less burdened existence. Similarly, the abortion regret narratives often speak of a backward facing yearning for an opportunity to undo the irrevocable in favour of bringing their deceased child into the world. In short, we see heartfelt expressions of a longing for a reimagined life across both narrative sets.

Diminished Wellbeing

This broad theme reflects women's overall sense that their psychological welfare and ability to take care of themselves has been impaired due to their reproductive choice. Within this broad theme, the narrative sets share three subthemes: declining mental health, deep feelings of shame, and relationship strain. Motherhood regret narratives uniquely had two subthemes—detrimental financial impact and stress— whereas the abortion regret narratives singularly included increased substance use and promiscuity.

Regardless of the outcome, women who regret their reproductive choice painfully attribute their declining mental health—frequently marked by depression and, at times, suicidal ideation—to their decision. Twenty-seven per cent of motherhood regret narratives detail the mental health challenges women have had since becoming mothers. Confiding her feelings in a post, Janine reflects on her decision to become a mother: "I hated myself for being so weak, letting others decide for me. We have a baby boy, and tomorrow we celebrate his first birthday. Everyone will celebrate except for me. The feeling of frustration for being a mother is stronger than anything. I made a huge mistake, and I cannot forgive myself. I hate my life, and I have suicidal thoughts." Janine is struggling with the negative impact motherhood has had on her mental health. Her feelings were exacerbated by the pressure she felt from her husband, parents, and in-laws to initially become a mother. Other women similarly felt societal or familial pressure to have children, which often amplified their regret.

Stories of declining mental health were also prominent among

abortion regret narratives but at a higher rate (37 per cent). Echoing motherhood regret, many of these are linked to recollections of feeling pressured into a reproductive decision. For example, Charlene felt pressure from her boyfriend who at age seventeen "wasn't ready to be a dad." Recalling her experience, she writes: "I rode home in awkward silence. I was sad and in pain. I spent my time healing at my baby's father's house with his mom. Nothing was the same. I fell into an abyss. I wanted to die.... I tried to put it all behind me and move forward, but my heart ached, and the pain would not go away." Like Janine, Charlene felt out of step with the expectations of the people closest to her, which amplified the isolation and depression she experienced.

Women's stories also included harbouring feelings of deep-seated shame—a subtheme in more than one-third of narratives in both sets. Instead of feeling joy, Julianne regrets motherhood and is mired in shame because her feelings conflict with society's scripted expectations of maternal bliss: "A few days after having the baby I felt intense regret and it hasn't gone away. I just hate my life now ... the sleep deprivation, the drudgery, the monotony, and I feel so guilty and ashamed for feeling this way." Julianne has gone to "both individual and group therapy," but "once they hear that I regret having a child, I become unwelcome." Her failed efforts to obtain support underscore the continued stigmatization of a female identity that "departs from culturally accepted valuations of mothering as adaptable and therefore as untouchable by any wish to undo it" (Donath 45).

Turning to abortion regret narratives, Cassie's feelings of shame have grown from the initial relief she experienced following her abortion and her evolving understanding of it: "The amount of relief I felt was enormous.... I didn't cry, and I didn't feel numb. I was back to normal." However, years later, she came to view her decision to abort as immoral, leading Cassie to feel "shame, anger, depression, anxiety, and resentment that clouded [her] life." Being "completely consumed" by shame, Cassie's overall wellbeing was dramatically impaired.

Diminished wellbeing was not limited to women's internal struggles with mental health or shame. In both narrative sets, slightly more than 50 per cent of the women connected their strained relationships with their partners, friends, or children to their reproductive decision. Motherhood regret was frequently intensified by the constant demands

of parenting, and women often resented their partners' stunted efforts at sharing childrearing and home responsibilities. For some women, having a partner who pulled their weight was not enough to inoculate their relationships from the impact of maternal regret or to repair the ensuing damage.

For example, Maureen and her husband had a vibrant relationship before having children. Shortly after the birth of their first child, they found their rhythm sharing parenthood responsibilities. However, their division of labour did not prevent Maureen from "hat[ing] almost every day of my life raising two children," nor did it save her marriage from buckling under the strain of regret. Although Maureen regretted having her first child, she eventually persuaded herself to have another so her child would have a companion. Following the birth of her second child, she quickly realized it was a mistake that accelerated the demise of her marriage: "[My] marriage is probably over. We don't talk, don't touch, and are both miserable. We don't have a clue as to how to fix our marriage because we have not had a chance to work on it since we had children."

Likewise, many women trace their relationship difficulties to their abortion decision. Karen had an abortion when she was a teenager. Well into adulthood, she married and had children. But Karen believes her abortion marked her with "an inability to trust," leading "anger and fear [to] bleed onto my relationship with my children and my husband." Karen describes how her regret had a destructive impact on her relationships, preventing her from being able to "connect and be fully present with those closest to me." She believes that her abortion contributed to the end of her marriage because she "wasn't able to be ... a good wife and mother." In another narrative, Sherrie similarly speculates: "I have always felt I would have been a more intimate wife and loving mother if there just wasn't that shame cloud I kept trying to ignore and hide from."

Across both sets of narratives, women trace their battles managing mental health, living with intense shame, and dealing with irreparable relationships to their reproductive decision. However, other subthemes of wellbeing were unique to each group. Nearly one-third of motherhood regret narratives also detailed how the financial impact of childrearing created a precarious day-to-day existence for them. Even more pervasive in the narratives, most women (70 per cent) discussed

the crushing stress and pressure they experienced as mothers. Although these subthemes were absent in the abortion regret narratives, two novel subthemes—substance use and promiscuity—emerged. Slightly more than one-third of women turned to, or increased, their consumption of alcohol and drugs to cope with their postabortion feelings. Others (17 per cent) described engaging in promiscuous relationships to blunt their feelings of regret.

Loss

Loss over a life that used to be, a future that could have been, or a present that is unbearable is the second major latent theme present in both narrative sets. Expressions of loss, however, are far more prevalent in the motherhood regret narratives. Within these temporal frames, three subthemes of loss are shared across the narratives: loss of control, being trapped, and the wasting of one's life. Each set also contains one unique subtheme—the loss of freedom and the loss of a child.

Seventy per cent of motherhood regret narratives describe a lack of control over one's life resulting from the demands of parenting. Unpacking this, Christine bemoaned how her daughter's needs consumed all the available space in her household leading her to conclude as follows: "Honestly, if I could go back in time, I would not have a child. I feel like I gave up some part of me." Christine's loss of control was cumulative. "As the years went by, dealing with childhood sickness, school issues, finances, teen drama, worrying ... all of it chipped away at me.... There was this resentment trickling into me." This chipping away was so profound that when her daughter left for college, Christine felt that her "body, time, career, money, marriage, etc., was not my own anymore," and she worried about recouping them.

Although relatively fewer abortion regret narratives (31 per cent) detailed a resulting loss of control, when expressed, it was nonetheless potent. Carla was eighteen years old when she became pregnant. She and her boyfriend had recently broken up, and as Carla describes: "I didn't know what I wanted.... After the abortion, I spun out of control. I started to drink more and was very confused about my relationships." Shortly after her abortion, she and her boyfriend ended up getting married, but the loss of control she felt never subsided, leading Carla to conclude thirty-five years later that "The abortion impacted our

marriage and our parenting."

Typically intertwined with a lack of control was the feeling of being trapped in a "life sentence" that could not be undone. As Melonie explains, three years after the birth of her daughter, and the subsequent birth of her son, her feelings of being suffocated and trapped had not subsided:

> I feel so trapped and helpless.... I find myself wondering more and more what my life may have been like had I not got married and had kids. I am completely miserable doing the same thing day in, day out, and I cannot see a way that this constant blur of tasks will ever end. I feel as if my body and mind have been destroyed and that sexually I no longer exist. I am completely a nobody. Just a body that seems to exist from one day to the next.... I cannot see how it will ever end. I feel utterly destroyed as a woman.

Melonie's feeling of motherhood internment was shared in 74 per cent of the motherhood regret narratives.

Equally palpable, but far less common, 30 per cent of the abortion regret narratives discussed feeling trapped. These feelings typically emerged from the secrecy surrounding the abortion decision. Veronica was engaged when she and her fiancé experienced an unplanned pregnancy: "I had an abortion because I wanted to walk down the aisle with a white dress, protect my reputation, and start my husband's second marriage 'better' than his first. I feared my parent's reactions." Carrying this secret throughout adulthood left Veronica feeling trapped, leading her to lash out in "great anger, rage, and moodiness," which was often acutely directed at her husband.

Like Veronica, Deborah felt trapped by the secrecy of her abortion, which her family insisted she maintain. When Deborah learned she was pregnant, her family said she was ill equipped to parent and had "no business trying to care" for a child. They encouraged her to abort and move on with her life. Deborah explains that her abortion was "swept under the rug" and "never has this event been spoken of." Feeling trapped by this secret for thirteen years, Deborah internalized her pain and "linger[s] in pure hell daily."

In both narrative sets, women's sense of loss also manifested in the feeling that they had wasted their life grieving either over a lost past or

a future that could have been had they not made a reproductive mistake. This expression of loss was more common in the motherhood regret narratives (64 per cent) compared to the abortion regret ones (23 per cent). Capturing the depth of her struggle, McKenzie writes the following: "I absolutely HATE my life now. I no longer look forward to weekends or future events because every single day is the same shit—feeding, crying, nappies, vomit, poo and trying to get her to nap." This is punctuated by her profound sense of loss over what she has relinquished by having a child. "I would give every cent I have plus more to go back in time and not have her. My life before a baby was so good—good career, great money, overseas holidays every year with my husband, dinner with friends etc." McKenzie concludes her post with a stark realization: "I literally could have done anything with my life!!! And I gave it all up to raise another human."

Other mothers whose children were older came to view their time spent parenting as a waste of their life. Monica's and Julianne's narratives embody these feelings. Monica raised four children, now adults, as a single mom. Reflecting on her experience, she describes herself as "an overly invested mom, [who] did everything by the book." Even though Monica "spent all [her] money ... energy ... youth to make them happy," she does not "like the adults they have become." She feels she wasted her life parenting and concludes: "I regret, deeply, being their mother or being a mother altogether, I feel cheated."

Unlike Monica, Julianne is married and more affluent, with five children, three of whom are adults, and two are small children. She writes: "If you saw me, you would see the Soccer Mom stereotype personified. Carpools, class projects, volunteer, ball practice, Pinterest—basically cut from central casting." But beneath this veneer, she feels as though she has wasted her life: "What you won't see is the times I hide in the bathroom crying. You don't see my self-esteem shattering because I am certain I am losing IQ points as a SAHM [stay at home mom]." At the end of her post, Julianne confesses she is "heartbroken" because "no one knows the actual [her] anymore because no one asks." For Julianne, motherhood has stripped her of any "hopes of personal accomplishment."

Sharing similar feelings, women who regret their abortion detailed feeling that they had wasted their life and mourned for a reimagined one. Mandy, with the encouragement of her boyfriend, had an abortion

at age nineteen. They broke up shortly afterwards, which left her feeling "betrayed and abandoned." Mandy aches for a do-over: "I wish so badly that I had kept my baby." She continues to struggle with her decision, which she credits for ruining her life and imagines how it could have been otherwise: "I truly believe that if I had not had the abortion I would have a wonderful family with the father and that I would be happily married and have a wonderful life with beautiful children and a wonderful home and I would be happy."

Karissa also longs for a life she did not experience. Within one year of having her first unplanned child at eighteen, she found herself pregnant again. She was "struggling" with raising a baby and felt "lost, confused, and scared," so she decided to abort her second unplanned pregnancy. But instead of making her homelife more manageable, Karissa believes it led to a destructive path that she wishes she could do over: "As my life went on, I couldn't love and couldn't relate to my children or anyone." Even though Karissa had "a good husband and career," she found herself "making wrong decisions" and "couldn't figure out why [she] was changing and [why her] life was so painful." After several years of parenting, Karissa "ended up losing [her] children." After her parenting rights were revoked, Karissa's "life had no meaning or purpose."

Although these three subthemes of loss were penned by women in both narrative sets, each group presents a unique subtheme. For women who regret motherhood, 75 per cent intensely felt the loss of freedom in relation to activities they had engaged in prior to having children. Most mothers, like Shannon, felt a constriction of their prior lifestyle: "I've lost my freedom to travel alone and to do things I like whenever I liked, as well as my career. It's as if I was in a dream, then all of the sudden wake up to my worst nightmare." Leanna also acutely longs for freedom: "I would give up everything I have to get my life back, my freedom ... when I think of the educational, professional, and social opportunities that I was not able to explore, I am beyond depressed."

While loss of freedom was not a salient feeling for women who regret their abortions, 26 per cent of their narratives expressed a feeling of crushing loss for their aborted child. For years Wanda clandestinely mourned for this lost child. Her journey was marked by a "grief spanning two decades [that] was compounded by guilt and consequences that left [her] feeling vanquished to the island of secrecy

and shame." Reflecting on her life, Makayla describes how her sorrowful loss drove her to drift "through life carrying tremendous guilt and shame," which manifested in her being "very angry and short fused." Only later in life did she realize what she "was experiencing was the grief and effects of [her] abortion."

Placing these regret narratives in conversation with one another reveals that a sense of diminished wellbeing and loss were similarly archived across the two sample sets. This thematic continuity was underscored by the overarching counterfactual longing in both groups to "imaginatively cancel or nullify losses or errors" (Landsman 48) in favour of a do-over.

Conclusion: Harnessing the Untapped Destabilizing Power of Maternal Regret

Despite the above-discussed continuities, the abortion and the maternal regret narratives have been marshalled in different ways. The abortion narratives have been exploited by the antiabortion movement to advance the enactment of restrictive laws to ostensibly protect women from the pain of repudiating motherhood. Although it is not our intent to challenge the sincerity of the embedded expressions of suffering (although, as noted earlier, research indicates that post-abortion regret is typically attributable to other causal factors), we do take umbrage at the movement's brazen deployment of these stories to mobilize a universalized patriarchal construct of sublime maternalism as a vehicle for asserting control over women's reproductive bodies.

This discursive construct, as Andrea O'Reilly argues, insists that all women want to become mothers, that mothering comes naturally to all women, and that women experience mothering as fulfilling and gratifying leaves no room for alternatives. This construct has received a full throttle endorsement from antiabortion politicians actively working to restrict state-level access to abortion services (Ehrlich and Doan) while laying the groundwork to further gut, if not overturn, Roe v. Wade before an increasingly conservative US Supreme Court.

In contrast, the motherhood regret narratives exist as the private confessions of individual women who long for a childless life. There has been no organized effort by those committed to reproductive rights to deploy them in an effort to dismantle the universalizing trifecta of

patriarchal motherhood embedded in the abortion regret narratives. Of course, motherhood may well be the truly desired pregnancy outcome, but as these narratives make clear, not when it is prescribed as the singular scripted possibility.

In closing, we wish to stress that there is a critical missed opportunity here. These narratives contain an untapped potential to dismantle the myth of maternal destiny that has increasingly been deployed by the antiabortion movement to assert patriarchal regulation over reproduction. As Donath aptly argues "Regret is an alarm bell that not only should alert societies that we need to make it easier for mothers to be mothers, but that invites us to rethink the politics of reproduction and the very obligation to become mothers at all" (xvii). So viewed, regret serves as "hegemony's watchdog," (57) which directly dismantles the centerpiece of the prowoman/prolife antiabortion position that it is "impossible to rip a child from the womb of a mother without tearing out a part of the woman herself—a part of her heart, a part of her joy, a part of her maternity" (Reardon 5). Whereas abortion regret has been politically propped up as the definitive reproductive experience, motherhood regret stands as a potent counternarrative that holds the key to launching a frontal assault on its unfounded universalizing script in favour of a robust human rights approach to reproduction that is firmly grounded in the multidimensional realities of women's lives and the variabilities that exist across the lifespan.

Tables

Table 1. Diminished Wellbeing

Subthemes	Motherhood Regret	Abortion Regret
Declining Mental Health	41 (27%)	60 (37%)
Deep Shame	52 (34%)	57 (35%)
Relationship Strain	79 (51%)	85 (52%)
Detrimental Financial Impact	43 (28%)	—
Stress	107 (70%)	—
Substance Use	—	52 (32%)
Promiscuity	—	28 (17%)
Sample Size	154	164

Table 2. Loss

Subthemes	Motherhood Regret	Abortion Regret
Loss of Control	107 (70%)	51 (31%)
Trapped	114 (74%)	49 (30%)
Wasted Life	60 (64%)	38 (23%)
Loss of Freedom	115 (75%)	—
Loss of Child	—	43 (26%)
Sample Size	154	164

Endnotes

1. We are both equal coauthors. We also wish to thank our outstanding research assistants Razan Dareer, Stephanie Moraes, and Veronica Santos Puim.

2. Though not specifically about maternal regret, and thus beyond the scope of this chapter, there is a robust body of scholarship documenting the mothering challenges that diversely situated women face, based on the intersection of race, class, immigration status, disability, gender/sexual identities, and the like. However,

for present purposes, it is important to note that this literature also challenges the idea of a universally joyous and fulfilling maternal experience that is embodied in the prowoman/prolife antiabortion position.

3. The page was not publicly active for two years. We speculate the page went dormant in 2018 until a new page administrator made it public again in 2020.

4. The data used in this analysis are publicly available and therefore exempt from human subjects' approval (Benzon).

Works Cited

Beard, George M. *American Nervousness, Its Causes and Consequences: A Supplement to Nervous Exhaustion.* New York: G.P. Putnam's Sons, 1881.

Benzon, Nadia von. "Informed Consent and Secondary Data: Reflections on the Use of Mothers' Blogs in Social Media Research." *Ethics In/Of Geographical Research*, vol. 51, 2018, pp. 182-89.

Charmaz, Kathy. *Constructing Grounded Theory: A Practical Guide Through Qualitative Analysis.* Sage Press. 2006.

Donath, Orna. *Regretting Motherhood.* North Atlantic Books, 2017.

Doyle, Nora. *Maternal Bodies: Redefining Motherhood in Early America.* University of North Carolina, 2018.

Ehrlich, Shoshanna J., and Doan Alesha E. *Abortion Regret: The New Attack on Reproductive Freedom.* Praeger, 2019.

Gonzalez v. Carhart, 550 U.S. 127, 2007.

"Infantiphobia and Infanticide." *Medical and Surgical Reporter*, vol. 14, 1866.

Kingston, Anne. "Mothers Who Regret Having Children Are Speaking Up Like Never Before." *Maclean's*, 11 Jan. 2018, www.macleans. ca/regretful-mothers/. Accessed 15 Apr. 2022.

Kronberg, Katie. "Am I Only the Only Woman Who Regrets Having Children?" *Off Our Backs*, vol. 22, no. 8, 1992, p. 17.

Landman, Janet. *Regret: The Persistence of the Possible.* Oxford University Press, 1993.

Maire, Corinne. *40 Good Reasons Not to Have Children*. McClelland & Stewart, 2009.

Montgomery, William Fetherson. "An Exposition of the Signs and Symptoms of Pregnancy, with Some Other Papers on Subjects Connected with Midwifery." *The American Journal of the Medical Sciences*, vol. 65, no. 1, 1857.

O'Reilly, Andrea. "Maternal Regret and the Reframing of Normative Motherhood," *in Maternal Regret: Resistances, Renunciations, and Reflections*, ed. Andrea O'Reilly (Bradford, Ontario: Demeter Press, 2022).

Reardon, David C. *Making Abortion Rare: A Healing Strategy for a Divided Nation*. Acorn, 1996.

Rocca, Corrine. "Debunking the 'Abortion Regret' Narrative: Data Shows Women Feel Relief, Not Regret." *Salon*, 13 Jan. 2020, www.salon.com/2020/01/12/debunking-the-abortion-regret-narrative-our-data-shows-women-feel-relief-not-regret/. Accessed 15 Apr. 2022.

Robinson, Gail Erlick, et al. "Is There an 'Abortion Trauma Syndrome'? Critiquing the Evidence." *Harvard Review of Psychiatry*, vol. 17, no. 4, 2009, pp. 268-90.

Rocca, Corrine, et al. "Women's Emotions One Week after Receiving or Being Denied an Abortion in the United States." *Perspectives on Sexual and Reproductive Health*, vol. 45, no. 3, 2013, pp. 122-33.

Ross, Loretta. "Reproductive Justice as Intersectional Feminist Activism." *Souls*, vol. 19, no. 3, 2017, pp. 286-314.

Siegel, Riva. "The Right's Reasons: Constitutional Conflict and the Spread of Woman-Protective Antiabortion Argument." *Duke Law Journal*, vol. 57, 2008, pp. 1641-92.

Storer, Horatio. *Why Not? A Book for Every Woman*. Lee and Shepard, 1866.

Treleaven, Sarah. "Inside the Growing Movement of Women Who Wish They'd Never Had Kids." *Marie Claire*, 18 Sept. 2016, www.marieclaire.com/culture/a22189/i-regret-having-kids/. Accessed 15 Apr. 2022.

Webster, Crystal Lynn Webster. "In Pursuit of Autonomous Womanhood: Nineteenth-Century Black Motherhood in the U.S. North." *Slavery & Abolition*, vol. 38, no. 2, 2017, pp. 425-40.

Chapter 4

Shocking Readers and Shaking Taboos: Maternal Body and Affects in Itō Hiromi's Work

Juliana Buriticá Alzate

Introduction

Japanese women writers have a long history of defying stereotypes of maternal love as a natural instinct and of creating alternatives to ideal motherhood through their poetry, prose, and nonfiction writings. Scholars such as Amanda Seaman, Megan McKinlay and Aoyama Tomoko have used literature to discuss motherhood discourses vis-à-vis low fertility in an aging society and feminism in Japan. This chapter joins these discussions by exploring the representation of mothering, especially of pregnancy, childbirth, and mother-daughter relationships, in the works of Itō Hiromi (b. 1955)—also known as the "childbirth poet"—who has played a pioneering and influential role in shaping cultural understandings around mothering and stands out for tackling complex, unspoken, and silenced affects such as regret and anger. This chapter's departing point is that ideals of motherly love as natural do not fit the actual lived experiences of motherhood—that is to say, motherhood as an institution, a gender expectation, as well as a norm and a role does not fit the variety of experiences of motherhood. A large number of Japanese authors, including Itō, have written texts

that resist these ideals, and I will offer a brief background of this vital literary trend. I introduce a selection of Itō's texts—including her poetry, fiction, and nonfiction—while paying special attention to one of her most famous poems, "Killing Kanoko" (1985). It was written when she was taking care of her first daughter, Kanoko, and it mainly addresses the desire to commit infanticide while touching upon other themes, such as abortion, breastfeeding, and postpartum depression. Since its publication, it has continued to shock readers, and I explore and celebrate such a shock as a way to shake patriarchal taboos and ideals.

This chapter is divided into four sections. I first present an overview of the representations of motherhood in Japanese literature as a background to Itō's work. I then introduce her poem "Killing Kanoko," and offer a close reading in terms of embodied anger and maternity. Next, I introduce a selection of her works that can be considered attempts to free more maternal bodies. Finally, I articulate the ways in which Itō's work has shaped current understandings of mothering, and continues to do so, from a feminist perspective.

Background: Representations of Motherhood in Japanese Literature

In Japanese literature written by male authors the motif of "missing the absent mother" prioritizes the idealization of motherhood from the perspective of the son over the reality of the actual mothers (Ikoma).[1] Rebecca Copeland calls this literary motif "mother obsession," characterized by "maternal love and the longing for an absent mother" (McKinlay). In fact, the absence of the mother appears to be a necessary condition for maternal love and respect, which are constitutive of the idealization of motherhood by male authors.

In contrast, when studying works by Japanese women writers we find narratives featuring present mothers—that is to say, narrative voices centred on the mother. These are women characters that become mothers throughout the story and speak from a motherly perspective. This is what Sharalyn Orbaugh calls "maternalism" or "mother-centered discourse" in relation to author Ōba Minako's work (Orbaugh, "Ōba" 267). This notion of maternalism as well as a portrayal of the complex dynamics between mother and child, including the interplay

between motherly and daughterly perspectives, also feature in the works by Itō herein explored.

Women's writings have historically challenged the causal links between gender and social expectations and ideas regarding the role of mothers inherited from and prescribed by the "good wife, wise mother" (ryōsai kenbo) ideology (Koyama 11). "Good wife, wise mother" was a slogan promoted by bureaucrats in the Meiji government, which shaped the relationship between women and the state. It aimed to advance the role of women through assigning female bodies the function of "reproduction through family structures" (Orbaugh, *Japanese* 336). The Meiji state also put forth a patriarchal, hierarchical, and heterosexual concept of family in which the role of the members of the family was defined by age, gender, and relationship to the head of the family (Imamura 30). Major elements of the Meiji family system have continued all the way into post-World War II decades, as the heterosexual nuclear family unit—which was later on composed of the breadwinner salaryman and a devoted wife and mother—was idealized and encouraged by the state. Yet this ideal has gradually weakened, and there are a variety of family formations in the face of contemporary demographic trends: low birth rate, marriage refusal and postponement, choosing to be single, an increase in the divorce rate, and an aging society.

The "good wife, wise mother" became a paradigm of womanhood that though shifted continued to affect women until the end of the twentieth century (Koyama). As such, women's restriction to the dual roles of wives and mothers has been subject to criticism within Japanese feminisms and has often been tackled by women writers (Ueda; Ueno, *The Modern*; Koyama). For example, *Bluestocking (Seitō)*—the first feminist journal begun by Hiratsuka Raichō and her literary group, published between 1911 and 1916—was the centre of discussions about female sexuality, health, reproductive rights, and work-life balance (Orbaugh, *Japanese* 337). It was not easy to challenge the status quo; articles that seemed to threaten the "good wife, wise mother" ideal faced censorship (337). Yet for the years that followed, many Japanese women authors managed to publish literature that offered a poignant social critique on ideal motherhood, such as Okamoto Kanoko (1889–1939), Uno Chiyo (1897–1996), Hirabayashi Taiko (1905–1972), Hayashi Fumiko (1903–1951), and Enchi Fumiko (1905–

1986), to name a few.

A later group of writers—such as Ōba Minako (1930–2007), Kōno Taeko (1926–2015), Takahashi Takako (1932–2013), Kurahashi Yumiko (1935–2005), and Tomioka Taeko (b. 1935)—also offer outstanding depictions, or lack thereof, of motherhood. This later group can be considered more explicitly feminist, as their works were published in the 1960s and 1970s. In general, these authors depicted single women, women who actively rejected the predetermined paths of heterosexual marriage and motherhood, women who fantasized with infanticide, or women who embraced their sexuality. As noted, authors posing similar questions in the prewar, occupation, and postwar periods were criticized or were simply dismissed (Ericson 76, 100). The 1970s and 1980s marked the rise of feminist discourse, and Japanese literature by women writers "began to describe the experience of women—especially the themes of sexuality, pregnancy and erotic desire—with a frankness rarely seen in the past" (Angles, "Translator's Introduction" vii.). Hence, women writers from previous generations paved the way for contemporary authors to play a more visible and leading role in the literary scene while introducing new themes and expressions.

Writers contemporary to Itō also stand out for their unique portrayals against and beyond idealized motherhood—for instance, Shōno Yoriko (b.1956), Uchida Shungiku (b.1959), Mizumura Minae (b.1951), Kirino Natsuo (b.1955), Hasegawa Junko (b.1966), Kawakami Mieko (b.1976), Murata Sayaka (b.1979), Kanehara Hitomi (b.1983), among others.[2] Thus, we may locate Itō—as a follower and a pioneer—and her work within a larger group of writers that challenge ideals of motherhood and gender systems and enable alternatives through their fiction.

"Killing Kanoko": Embodied Anger and Maternity

"Killing Kanoko" is a long poem written in two separate columns, upper and lower threads in Japanese, or right and left threads in English. The first thread primarily addresses the theme of abortion, but it also touches on the subjects of breastfeeding, postpartum depression, and the desire to commit infanticide. The main narrator is Hiromi. The second thread describes the suicide of twenty-four-year-

old Hiromi by a friend and the actual infanticide of Kanoko (the narrator's six-month-old daughter) in a rage attack. According to Jeffrey Angles, "The bold expression of a young mother's desire to commit infanticide shocked many readers and earned Itō a place in the tabloid newspapers" ("Translator's Notes" 120). Even today, "Killing Kanoko" is a unique poem that continues to cause shock among readers. Critics have avoided the use of the word "shock" to refer to a literary work, as its visceral quality seems to clash with "the mediated nature of literary response" (Felski 105). Usually, when discussing "literature's power to disturb" we do not use everyday speech but rather "specialized language of transgression, trauma, defamiliarization, dislocation, self-shattering, the sublime" (Felski 105). Although this terminology is useful to identify nuances that help clarify our understanding of different experiences, in order to bridge the gap between theory and everyday life, it might also be useful to appeal to familiar references. Hence, the emphasis on the shock caused by "Killing Kanoko." As Rita Felski explains, shock is "a reaction to what is startling, painful, even horrifying. Applied to literary texts, it connotes something more brusque and brutal" (105). The shock caused by this literary work can be interpreted as a feminist strategy to dismantle or at least shake patriarchal ideals, myths, and taboos in everyday life.

One of the characteristics of "Killing Kanoko" is that it uses polyphonic devices to depict several points of view. Even in some sections of the poem in which the narration is being told in the first person, the reader feels that each line represents a different voice. This strategy highlights the individual and particular dimension to mothering, and it also creates a space in which these experiences are being shared, highlighting the multiplicity of experiences related to the maternal body (Quimby 34).

Itō's poem starts off with the details from a doctor at an abortion clinic about the leg of an aborted fetus, fetuses who are born alive, and patients dealing with or suppressing feelings of fear and guilt: "Here on this floor, all of the women are trying to deal somehow with their feelings about getting an abortion, and then we hear the crying of a baby" (Itō, *Killing* 33). This is one of the quotes from Magda Denes's book *In Necessity and Sorrow: Life and Death in an Abortion Hospital* published in 1976. This reference exposes Itō's interest in the

psychological dimension of abortion as well as her intent to problematize the debate. It is clear that both authors, Itō and Denes, are prochoice and in their very different types of texts readers find an understanding of abortion as a necessity, but still both authors do not hold back on the descriptions of the horror, sorrow, or pain that in some cases comes along with this decision. In "Killing Kanoko," the narrator is reading the details from the book while her sister casually says that she recently aborted a "brat" (gakincho). The narrator says the word "brat" is not the one she would use (Itō, *Killing* 33). Even if she congratulates her on her abortion, she seems conflicted with the way she refers to her aborted fetus. Itō poetically problematizes the tensions between life and death and between being born or unborn while addressing the blurry boundaries between fetuses and babies. Here Itō continues to push the limits of the definition of fetuses and babies:

> I had an abortion in the second trimester / I asked if the baby was a boy or a girl / But it is a lie to call it *a baby* / I should have called it a fetus / Of course / they won't say if it's a boy or a girl / Because the shock is too great / To the maternal body / The maternal body wonders / Was it a female fetus that looked like / Kanoko? Was it a male fetus that looked like Kanoko? (*Killing* 35)

Itō's position grants entire autonomy to choose to the maternal body, yet she problematizes the intertwined relationship between pregnant woman and fetus. The maternal body wonders what is happening inside her and points to the possibility of humanizing and imagining a relationship with one's "baby" through knowing the sex of the fetus, and this potentially affecting one's decision. Itō seems to be aware that the maternal body has a delusional construction of the fetus as a baby, as she is clear about it being "a lie"—that is to say, a psychological and social construction because in reality, she is aware that an unborn fetus is radically different from a baby. Yet those differences are being problematized in the poem in terms of playing a significant role in the psychology of abortion.

This excerpt also problematizes the relationship between the pregnant woman—or to use the poet's words, the "maternal body"—and the other being inside her. It is worth noticing that throughout the poem the author does not talk about mothers who abort, perhaps because in the debate over abortion it is important to differentiate

mothers of born babies and women pregnant with fetuses. Similarly, the poem addresses the differences between fetuses and babies. The antiabortion side of the debate argues for the fetuses' inalienable right to life from conception; hence, it conceptualizes abortion as homicide. From this side of the debate, women who interrupt their pregnancies are accused of being child murderers. Itō's poem certainly builds upon this accusation but challenges it.

The poem's treatment of infanticide also calls for examination. The narrator shares with the readers an intimate secret: "I have committed infanticide/ I have disposed of dead bodies/ It's easy if you do it right after giving birth/ It's easier than an abortion if you just/ don't get found out/ I have all the confidence/ To do it without being discovered/ I can bury any number of Kanokos" (*Killing* 37). In a later poem "The Painted Cat Flies in the Sky" (1993), originally written in English, she "changes her mind" and argues the opposite:

> I want to kill people / Of course I know I can't really do it /so I thought / I'll get pregnant and get an abortion / that's the easiest way to murder / I could think of / I have been saying that abortion is not murder / it is only excretion / Araki-san, do you laugh at me for changing my mind? / but well, it's true, I felt it, making love with a penis and having fun / I wanted to face it / it / there. (Itō, "The Painted" 153-54)

In both passages, there are not any traces of guilt or regret; in fact, the narrator says that infanticide and abortion are "easy." In "Killing Kanoko," the real problem is rooted in being discovered rather than in the act in itself. Hence, Itō situates morality as well as the stigma of abortion solely in the social dimension. Yet the actual description of Kanoko's infanticide contradicts this version as feelings of guilt and remorse emerge. I contend that Itō is comparing abortion and infanticide, as she is ironically playing with the arguments—from the antiabortion side of the debate—that often draw an analogy between both experiences. At the same time, she is also trying to understand or relate to such a posture. Itō's poetry, rife with contradictions, highlights the complexity of the maternal body rather than offering definite answers.

The author implicates herself in the poem by using her real name, but the use of "san" and the third person creates an impersonal

distance between author and character (Nakayasu). Similarly, Kanoko —the name of the author's real daughter—is written in katakana, creating a double movement of implicating and alienating themselves from the poetic act (Nakayasu). The actual infanticide in the poem and the fantasies of infanticide are "imagined incidents" that highlight the vulnerability, fragility, and intensity of a mother's emotional state (Tilton-Cantrell 184). Ellen Crystal Tilton-Cantrell insists that "Killing Kanoko" does not realistically address the topic of child abuse. In fact, abortion, infanticide, and child abuse are depicted in surreal ways. Hence, "Killing Kanoko" can be rendered as a "therapeutic poem" that liberates women who struggle trying to fit into an ideal (183). Along these same lines, Ueno Chizuko writes that "It sounds as though this act of poetic narration might have saved her from the actual act of infanticide. The excessiveness of her aggressive expression keeps her from excessive damage to herself" ("Foreword" 5).

"Killing Kanoko" is thus a poetic exploration of strong and dark emotions associated with mothering, and it is also an affirmation of one's right and/or ability to end one's pregnancy. The poem's final stanzas include several voices of women friends who have also aborted or abandoned their children or who wish they could do so. The poem depicts female solidarity and mutual understanding regarding abortion. The sentence "congratulations on your destruction" ("horoboshite omedetōgozaimasu") is a recurring motif throughout the poem. It creates a world in which abortion and abandoning children are not only acceptable but also encouraged (Tilton-Cantrell 185). Nevertheless, Itō does not idealize abortion, since feelings of fear, guilt, and anxiety are prominent in the poem. The sentence "congratulations on your destruction" also captures juxtaposing feelings, as it refers to the destruction of the body: Sometimes it may refer to the maternal body, but mostly it refers to the aborted body. Yet in other passages, it may capture the mother's own desire to destroy, or it may point to her own destruction: "Either possibility implies that the (usually celebrated) event of a baby's birth leads to destruction" (Tilton-Cantrell 194).

The repetition of this sentence creates "recurring, almost hypnotic cadences that parody the congratulatory message a young mother hears repeatedly upon becoming pregnant or giving birth" (Angles, "Introduction" 10). The rhythmical effect of the repeated "congratulations on your destruction" also builds a setting similar to a healing

trance state, adding to the therapeutic effect of the poem. In fact, according to Sarah Fox, this key sentence "supports the poet's objective to liberate herself (by obliterating child, father, husband) in service to language, the channeling of shamanic/poetic utterance" (Lima and Fox). The absence of the voices of the children and fathers also add to the notion that the maternal body belongs solely to the mother, reinforcing the feminist position in this debate: my body, my choice.

The title of the poem "Happy Destroying" (1993) is the author's own rendering of the words "horoboshite omedetōgozaimasu" ("congratulations on your destruction") (Angles, "Translator's Notes" 124). In "Happy Destroying," Itō actually writes: "And there is this place / That keeps repeating in my poems...*Happy Destroying* (this is in English) / Or *Congratulations on your death*" (*Killing* 87). Here lies perhaps a clue to understanding the importance of death—literally and metaphorically—in her work, and how it evokes juxtaposing, contradictory feelings. In other words, "Happy Destroying" points to the paradoxes enclosed within, or to the coexistence of the opposites good/evil, life/death, as she writes that the word "congratulations" is "unclean/and bright at once" (*Killing* 88).

"Killing Kanoko" also displays a connection between sexuality and mothering. The pregnant body is depicted as a source of sexual pleasure: "When I used to think about childbirth / I could masturbate endlessly / I imagine the approaching moment of birth / The pleasant movements of the expectant mother's fingers" (Itō, *Killing* 36). Here, pleasure is completely centred on the mother; thus, it can be read as an example of the empowerment of mothers (O'Reilly). The pregnant body as a source of pleasure is not a typical literary image, but Itō's poem creates it: "I have had a pleasant pregnancy," and "I could eat as much as I wanted" (36). "Pleasant pregnancy," "tanoshii ninshin," literally, "a fun pregnancy"—through these lines Itō includes the possibility of it being a pleasurable experience. Eating without restraints, as well as masturbation, bring pleasure to one's body. Though traditionally considered as self-indulgent, they are here reclaimed as part of the pregnant experience (Tilton-Cantrell 189).

Itō also includes the portrayal of breastmilk following an abortion. Breastmilk functions as a reminder of the terminated pregnancy. There are no feelings of regret; in fact, "congratulations" are also given in this context, both for the abortion and for the milk. The narrator continues:

"In any event / It is a joyous thing for milk to come out / For something sweet [and drinkable] to spill forth / From a place that previously had nothing" (Itō, *Killing* 34). There is a sort of ode to breastmilk—a depiction of its production as a pleasant experience, followed by an intense focus on other bodily fluids:

> Drink it and you will grow plump / For me to secrete something / Like the cow's milk that you / Spend money to buy / I secrete / I secrete it like urine / I secrete it like saliva, tears, or vaginal discharge / From my anus, from my mouth, from my urethra, from my vagina / the milk spills out in large quantities / I become happy/ I become pleased. (Itō, *Killing* 35)

In this excerpt the narrator is not only celebrating breastmilk but also comparing it to other bodily fluids with a joyous tone. According to Joanne Quimby, breastmilk is treated not only as a bodily fluid but also as the result of involuntary functions of producing and secreting breastmilk, which in turn allows for thinking of the body as being intrinsically "maternal" and "milk-producing" (30). In addition, Itō combines fluids that are traditionally "considered polluted or abject," with the "sanctified image" of nursing (Tilton-Cantrell 189).

These passages concerning bodily fluids and pleasure (including masturbation and eating plenty in relation to pregnancy) show a close link between Itō's poetry and Julia Kristeva's theories of abjection and her definition of jouissance. Through the depiction of the body as leaky, the poem undermines the fiction of a unified and complete self. Abjection requires expulsion, through which a seemingly fixed boundary is established. In Kristeva's own words: "It is as if the skin, a fragile container, no longer guaranteed the integrity of 'one's clean self'" (53). Hence, Itō depicts the body as being permeable, changing, and threatening to stability and coherence—that is, as an abject body. However, Itō's poem does not simply comply with a fixed definition of abjection. In fact, she challenges certain aspects of its definition through her focus on pleasure and her description of breastmilk as "sweet" and "drinkable." Itō moves away from depicting "physical emotions of horror and disgust" that are often related to the abject (Ahmed 93). Therefore, we may also say that the very idea of abjection is being subverted in this poem (Quimby 32).

Itō suggests that even when there are pleasant moments, mothering

confronts us with brutal frustration, exhaustion, maternal regret, and rage. She opens up a space—in full honesty—to say: Sometimes it is too overwhelming. For instance, the mother-narrator in the poem says: "Kanoko eats my time / Kanoko pilfers my nutrients / Kanoko threatens my appetite / Kanoko pulls out my hair / Kanoko forces me to deal with all her shit / I want to get rid of Kanoko / I want to get rid of filthy little Kanoko" (Itō, *Killing* 36). In traditional Japanese literature, the mother has been portrayed "as tender and merciful and always ready to sacrifice herself for the child's welfare" (Ueda 13). Itō's portrayal moves further from that canonic representation as she conveys exhaustion, frustration, regret, and anger when coping with mothering. There is an implicit conflict between the needs of the mother as a person and the needs of her child, producing a mother-child opposition also evident in some of her other poems, such as "Healing Kanoko's Rash."

This opposition is also explicit via the recurring image of a baby wanting to bite the mother's nipples. Breastfeeding is not the ultimate bonding experience between mother and child but rather a source of conflict: "She bites my nipples, wants to bite my nipples off / She is always looking for just the right moment to do so" (Itō, *Killing* 36). Also: "I want to get rid of or kill Kanoko who bites off my nipples" (Itō, *Killing* 36). The aggressive feelings are harboured by both the child and the mother, which challenge the idealized mother-child dyad. In the very last concluding sentence, we find a provoking invitation: "Let's all get rid of them together/ All of the daughters/ All of the sons/ Who rattle their teeth/ Wanting to bite off our nipples" (39). These lines capture a desire for the communal and point to a shared frustration and a shared search for liberation by mothers. It reinforces that the main message is not to get rid of Kanoko by herself but rather to get rid of the sociocultural oppression imposed by ideal motherhood. Actually, in an interview Itō said that after "Killing Kanoko" she has had to explain herself, as she figuratively meant: "Kill your children because you are more important" (Schunnesson). In this position, we can identify a search for balance between caregiving and self-care, and even more than balance, we see a radical affirmation of self-care—not in terms of self-indulgence—but as self-preservation (Lorde 131).

Freeing More Maternal Bodies

Besides "Killing Kanoko" there are multiple texts that complement the representation of embodied mothering by Itō. In *Good Breasts, Bad Breasts* (*Yoi oppai, warui oppai*), Itō describes in detail what it feels like to be pregnant and the weekly changes she experienced. Even though it is a nonfictional personal account, she is aware of the array of differences in relation to the pregnant experience. Honesty and inclusiveness characterize her writing; while reflecting on her day-to-day life, Itō covers all kinds of practical subjects. For instance, readers will find an explanation about the boshitechō (the maternity health record book used at every medical appointment in Japan) and also information about intimate subjects, such as sex positions during pregnancy. Rather than depicting motherhood and sexuality as mutually exclusive—as they are often deemed—she encourages their coexistence (Seaman 119).

One of the most striking aspects of this book is that it contains several references to Itō's famous statement equating fetuses and poop: "A fetus is, in fact, poop" (*Yoi oppai* 33; my translation). To the question about fetuses not being really poop, Itō replies: "During pregnancy I was sure it was poop, but during the instant of giving birth, it wasn't poop. After giving birth to it, it became poop again. It just doesn't stick to your hands like poop, and it looks too much like me" (74; my translation). Itō places pregnancy and childbirth away from an idealized, sanitized, and oppressive fantasy and nearer to other bodily experiences. Thus, her famous statement about fetuses and poop is liberating, as it "free[s] women from widespread idealized notions of motherhood that leave women feeling constrained and self-critical" (Tilton-Cantrell 177).

Itō's best parenting advice throughout this book is rudeness (gasatsu), laziness (gūtara), and negligence (zubora) (*Yoi oppai* 134; 155). Itō offers parents an alternative way of being—one that does not imply that one must try to fit into the ideal, perfect mother model. That being so, critics have praised Itō's childrearing books because she discusses the challenges faced by parents and offers relief and empathy; her frank views differ from the dominant representation in parenting magazines (Tilton-Cantrell 176-77). These three key words open the space to validate often unspoken or silenced affects and stress the importance of self-care.

"Peristalsis" ("Zendō") is one of the poems that secured Itō's reputation as a "childbirth poet," as it starts off with a description of the process of the narrator's pregnancy (Morton 105). This poem provides an insider's look at pregnancy and childbirth; it allows us to access all those intimate conversations between people united by this shared experience. It also shows how pregnancy and childbirth are anchored on the functions of the body, such as excretion and expulsion. Similarly, in A Woman's Life (Onna no ishō), Itō also depicts pregnancy as a process with marked stages that challenge fixed notions of subjectivity. Itō's depiction of the pregnant body is grounded on the materiality of the body—in the morning sickness or the movements from within—and her trademark rendering of pregnancy and childbirth in connection to defecation still holds true. In this latest rendering of pregnancy, there is also the image of a free and empowered maternal body full of confidence: "While I was pregnant, I was filled with life, physiologically, I felt I could do anything. Whatever the future opens for me, I'm confident I can take it on, with this uterus, these ovaries, these breasts, and these mammary glands" (Itō, Onna 98-99; my translation).

Finally, I would like to introduce the long narrative poem "Wild Grass on a Riverbank" ("Kawara arekusa") for which Itō received the Takami Jun Prize in 2006. This narrative is written from the daughter's perspective, the unnamed narrator who is sometimes referred to by author and translator as Kawara Natsukusa (Angles, "Translator's Preface" 11). Natsukusa travels with her mother and siblings from the wasteland to the riverbank. The mother is a poet that reads poems by Itō Hiromi, thus like in "Killing Kanoko," the mother in the poem overlaps with the author, and when the mother is arrested for child abuse, the reader finds out that her name resembles "Hiromi." There is another mother in this poem: Okaasan, which literally means "mother" in Japanese. It is a dog who the mother says raised the children too. These self-referential elements reveal strategies for self-mocking, as she creates so-called bad mothers with her own name. The narrator, who is the oldest daughter, takes on a parenting role with the support of an imaginary friend or an alter ego named Kawara Alexa (Arekusa in Japanese). Towards the end of the poem, Natsukusa leads her siblings from the riverbank to the wasteland. They return to their father, who says: "What happened to mama? Didn't she come with

you? / My little brother said, She'll be coming later / I said / That's what she said, but her passport is bad / She might not be able to come / Our millennia-old father said / That's right, she must be coming / She'll manage to make it somehow, if she can't, we'll all get flawless passports and move to the riverbank" (*Wild Grass* 95).

Itō's depiction of the mother is nuanced; she embodies rudeness, laziness, and negligence, yet there are also depictions of joyful bonds between mother and children. The mother leaves behind two partners, and the children gradually become more independent. The complexity of the mother cannot be reduced to being abusive or bad.

Due to the prominent use of nature's imagery and the interest in both environmental and societal issues, this narrative poem bears eco-feminist tones. Characters become plants, and plants are characters, which is representative of the themes of migration, alienation, and survival. Here, wild grass or "weeds" are not meant to be removed or disappear, but rather, they are symbols of the "vitality" of migrants who learn to "flourish" in new environments (Angles, "Translator's Preface" 14). This poem not only offers a portrayal of mothering beyond idealization and naturalization, but it is worth rereading it in the context of family separation vis-à-vis the global migration crisis.

Conclusion

In closing, I would like to highlight Itō's role in shaping current understandings of mothering. By focusing on the body and on the multiplicity of experiences, Itō's texts stand against the ideology of self-sacrifice and maternal love as a natural instinct. Her poetry and auto-biographical texts elicit feminist conceptions of parenting and move further from idealized and sanitized ideals of motherhood. Itō definitely brings to the center of her texts all of our "repressed cultural impulses" next to "audacious and shocking personal narratives" (Lima and Fox). Itō depicts mothers that live for themselves and not exclusively for their children, who have ambivalent feelings, and thus firmly stand against an ideology of self-abnegation. Therefore, these texts invite mothers to embrace their ambivalence, imperfections and conflictive relationship with their children, while prioritizing self-care.

Ideals of motherhood are pervasively entrenched in contemporary society; there seems to exist a sort of invisible imperative of ideal

motherhood pressuring generations of mothers. As Thurer explains: "To confess to being in conflict about mothering is tantamount to being a bad person; it violates a taboo; and worse, it feels like a betrayal to one's child. In an age that regards mothers' negative feelings, even subconscious ones, as potentially toxic to their children, it has become mandatory to enjoy mothering" (chap. 21). Therefore, literary depictions —like the ones herein presented—that break the silences around negative affects and challenge myths of idealized motherhood provide a sense of liberation from fixed ideals, and offer a glimpse at the multiplicity and complexity of maternity.

Endnotes

1. For example, this motif can be found in the narratives by male authors across generations, such as: Natsume Sōseki (1867–1916), Tanizaki Jun'ichirō (1886–1965), Shiga Naoya (1883–1971), Kawabata Yasunari (1899–1972), Nosaka Akiyuki (1930-2015), Ōe Kenzaburo (b. 1935), Nakagami Kenji (1946–1992), and Lily Franky (b. 1963) (Copeland 136-37; Mc Kinlay par 8; Ikoma). Ueno Chizuko's study of the representation of mothers in postwar literature by male authors based on Etō Jun's *Maturity and Loss: The Disintegration of the "Mother"* (*Seijuku to sōshitsu: "haha" no hōkai,* 1993) is worth referencing. Ueno points out that Etō Jun's book deals with the theme of motherhood by going beyond the motif of the "loss of mother," and towards the "disintegration of mother-hood" (*The Modern* 163).

2. See: Shōno Yoriko's *A Mother's Development* (*Haha no hattatsu,* 1996); Mizumura Minae's *Inheritance from Mother* (*Haha no isan,* 2012, trans. 1016); Kirino Natsuo's *I'm Sorry, Mama* (2004), *Tokyo Island* (*Tokyo jima,* 2007), *The Goddess Chronicle* (*Joshinki,* 2008; trans. 2013), *Tamamoe!* (2005), *Happiness* (*Hapinesu,* 2013); Hasegawa Junko's *Germination* (*Hatsuga,* 2004); Uchida Shungiku's *A Manga Talk about Japan's Sex Education* (*Manga nihon seikyōiku tōku,* 2012); Murata Sayaka's *Giving Birth to Murder* (*Satsujin shussan,* 2014) and *Vanished World* (*Shōmetsu sekai,* 2015); Kawakami Mieko's *Breasts and Eggs* (*Natsu monogatari,* 2019; trans. 2020), and Kanehara Hitomi's *Mothers* (2011).

Works Cited

Ahmed, Sara. "Embodying Strangers." *Body Matters: Feminism, Textuality, Corporeality*, edited by Avril Horner and Angela Keane, Manchester University Press, 2000, pp. 85-97.

Angles, Jeffrey. "Introduction: Itō Hiromi, Writing Woman." *Special Issue on Itō Hiromi*, edited by Jeffrey Angles, *U.S.-Japan Women's Journal*, vol. 32, 2007, pp. 7-16.

Angles, Jeffrey. "Translator's Introduction." *Killing Kanoko: Selected Poems of Hiromi Itō.* Action Books, 2009, pp. vii–xii.

Angles, Jeffrey. "Translator's Notes." *Killing Kanoko: Selected Poems of Hiromi Itō.* Action Books, 2009, pp. 117-25.

Aoyama, Tomoko. "Narratives of Mother-Daughter Reconciliation: New Possibilities in Ageing Japan." *Mothers at the Margins: Stories of Challenge, Resistance and Love*, edited by Lisa Raith, Jenny Jones, and Marie Porter. Cambridge Scholars Publishing, 2015, pp. 245-60.

Copeland, Rebecca. "Mother Obsession and Womb Imagery." *Transactions of the Asiatic Society of Japan*, vol. 3, 1988, pp. 130-50.

Ericson, Joan E. "The Origins of the Concept of 'Women's Literature.'" *The Woman's Hand: Gender and Theory in Japanese Women's Writing*, edited by Gordon Paul and Walker Janet, Stanford University Press, 1996, pp. 74-115.

Felski, Rita. *Uses of Literature*. Blackwell Publishing, 2008.

Ikoma, Natsumi. "To Miss the Missing Mother: Absence of Real Mothers in Japanese Literature by Male Authors." Presentation at the Nineteenth Asian Studies Conference (ASCJ). Meiji Gakuin University, 20 June 2015.

Imamura, Anne. "The Japanese Family Faces Twenty-First Century Challenges." *Education about ASIA*, vol. 8, no. 2, 2003, pp, 30-33.

Itō, Hiromi. *Wild Grass on the Riverbank*. Translated by Jeffrey Angles. Action Books, 2014.

Itō, Hiromi. *Onna no isshō (A Woman's Life)*. Iwanamishinsho, 2014.

Itō, Hiromi. *Yoi oppai, warui oppai (Good Breasts, Bad Breasts)*. Kanzenban, 2010.

Itō, Hiromi. "Kanoko goroshi" ("Killing Kanoko"). *Itō Hiromi shishū (Poetry Collection of Itō Hiromi)*, gendaishi bunko 94. Shichōsha, (1985) 1988, pp. 66-77.

Itō, Hiromi. "Killing Kanoko." *Killing Kanoko: Selected Poems of Hiromi Itō*. Translated by Jeffrey Angles. Action Books, 2009, pp. 33-39.

Itō, Hiromi. *Killing Kanoko: Selected Poems of Hiromi Itō*. Translated by Jeffrey Angles. Action Books, 2009.

Itō, Hiromi. "The Painted Cat Flies in the Sky." *Watashi wa anjuhimeku de aru: Itō Hiromi shishū (I Am Anjuhimeko: Poetry Collection of Itō Hiromi)*. Shichōsha, 1993.

Itō, Hiromi. "Zendō" (Peristalsis). *Itō Hiromi shishū (Poetry Collection of Itō Hiromi)*, gendaishi bunko 94. Shichōsha, (1985) 1988, pp. 51-53.

Koyama, Shizuko. *Ryōsai Kenbo: The Educational Ideal of "Good Wife, Wise Mother" in Modern Japan*. Brill, 2013.

Kristeva, Julia. *Powers of Horror: An Essay on Abjection*. Translated by Leon S. Roudiez. Columbia University Press. 1982.

Lima, Lucas de, and Sarah Fox. "Killing Kanoko." *Rain Taxi Online Edition*, 2020, www.raintaxi.com/killing-kanoko/. Accessed 29 Apr. 2022.

Lorde, Audre. *A Burst of Light: Essays*. Firebrand Books, 1998.

McKinlay, Megan. "Unstable Mothers: Redefining Motherhood in Contemporary Japan." *Intersections: Gender, History and Culture in the Asian Context*, 2002, intersections.anu.edu.au/issue7/mckinlay. html. Accessed 29 Apr. 2022.

Nakayasu, Sawako. "Translating Itō Hiromi." *How2*, vol. 1, no. 6, 2001.

O'Reilly, Andrea. "Feminist Mothering." *Maternal Theory: Essential Readings*, edited by Andrea O'Reilly, Demeter Press, 2007, ch. 48, Kindle.

Orbaugh, Sharalyn. *Japanese Fiction of the Allied Occupation: Vision, Embodiment and Identity*. Brill, 2007.

Orbaugh, Sharalyn. "Ōba Minako and the Paternity Maternalism." *The Father-Daughter Plot: Japanese Literary Women and the Law of the Father*, edited by Rebecca Copeland and Esperanza Ramirez-Christensen, University of Hawai'i Press, 2001, pp. 265-91.

Quimby, Joanne. "How to Write 'Women's Poetry' without Being a 'Woman Poet': Public Persona in Itō Hiromi's Early Poetry." *Special Issue on Itō Hiromi*, edited by Jeffrey Angles. *U.S.-Japan Women's*

Journal English Supplement, vol. 32, 2007, pp. 17-42.

Seaman, Amanda. *Writing Pregnancy in Low-fertility Japan*. University of Hawai'i Press, 2017.

Schunnesson, Tone. "Poesi för trasiga kvinnor" ("Poetry for Broken Women"). *BON*, 2016.

Thurer, Shari L. "The Myths of Motherhood." *Maternal Theory: Essential Readings*, edited by Andrea O'Reilly, Demeter Press, 2007, ch.21, Kindle.

Tilton-Cantrell, Ellen Crystal. "Autonomy and Dependency Relationships in Poetry and Fiction by Tomioka Taeko and Itō Hiromi." PhD dissertation. Yale University, 2013.

Ueda, Makoto. *The Mother of Dreams: Portrayals of Women in Modern Japanese Fiction*. Kodansha International, 1986.

Ueno, Chizuko. "Foreword." *Special Issue on Itō Hiromi*, edited by Jeffrey Angles, *U.S.-Japan Women's Journal English Supplement*, vol. 32, 2007, pp. 3-7.

Ueno, Chizuko. *The Modern Family in Japan: Its Rise and Fall*. Trans Pacific Press, 2009.

Chapter 5

"It's Not Enough for Me": Maternal Regret in HBO's *Big Little Lies*

Rachel Williamson

Introduction

The HBO miniseries *Big Little Lies* (2017–2019) has been widely celebrated as a critical and commercial success; it garnered multiple awards and accolades, prompting a second season, despite original insistence that it would be a stand-alone limited series. Adapted from the novel of the same name by Australian author Liane Moriarty, the book came to the attention of A-list celebrities Reese Witherspoon and Nicole Kidman, who optioned the rights to adapt it for the screen. The process has consequently been celebrated for being "female centric" from its very inception (despite being written by David E. Kelley and directed by Jean-Marc Vallee). The show is, unusually for Hollywood, based on source material by a female writer, was developed and produced by women, and features a star-studded cast of strong female leads. Indeed, actor Laura Dern in her Emmy acceptance speech for her work on the show described the cast as an "incredible tribe of fierce women and mothers." Accordingly, the series has been endorsed for publicizing specifically female experiences, including many women's ambivalent and ambiguous encounters with motherhood. Throughout the seven episodes, which move in time between the present and the recent past, *Big Little Lies* tells the story of five suburban

mothers (the so-called Monterey five) living in the wealthy seaside town Monterey, California. Over the course of the series, their carefully constructed appearances begin to fracture as anxieties, regrets, and secrets—regarding relationships, parenting, work, sex, their pasts, their children—leak out and bleed into their lives. Clearly, some of these lies that these characters tell not only to one another, but also to themselves, are bigger than others. Although the show pivots around the biggest of these, including the murder that sits at the centre of the "whodunit" story and which functions as the catalyst that sets the show's plot in motion, of particular interest here is the show's exploration of maternal regret.

As we shall see, despite their seemingly perfect lives and the fact that many of the female characters did indeed desire to become mothers, most of the women in *Big Little Lies* are unhappy; they love their children but experience shame for feeling unfulfilled by motherhood and the hopes they had for their lives before they had children. The series thus seeks to trouble idealized versions of hegemonic motherhood by depicting instead maternal regret as it manifests in mothers' experiences that are complicated by disappointment, frustration, and/or rage. Although the appearance of these dissatisfied, regretful mothers is potentially transgressive and startling, I contend, however, that the show is also unable to fully escape the ideologies of intensive mothering and neoliberalism, which prop up idealized maternity and render maternal regret abject and unspeakable. Specifically, despite seeming to create a space that allows for the articulation of maternal regret, at the same time, *Big Little Lies* problematically reiterates hegemonic motherhood by sublimating the mothers' articulations of regret into overly familiar "mama-bear" tropes, wherein a mother's needs and desires are suppressed for the sake of her child's. As such, although maternal regret is, to some extent, normalized by *Big Little Lies*, it is also paradoxically positioned as the purview of the bad mother, thereby highlighting just how controversial and challenging maternal regret remains to longstanding, conventional understandings of maternity. In this chapter, I consider first the ideological framework that constructs a seemingly impossible maternal norm, and which renders maternal regret difficult to articulate for fear of retribution. I then unpack how the experiences of several key characters in *Big Little Lies* voice this regret but do so in

terms that vacillate between subversive transgression and ideological complicity.

"Having It All": Idealized Motherhood and Maternal Regret

Central to the disappointment many of *Big Little Lies'* mothers encounter is the disjuncture between the idealized representations and cultural understandings of maternity and their own embodied experiences, which are imbued with disappointment and dissatisfaction. Although the valorization of motherhood is not new or specific to today's context alone, the return to family values and growth in a prenatal, child-centric discourse within the West during the 1980s certainly exacerbated the situation, prompting a return to regarding the maternal role as the ultimate expression of socially condoned femininity from which all women should derive satisfaction and pleasure. This dynamic amplified the ideology of intensive mothering (a term famously coined by Sharon Hays), wherein constructions of motherhood are underpinned by the essentialist belief that motherhood is biologically desirable, natural, instinctive, and ultimately fulfilling to women (Hays 129; see also Douglas and Michaels). Importantly, as scholars have noted, this ideological model draws on liberal feminism's rhetoric of choice and, in doing so, evades being labelled as a nostalgic or retro regression: instead, intensive mothering is represented as the "truly modern, fulfilling, forward-thinking version of motherhood" (Douglas and Michaels 23). Furthermore, it also renders maternal disappointment and regret worryingly difficult to speak, given the fact that motherhood is purportedly desired by all women and freely chosen. As such, if a mother feels unfulfilled in her role or holds regrets regarding the path her life has taken, the problem is perceived to lie with her rather than the ideological framework that constructs maternity in such restrictive, essentialist terms (see Kingston).

The emphasis on choice within intensive mothering is likewise echoed in contemporary neoliberal ideologies that stress individual responsibility. Academic work in this area focuses, in particular, on the impact this has on perpetuating and updating myths of good motherhood while simultaneously demonizing and repudiating individuals who deviate from such norms. Thus, the ideological work of

neoliberalism is primarily accomplished through stressing personal accountability and failure. Furthermore, sociologist Angela McRobbie identifies the manner in which much of feminism's political agenda has been coopted and adapted to fit within a wider social and economic context wherein equality is viewed as commonplace, and success, pleasure, and enjoyment are emphasized. Within such a framework, it would initially seem that contemporary women have benefited from feminism's influence and, in a generous reading, can be seen as the embodiment of a functioning meritocracy, free to access the equal opportunities available to them irrespective of race or class. However, McRobbie maintains that this problematically demands a diluting of feminist inquiry through the emphasis on practices that are "understood to be both progressive but also consummately and reassuringly feminine" (721). As such, motherhood fits McRobbie's identification of a culturally sanctioned, idealized feminine practice par excellence and, as Rachel Thomson et al. point out, becomes the ultimate endgame in the story of femininity, drawing on the neoliberal, postfeminist belief that today's women can indeed "have it all":

> The general trend is towards later motherhood, delaying the birth of a first child until education is completed and the career is well-established. Emotional stability, financial security and the "right" relationship are expected to fall in line with this life trajectory, making birth the apex of achievement for grown-up girls living the success-story narrative of contemporary times. (2)

It is here in the emphasis on individual accountability that the ideologies of intensive mothering and neoliberalism can be seen to intersect and starkly delineate the dichotomous construction of good and bad mothers. If becoming a mother is a choice, then the inability to meet the requirements of idealized motherhood is portrayed as the result of a choice poorly made. Significantly, many of the mothers in *Big Little Lies* embody this "success-story narrative" (with the exception of Jane, whose child, Ziggy, is the product of rape). They are, for the most part, middle-aged and upper-class educated women who held successful careers prior to becoming mothers, which many of them subsequently abandoned in order to concentrate on full-time parenting. Those who do continue to work often do so in a part-time capacity so as to meet the

dictums of intensive mothering; helicopter-parent Madeline, for instance, confesses to newcomer Jane that she works twenty hours a week "but it doesn't really count."

Thus, the early episodes of Big Little Lies are quick to establish the mothers as having benefited from making the right choice—that is, they can be seen to have followed the socially condoned pathway mapped out for women, which has led them to inhabit an upper-class, escapist world. The excessive wealth on display therefore functions as a signifier of their success, which is quickly made apparent through the mothers' meticulous appearances, the roomy Volvos competing for car parks at school drop-offs, and the vast, architecturally designed beach-front homes (leading to numerous reviews and twitter feeds describing the show as "property porn" [see Roy]). Consequently, it is easy to assume that these women do indeed "have it all." However, although the show certainly begins as a gossipy, bitchy dive into a world of excessive wealth and first-world problems, the gradual exposure of the women's personal failures to live up to the idealized expectations made of contemporary mothers and the related mapping of their maternal dissatisfaction and regret can be read instead as potentially trans-gressive, posing a challenge to normative maternal constructs. This pivot away from a melodramatic and indulgent "sudsy, delicious series about affluent women Mean Girls–ing around" (Abod-Santos) is therefore clearly intentional, designed to depict the corrosive impact that the struggle to maintain the appearance of "having it all" can have on women. Over the course of the seven episodes, this struggle manifests in articulations of maternal regret from a range of characters and is expressed as a longing for something other than motherhood, a desire to put their own needs first and be something more than just a mother; indeed, when Jane considers leaving Monterey in order to "do what's best for my kid," Madeline protests and exclaims in outrage, "What about what's best for us?!" Motherhood alone, Big Little Lies seems to suggest, may not be.

Big Little Lies is not unusual in seeking to document the conflict many mothers experience between the desire to satisfy their own needs while meeting the often-competing demands of their children. Where Big Little Lies differs from other literary and popular culture texts, however, is in its suggestion that the eradication of self, when combined with the suppression of personal desires demanded by idealized

maternity, can also figure as a key source of maternal regret—a long-ing for missed opportunities or a former life. Given the conflation of maternity with culturally condoned femininity, the characters' articulations of maternal regret therefore threaten to rupture the various women's carefully constructed, albeit tenuous, appearances of perfection and the fantasy that the modern mother can indeed "have it all." Although the characters' experiences of regret may vary, it is not by accident that many of the women affected can be seen grappling with this cultural taboo, thus suggesting it is perhaps a far more common experience than its almost total absence in representational form and discourse would otherwise imply.[1]

"What about What's Best for Us?!": Articulations of Maternal Regret in *Big Little Lies*

For Monterey newcomer and young mother, Jane, her maternal regret is irrevocably bound up with the ongoing effects of the traumatic rape she suffered during which son Ziggy was conceived. From the beginning, Jane is positioned as something of an outsider, her difference most clearly signified through costuming choices. Whereas the other Monterey mothers are immaculately presented in their varying uniforms of heels and skirts, cashmere coats, or top-end activewear, Jane uses clothing to hide behind and is therefore most often depicted in black jeans, Doc Marten boots, hoodies, or oversized parkas, with her hair scraped back in a tight, austere ponytail. Her peripheral status is further emphasized through her confinement to the edges of the frame in crowded mise-en-scenes. Although the full details of Ziggy's conception are not revealed until episode three, "Living the Dream," the knowledge that Jane sleeps with a gun under her pillow, combined with the repeated use of flashbacks throughout the preceding episodes, offers some context for Jane's reserved, self-protective manner. The silence accompanying these images amplifies their significance further. In a series that has been celebrated for its soundtrack and thoughtful use of both diegetic and nondiegetic music, which often functions to connect characters through shared experiences or feelings, the quiet of these flashbacks feels vast and utterly isolating. Thus, although the specifics may have remained unknown, the cumulative effect is one of trauma and, not surprisingly, therefore functions as a key source of

Jane's maternal regret.

As per the newly emerging accounts of maternal regret in academia and editorials (see Brown or Kingston for examples of these), *Big Little Lies* makes clear that Jane loves her child. She is physically affectionate with Ziggy and is often depicted hugging him at school pickups or playfully piggybacking him around. The small apartment they live in is a further testament to the care and affection she shows him: Ziggy's room has been lovingly decorated with Star Wars bedding and hand-crafted mobiles of the planets, while his artwork is proudly on display in their tiny kitchen. Furthermore, in keeping with the ideological requirements of intensive mothering, Ziggy's wellbeing has been prioritized over Jane's who sleeps on a pullout sofa in the living room and works long hours at night. Despite her evident love, however, the trauma of Ziggy's conception imbues Jane's experience of motherhood with regret. This is alluded to in her first meeting at a cafe with Madeline and Celeste, where Jane tentatively confides the following: "It's weird. Sometimes when I'm in a new place I get this sensation, like, if only I were here.... It's like I'm on the outside looking in. You know, like, I see this life, this moment, and it's so wonderful but it doesn't quite belong to me. Does that make any sense?" Further exacerbating the detachment and dissatisfaction with motherhood voiced in this exchange is Jane's barely suppressed, lingering fear that Ziggy will exhibit signs of violence inherited from his father (who we later learn is, in fact, Celeste's husband, Perry). This becomes even more prescient in light of an incident on the first day of school, when Amabella, the daughter of uberwealthy and powerful CEO working-mother, Renata, accuses Ziggy of attempting to choke her. Although this establishes a context for conflict between the various mothers, it also threatens to destabilize Jane and raises understandable concerns and doubts within her regarding her own son. These doubts begin to inform Jane's interactions with Ziggy, as in the instance where she is consoling Ziggy, reassuring him in gentle tones that "Baby, you're not a monster," before physically pushing herself towards him, her voice hardening to state, "Ziggy, there's NOTHING wrong with you." The gesture is abrupt and almost frightening, a moment that is itself verging on violence. Thus, the scene speaks vividly to the enduring impact sexual violence has on women while also highlighting the extent to which Jane's experience of motherhood is irrevocably tangled up with

her rape. She may love Ziggy, but there can be little doubt that she experiences regret about becoming a mother in light of the horrific circumstances under which he was conceived.

Although Jane is positioned as the outsider and while her maternal regret can be attributed to a very specific cause, the series goes to some lengths to show that Jane's feelings regarding motherhood are also shared by other mothers, including the vastly different Renata. From the outset, Renata and Jane are established as antithetical characters even before the crisis at the school induction day occurs. Indeed, the first time they meet, Renata mistakes the much younger and poorer Jane for a nanny. Such a move is deliberate, intended to position the different women as overly familiar archetypes (the career-mother versus the abject single mother) in order to later subvert viewers' expectations and emphasize instead the women's points of connection. We see this unfold, for instance, in a carefully edited sequence where Renata is shown losing her cool as she howls with fury, "I said THANK YOOOUUU!" The episode cuts on both the protracted yell but also the feeling of frustration and disappointment underpinning it to segue to Jane as she likewise stands on the beach, screaming with rage and exasperation. In each scene, the ocean can be seen in the background behind the women, functioning expansively as a symbol for what are portrayed as specifically female experiences, including, here, the often surging, tumultuous, and competing feelings elicited by motherhood. Specifically, despite appearing to indeed "have it all"—a career, an architecturally designed beachfront home, marriage, and a family— Renata shares in common with Jane a sense of profound dissatisfaction with her life. She is keenly aware of the judgments made against her by the other mothers, as she explains to her husband, Gordon that she is not liked: "What kind of person chooses to work? Certainly not a mother, not by any acceptable standards." More tellingly still, she later asks Gordon whether she has "become tragically unfun," before noting she has become "one of those people I swore I'd never turn into." Combined, Renata's comments highlight her sense that her life has not unfolded in the way she had imagined it would, or rather it has, but the trajectory itself, which has culminated in a difficult juggle between career and motherhood, has failed to live up to her expectations and hopes, thus generating profound regret despite a surface-level appearance of perfection. Accordingly, in the somewhat surprising linking of

Jane and Renata, two seemingly antithetical characters, it seems reasonable to conclude that *Big Little Lies* is attempting to show that regretting motherhood (or at least aspects of it) may actually be a relatively common, possibly even ubiquitous, experience.

Less surprising, perhaps, given the shared narrative of abuse and sexual violence, are the parallels drawn between Jane's and Celeste's stories. Indeed, the gradual realization that what first appears to be a heightened, erotically charged passion between Celeste and husband Perry is, in fact, violent and abusive in nature is one of the biggest "little lies" of the series. Although the revelation in the season finale that Perry is also single mother Jane's rapist and her son's father underscores the connection between the two women, the point is made much earlier at the cafe where Jane recounts her sense of detachment from motherhood and her life. Here, the camera cuts back and forth between the two women using reverse point of view shots to depict Celeste thoughtfully nodding. As Madeline briskly moves the conversation onto other topics, the two women stare at one another in mutual recognition—connected by their experiences of violence but also a shared awareness that the veneer coating their lives in actuality masks disappointment and unhappiness.

This is especially true of the glamorous, exceptionally wealthy, and exquisitely beautiful Celeste, played with quiet restraint and poise by Nicole Kidman. In many ways, Celeste's trajectory fits perfectly the "success-story narrative of contemporary times," inviting others to view her with barely disguised envy. For Celeste, the knowledge that she has done everything "right" (studied, travelled, and had a career before settling down with a seemingly adoring husband to begin a family) renders her own maternal regret and disappointment near impossible to articulate. The series amplifies this by portraying Celeste and Perry (a wealthy and successful businessman) as something of a golden couple. The first time we observe them together, for instance, is when the family breakfast together on their enormous balcony overlooking the beach. The couple coparent, alternately joking with their twin sons and admonishing them to eat. Throughout the scene, they flirt and laugh, physically affectionate with one another. As Perry kisses Celeste, Charles Bradley's sexy, soulful diegetic music plays in the background while the sun shines and the sea crashes behind them. A quick cutaway to a chorus member rolling her eyes and stating "there

should be like a five-year limit on how long couples get to be gooey" completes the move: The intimacy and idealized white, heteronormative domesticity on display appears magazine perfect. As such, it is a setup we are invited to observe, aspire to, and covet, much like the nanny watching and smiling indulgently from the kitchen. Celeste's awareness that her life in many ways meets—indeed, even exceeds—the requirements of idealized maternal femininity contributes troublingly to her inability to leave the relationship. In addition, it also makes her regret, already a taboo subject, increasingly difficult to speak. As this is the life she purportedly desired and chose of her own free will, voicing regret courts fears of retribution and accusations of being a selfish, uncaring, and ungrateful mother—a point that Celeste herself appears to be cognizant of.

This is made vividly apparent in episode four, "Push Comes to Shove", when Celeste temporarily resurrects her legal career. It is clearly a significant decision that not only has profound ramifications on her relationship with husband, Perry, but forces Celeste to acknowledge that her experiences of motherhood have ultimately left her unfulfilled and dissatisfied. Following Celeste's revelation that she is undertaking the work, Perry attempts to undermine Celeste's confidence by manipulating and controlling her. Despite the increasing abuse, however, this episode marks a turn in Celeste's character, signified through a costuming change and shift in Kidman's performance. In this episode, she plays Celeste as confident, charming, and legally astute, a far remove from the ethereal, distracted beauty that Kidman had leaned into in previous episodes. The point is reinforced during an exchange in a car where Madeline observes the following with pride and admiration: "I've never seen you like that. In the four years I've known you, your face looked different; your body changed." Celeste replies by tooting the car horn and yelling jubilantly, "You're right. I fucking miss it! Whooo!" The vigour and exuberance she displays here thus suggests that the demands made on her to prioritize her family's needs and interests over her own have impacted negatively on her identity, amounting in a deadening erasure. Significantly, even the cinematography changes at this point to underscore the transformation in Celeste. Although scenes routinely unfold inside cars showing characters driving, the women are usually shot in profile or even from slightly behind to mirror the point of view of a child whose subjectivity

takes precedence over their own. However, here, the camerawork shifts to depict the women front on, thus offering them more agency and control. This, when coupled with the use of reverse shots, establishes intimacy between the pair, prompting Celeste to make her guilty admission that motherhood has left her unfulfilled: "It's just for six years I've been wiping runny noses, organising playdates, doing everything to be a good mom, you know? And today I felt alive. I felt good. Is that crazy? I feel so ashamed for saying this but being a mother? It's not enough for me. It's just not. It's not even close. So there you are. I'm evil."

Maternal regret figures here as an acknowledgment that motherhood is not always the ultimate endpoint and "happy ever after" for women that it is routinely portrayed to be. Rather, as Celeste points out, motherhood alone can be "not enough." Furthermore, the fact that her admission causes Celeste great shame highlights the difficulty of voicing regret in a social context that valorizes maternity and pitches motherhood as the pinnacle of a woman's life. So ingrained is this ideological perspective that any deviation from the culturally condoned script is imagined to be "evil"—the fault of the individual woman and therefore open to accusations of bad mothering. Consequently, the very fact that *Big Little Lies* carves out space for Celeste to articulate her maternal regret and desire for something other than motherhood alone can be read as "a subversive act" (Koehler).

Like Celeste, the series also portrays Madeline as far from satisfied with her own life. Although the accusation is made by husband Ed in a heated argument about Madeline's apparently unresolved feelings for her ex, Nathan, it is equally applicable to her experiences as a mother. As per the other characters, *Big Little Lies* suggests that Madeline represses her unhappiness and regret beneath a surface facade. Indeed, Moriarty's novel describes Madeline as a "glittery girl" (16)—an analogy that not only suggests a sparkly and effervescent demeanour but also alludes to the reflective qualities of glossy surfaces—and A-list celebrity Reese Witherspoon leans into the characterization with relish. She plays Madeline as the quintessential helicopter-parent, who appears to have embraced the cult of motherhood to almost manic levels, hurling herself into organizing children's parties and spectacular events with evident glee. In adapting the novel for the screen, however, Witherspoon personally requested the most significant departure from

Moriarty's source material via the inclusion of Madeline's extra-marital affair, arguing that "I didn't have anything to play but perfection, and I just think those people who are perfect [are] all full of shit... I think there's something fascinating about a person who projects perfection or is very judgmental of others who is clearly just swimming in their own discontent" (qtd. in Birnbaum).

Crucially, Madeline's "discontent" is fundamentally bound up with her role as a mother and her longing to be something more. She attempts to articulate this dissatisfaction to Ed, a feeling that has been amplified by her two daughters' increasing independence: "I feel like they're both just slipping away.... I just feel like they're gonna grow up, and they're going to be gone. And it'll be just you and I, and we'll be onto another chapter of our life, and you have another chapter. You have a business, and I don't. I'm a mom." Central to Madeline's discontent, then, is her acknowledgment that she has been somehow reduced by motherhood, her sense of subjectivity sublimated into her maternal function wherein her own needs and interests cease to hold sway or significance. This is further exacerbated by her identification that the experience affects Ed differently and is therefore a gendered one that is specific to women given the long-standing conflation of idealized femininity with maternity. Later, Madeline seeks to voice her feelings once again, this time in conversation with eldest daughter Abigail, who has just revealed her intentions not to go to college:

When it all comes down to it, you have to be independent. You have to be self-sufficient. I was a very young mother when I had you. All that "it takes a village" crap is only good to a certain extent, cause even the best laid plans of your life go, "Poof!" in your face, and in that case you need to be strong and independent and educated and a strong woman.

Although the exchange is intended to motivate Abigail to continue with her education (as befits the "success story" for contemporary women), it also gives voice to Madeline's maternal regret, which figures here as loss and grief for "the best laid plans of your life." Regret may be a normal component of life (the "what if" of missed opportunities and paths not taken); however, the suggestion that a woman might regret having a child remains startling. In light of this, Abigail's dismissive response—where she points out that Madeline "said strong

twice"—reflects a broader cultural refusal to listen to this hitherto largely unacknowledged maternal perspective.

Madeline's longing for something more to her life than motherhood also helps explain the inclusion of her affair with theatre colleague, Joseph Bachman, an addition that presents the possibility of reading Madeline as another example of a regretful mother. In the series, the affair, now concluded, is briefly resurrected with an illicit, ebullient kiss. In conversation with Celeste, Madeline claims that she "hated every minute of it" only participating "out of reflex." However, the women's conversation continues to play out over the top of flashbacks to the couple kissing, Madeline's hands roving over a male body in closeup as well as shots of fragmented, eroticized body parts bathed in a saturated blue light. Discord is thus created between the dialogue and what we see onscreen. Given the long tradition of constructing motherhood as incompatible with sexuality, this representation is subversive on its own; however, it becomes even more so when viewed as an articulation of Madeline's maternal regret. In severing her sexuality from procreation and the family, Madeline's expression of desire for its own ends and purposes raises questions regarding who and what our bodies are intended for. As such, in rejecting the dominant discourse of perpetual maternal self-sacrifice, her affair becomes yet another vehicle within the series for expressing dissatisfaction with, and a yearning for something other than, motherhood.

"Hey Mama Bear!": The Sublimation of Maternal Regret in *Big Little Lies*

Clearly, then, *Big Little Lies* is engaged in an effort to articulate maternal regret and can consequently be read as transgressive. This is complicated, however, by the series' inability to fully escape the tight ideological grip that intensive mothering and neoliberalism hold over the cultural imagination. As we shall see, this discursive framework thus complicates the series' seemingly subversive articulations of maternal experiences causing them to be, paradoxically, capable of being read as ideologically complicit at the same time.

As working mothers, Celeste's, Jane's, and Renata's expressions of regret are notably undercut by the neoliberal imperative placed on contemporary women to return to the workforce in order to be

economically self-sufficient, contributing citizens. While the com-
bination of work and motherhood has been interrogated and identified
as problematic in the past by a variety of feminists and maternal
scholars (Sharon Hay's now famous identification of the "cultural
contradiction" of motherhood speaks to this, as does the literature on
the pressures of the second shift), more contemporary discussions
regarding the "motherhood penalty" suggest that many of these issues
remain largely unresolved (see Thomson et al.). Indeed, in line with
neoliberalism's hyperindividualism, the responsibility to reconcile the
competing impulses to be both a full-time mother and earning citizen
has fallen on individual women, amounting in "private solutions to
public problems" (Thomson et al. 193). Tellingly, *Big Little Lies* portrays
each of the Monterey five in active employment. As such, despite the
fact that *Big Little Lies* exposes the tension between work and mothering
as central to Renata's maternal regret, through depicting other mothers
who are able to successfully negotiate this juggle, the series also
troublingly suggests that Renata's problem is the result of her inability
to strike a happy balance. Consequently, Renata's maternal regret can
also be reframed as an expression of individualized failure and thus
threatens to condemn her as a bad mother.

Conversely, Celeste's and Jane's engagement with paid employment
does the opposite, effectively absolving them from their guilty admiss-
ions that motherhood is an unfulfilling and ambivalent source of
tension. As a young, single mother, Jane's maternal identity already
courts the risk of being positioned as the much repudiated, abject other
to the fetishized neoliberal maternal norm. As previously noted,
neoliberalism has updated the tenets of intensive mothering to
incorporate economic capacity and, consequently, young, working-
class, single mothers, as well as women of colour are frequently
demonized and repudiated under a meritocratic guise (McRobbie).
In many ways, Jane embodies the new social figure of the "mum-
trepeneur," an ideal neoliberal maternal-feminine subject. Despite
being a young, single mother, she has managed to avoid needing welfare
support by creating a new career for herself as a bookkeeper, a job
that is flexible and thus enables her to work around her solo parent-
ing responsibilities. Consequently, unlike the more maligned career
mother, Renata (whose commitment to work is perceived as com-
promising her ability to fulfil the requirements of intensive mothering),

Jane escapes repudiation for pragmatic reasons. This is further assisted by the removal of choice itself: Jane may be a young solo mom, but Ziggy is also the product of rape, and Jane cannot, therefore, be equated with the abject figure of the teen welfare mom. Thus, it is through her efforts to "do what's best for my kid" (i.e., working) that Jane escapes the same repudiation Renata is subjected to.

Celeste's maternal regret is, likewise, problematically sublimated into her embrace of idealized maternity as framed by the intersecting ideological perspectives of intensive mothering and neoliberalism. As we have seen, Celeste's desire for something more than motherhood alone can potentially be interpreted as an expression of maternal regret, caused not only by her relationship with her children or her yearning for her old career but also by the broader constrictions imposed by socially condoned maternal femininity. Celeste's performance of perfect motherhood has thus effectively trapped her within her own life, including her marriage to Perry, which is bound by their children. At first glance, then, her confession that motherhood is "not enough for me" seems to challenge the appropriate feminine trajectory under neoliberalism. It becomes less subversive, however, when considered in tandem with her developing plans to leave abusive husband, Perry, and raise the children as a single mother. In order to escape being stigmatized as per the much repudiated figure of the abject working-class, welfare-dependent, solo mum, Celeste therefore needs to be seen to be an inward-looking, self-sufficient citizen with her own earning capacity and individualized solutions. Thus, Celeste's reentry to the workforce is a means to an end rather than an attempt to put her own desires first. Ultimately, then, Celeste's expression of the unspeakable—her sense that motherhood alone is not, in fact, enough—is less a radical effort to map maternal regret and more a necessary justification in reconciling the conflicting demands of intensive mothering (which demands full-time investment in one's children) with neoliberalism (wherein mothers are expected to return to paid employment).

Similarly, the subversive possibilities of reading Madeline's affair as an articulation of regret are likewise undone but this time via the return of the conservative and long-standing suggestion that sexuality and maternity are incompatible. Madeline, it seems, is keenly aware that her desire and sexuality cannot be reconciled with her maternal

function—a point that she alludes to in episode six, "Burning Love," during an argument with eldest daughter, Abigail. On discovering Abigail's "secret project" (to auction her virginity online to the highest bidder as a fundraiser for Amnesty International and a social commentary on sex trafficking), Madeline attempts to connect with Abigail, insisting that "I'm not fucking perfect! I make mistakes, too." She then confesses that she cheated on Ed and, in doing so, risked "the two things I value most in this world—my marriage and my children." Significantly, her act of confessing is intended to prevent Abigail from making a disastrous mistake. It can therefore be read as a fiercely protective act redolent of the familiar "mama bear" character trope, a figure that Madeline is clearly cognizant of, having hollered it at Jane as an affectionate term of endearment in an earlier episode. Her sexuality is consequently, in this moment, sublimated into her identity as a mother, which takes precedence over her own desire. Thus sexuality, which initially functioned as an expression of Madeline's maternal regret and longing for something separate and other to motherhood, is stripped of its potential, reduced instead to something that needs to be renounced and sacrificed in order to fulfil the requirements of good mothering.

Conclusion

Much like the series itself, the conclusion is characterized by ambiguity and ambivalence. Certainly, Big Little Lies does offer something new in its publicizing of maternal experiences, specifically through articulating the various women's regrets regarding the paths their lives have taken and the subsequent guilt and shame such dissatisfaction elicits. Despite their different circumstances, the series posits that the one thing these mothers share in common is a desperate longing to be something other than "just" a mother. However, Big Little Lies is also clearly informed by neoliberal discourses, wherein representations of working mothers have been updated and rendered safe and acceptable for largely pragmatic reasons and where the equation of maternity and sexuality continues to destabilize and purportedly threaten hegemonic structures in worrying ways. Despite best intentions, then, Big Little Lies does fall prey to a fetishizing of the maternal-feminine in the figures of these self-regulating "yummy mummies" whose desires are

carefully scrutinized, managed, and controlled. The minor differences between the series' and the book's endings echo this. Whereas Moriarty concludes her novel with Bonnie receiving a sympathetic sentence for pushing Perry to his death and Celeste campaigning about the prevalence of domestic violence, the series closes in around the women and their fiercely guarded secret. The final shot is a lingering point of view depicting the women and children on the beach through a set of binoculars. It is an odd shot to end on (particularly given the original insistence that *Big Little Lies* would be a standalone limited series) that in many ways undermines the narrative of sisterhood that has preceded it. While the moments immediately before had felt joyous and idyllic—featuring carefree children splashing in the waves as their mothers sat or walked together, physically, close and affectionate—the framing of the closing shot is far more threatening. It suggests instead that the connections that have formed between the mothers, and which had been so laboriously celebrated throughout the series, are in fact fragile, tenuous, and, as always, subject to ruthless surveillance and judgment. Consequently, the articulations of maternal regret that initially seemed startling and transgressive are also undone through this emphasis on the women as guilty of not only murder but also for failing to fulfil the tenets of hegemonic, idealized good mothering.

Endnotes

1. Andrea O'Reilly, for instance, points out that "even fictional mothers expressing regret are controversial" (qtd. in Kingston). Consequently, most representations of maternal regret manifest in comic form, which renders them "socially acceptable" (Brown).

Works Cited

Abod-Santos, Alex. "Big Little Lies Episode 6, 'Burning Love': Men Like Perry Aren't Good Men." *Vox*, 26 Mar. 2017, www.vox.com/culture/2017/3/26/15048804/big-little-lies-episode-6-recap-burning-love-kidman-perry. Accessed 17 Apr. 2022.

Birnbaum, Debra. "'Big Little Lies': Reese Witherspoon on Her Twisty HBO Show." *Variety*, 31 Jan. 2017, variety.com/2017/tv/features/big-little-lies-reese-witherspoon-hbo-jean-marc-vallee-12019

73903/. Accessed 17 Apr. 2022.

Brown, Lola Augustine. "Regretting Motherhood: What Have I Done to my Life?" *Today's Parent,* 8 June 2017, www.todaysparent.com/family/parenting/i-regret-motherhood/. Accessed 17 Apr. 2022.

Douglas, Susan, and Meredith Michaels. *The Mommy Myth: The Idealization of Motherhood and How It Has Undermined Women.* Simon and Schuster, 2004.

Hays, Sharon. *The Cultural Contradictions of Motherhood.* Yale University Press, 1998.

Kingston, Anne. "Mothers who Regret Having Children are Speaking up Like Never Before." *Maclean's,* 11 Jan. 2018, www.macleans.ca/regretful-mothers/. Accessed 17 Apr. 2022.

Koehler, Sezin. "'Big Little Lies' Takes on an Unspeakable Taboo: Mothers Who Regret Motherhood." *Wear Your Voice,* 22 Mar. 2017, wearyourvoicemag.com/big-little-lies-taboo-mothers/. Accessed 17 Apr. 2022.

McRobbie, Angela. "Top Girls?: Young Women and the Postfeminist Sexual Contract" *Cultural Studies,* vol. 21, no. 4-5, 2007, pp. 718–37.

Moriarty, Liane. *Big Little Lies.* Berkeley Books, 2015.

Roy, Jessica. "For 'Big Little Lies' Fans, the Houses Are as Much of a Draw as the Drama." *Los Angeles Times,* 6 June 2019, www.latimes.com/home/la-hm-big-little-lies-architecture-design-aesthetic-20190607-story.html. Accessed 17 Apr. 2022.

Thomson, Rachel, et al. *Making Modern Mothers.* The Policy Press, 2011.

Vallée, Jean-Marc, director. *Big Little Lies.* HBO, 2017.

Chapter 6

"Yes, My First and Only": Dealing with Assumptions of Regret about Family Size

Karla Knutson

W hen my daughter was four months old, an acquaintance holding her ten-month-old son asked if I planned to have more children. Taken aback at how soon I was being asked about having more kids after having just given birth, I replied that this child had just arrived, but that I enjoyed having one child. She immediately volunteered that she loved her son so much that she "could not imagine not having another."

This brief interaction is recognizable, undoubtedly, to many parents and, indeed, to many mothers. While common and perhaps intended to be friendly and a chance to bond—and certainly seen as innocuous by those who feel comfortable asking about others' reproductive choices —a situation like this belies the expectations undergirding the size of families, the feelings mothers are supposed to have, as well as a script for the correct emotional performance of motherhood. In the encounter described above, the other mother wanted to demonstrate her love for her child and for children in general, which are positive emotional stances. However, her statement also implies that one of the essential ways that mothers signal love for existing children is by having more of them.

The "only child" has been a stigmatized object of suspicion, derision, and pity in American culture. Despite research contradicting these assumptions published in both academic and popular venues, including

111

a widely circulated article titled "The Only Child: Debunking the Myths," in *Time* in 2010, these stereotypes remain intact. The first results of a Google search for "only child" emphasizes the negative perceptions still surrounding them, with recently published articles titled "Only Children Are Not Doomed" in *The New York Times* in 2020, "The Truth about Only Children: Are They More Insular and Confident?" in *The Guardian* in 2018, and "Is Only Child Syndrome Real?" in *Scientific American* in 2019. The "syndrome" these singletons supposedly suffer from is a result of both lack and abundance caused by their family structure—lack of siblings and thus socialization as well as an abundance of undivided attention from and focused concerted cultivation[1] by their parents, leading to spoiled yet accomplished children.

I argue that the stereotypes of only children also stem from the way American culture[2] perceives their mothers as well as motherhood as an institution. The mothers who actively choose to have a single child, or who merely appear to have chosen that path, are figures of suspicion in pronatalist societies, as these mothers refuse to prove their love for their existing children and for all children by having additional children, flouting social expectations. This suspicion is undergirded by the long-standing interrelationship between pronatalist and eugenics movements, as these questions are directed at only certain mothers—those who are encouraged to reproduce because of their racial identity and socioeconomic status (Read, Crockett, and Mason; Monach; Lovett). These types of mothers are supposed to have many children, and if they do mother only one child, they are presumed to regret their decision. Mothers who are able to only have one child are assumed to share this regret. When they do not, the mothers of only children are questioned about their love for their existing child, as if family size and structure are a comment on a mother's emotional stance towards children.

This suspicion arises because of patriarchal motherhood's essentializing assumption that all women feel an innate, unwavering desire to be mothers—an assumption that erases women's subjectivity and agency regarding reproductive choices as well as the continuing expectations of intensive mothering. Like their only children, the mothers who choose to have one child are viewed by many in American culture as selfish, indulged, and lonely. The problematic rhetoric

encouraging mothers to continually prove their maternal devotion by having multiple children focuses, like most of the standards of "good mothering," on the commonly perceived effects of family size on children's development and happiness rather than on the wellbeing of the mothers. This pronatalist rhetoric implies that mothers will regret the harm they cause their child by not providing a sibling. In *Regretting Motherhood: A Study*, Orna Donath calls regret "hegemony's watchdog" and implores readers to consider the question of "how regret is used in a society that encourages and demands birth" (57). My chapter answers this question by demonstrating how the rhetoric surrounding only children and their mothers employs the spectre of regret as a threat, leading mothers who may not desire more than one child to believe that this family structure is somehow harmful to their child and perhaps, eventually, to them as well. My contribution to this collection explores the threatening rhetoric of potential regret mothers of only children encounter, as articulated in studies of the mothers of only children, of family size, and of maternal regret as well as in my personal experience as a mother of one child by choice. Using brief narratives, I will articulate how I have tried to challenge the assumptions of maternal regret with which I am frequently confronted.

This chapter then suggests that mothers who desire to have only one child can resist the damaging rhetoric about only children and their mothers by articulating how a decision to have one child often is a conscious choice and for many mothers a feminist choice made intentionally in light of the wellbeing of the mother and any existing children. Articulating the benefits to the mother of having an only child, as well as benefits to the child and family, can reduce the stigma associated with these identities, which can be beneficial even to families who wished to but did not have more than one child. Confronting platitudes about "appropriate" family size and structure can also help women feel empowered to make choices that are right for them and their families as well as challenge the exhortations of intensive mothering and essential motherhood, including presumed regret about number of children.

Only Children: Theoretical Context and Social Context

Negative stereotypes of only children were introduced to the United States (US) by psychological research beginning in the late nineteenth century. At this time, psychologist E.W. Bohannon published a study of "peculiar and exceptional children," attributing to the forty-six only children in the sample of 1001 children—a "marked tendency to peculiarities" which were described as "disadvantageous" (475), including qualities such as "selfishness, 'spoiled,' temper, jealousy, untruthfulness, stubbornness, and haughtiness" (491) as well as social difficulties and overall poor health and "vitality" (493-94). In reference to these results, G. Stanley Hall, Bohannon's supervising professor and later the first president of the American Psychological Association, supposedly said "Being an only child is a disease in itself" (Falbo and Poston, Jr. 18). Other psychologists concurred, including Abraham Brill (Falbo and Polit, "Quantitative" 176) and Alfred Adler (Falbo 38).

This view persists in American culture, despite the frequency with which scholars have published studies discrediting a negative impact of a single-child family structure upon the personality, sociability, intelligence, and achievement of only children. Indeed, the research on only children demonstrates benefits of this sibship structure. In the late 1980s, Toni Falbo and Denise F. Polit conducted three meta-analyses of over two hundred studies published since 1925, including only children in the data sample ("Quantitative" 176). In their first review, the examination of only children's outcomes demonstrated no significant statistical difference from firstborn children or those with one sibling in the categories of sociability and adjustment, which Falbo later notes was "a remarkable finding" that contradicted previous understandings that stigmatized only children and single-child families (Falbo 40-41). The review also found only children exceed the outcomes of their peers with siblings in the categories of intelligence, achievement, and character ("Quantitative" 185). Their second review examined the studies of personality characteristics and again found no statistically significant difference between single children and those with siblings, except in only children's increased achievement motivation (Polit and Falbo, "Only" 318). The third review pointed to the enhanced intellectual, specifically verbal, abilities of only children in contrast to children from large families and younger children in families (Polit and Falbo, "Intellectual" 278). Subsequent research by Falbo and Poston, Jr.

on single-child families in China as well as the work of other research-
ers looking at children in a variety of national settings (Blake; Downey;
Laybourn; Mancillas; S. Newman) has continued to challenge the
negative perceptions of only children and point to the benefits they
accrue from increased attention and resources.

Pronatalist Platitudes and Threatened Regret

Drawing upon the prevailing cultural attitude towards only children,
the platitudes regarding family size shared with parents of one child in
the US are well-known and easily anticipated in casual conversations
with those people who feel free to comment on family size. These
recognizable exchanges commonly follow variants on a similar
discourse structure. First, the person inquiring asks a question that
emphasizes the presence of only one child, such as "Is this your first?"
or "Do you have any other kids?" Of course, the asker cannot be
faulted for only seeing one child; however, asking whether there are
other children in a family belies the expectation that having more than
one is the conventional structure for a conventional family in con-
temporary American culture. However, it remains a fairly innocuous
question, one in which the asker might still be able to exit the
conversation politely. The questioner—whether a neighbour, customer
service representative, colleague, acquaintance, family friend, distant
relative, or stranger on the sidewalk—imposes with the next statement,
a follow-up tinged with normative expectations. These phrases range
from intrusive inquiries, such as "So when will you give her a little
sibling/brother/sister?" to unsolicited advice, such as "Don't wait too
long!" accompanied occasionally by a vulgar comment on the limits of
women's reproductive period, like "Tick-tock!" or even a con-
descending reminder of the adverse effects supposedly suffered by only
children: "You know, it's important for kids to have playmates" and
"They shouldn't have to shoulder all the burden of taking care of you in
old age." When the mother attempts to respond politely, the other
person often closes with an admonishing threat, "You'd regret not
having more."

This type of pronatalist rhetoric is unpleasant to experience in
conversation with strangers and acquaintances (although the level of
frustration experienced depends upon the particular conversation's

tone and diction as well as the relationship the woman perceives herself as having with that person). However, the rhetoric can become hurtful and often harmful when these platitudes are believed and repeatedly verbalized by those close to her and thus inform the social fabric of her life, often from an early age. In many pronatalist societies, platitudes about having multiple children are so engrained that even mothers who articulate their regret about becoming mothers have internalized the expectation to have multiple children and acted in accordance. The influence of the beliefs about only children, single-child families, and appropriate family structure is evident in Donath's study of maternal regret. The language used by several interviewees living in the pronatalist context of contemporary Israel to explain why they decided to have more than one child "in spite of their regret" of motherhood (147) reflects common assumptions about only children. Reasons offered for this choice focus on the quality of life of the existing child or children and downplay the mother's emotional health. One mother cites the negative effects of a lack of siblings: "And I think it's not good for them, that they don't have another sibling, but it is very good for me" (qtd. in Donath 149). Another mother alludes to having more than one child as a widely understood truth, a cultural mandate: "It was clear that I had to have another child, because I had to. Because you can't have only one child" (qtd. in Donath 151). Yet another refers to a recognizable platitude about how having multiple children does not necessarily involve more work than having a single child: "Once you have one, it's like having three, or seven. It really doesn't matter. Once you are a mother—that's it" (qtd. in Donath 148). This mother also shares the belief that siblings increase the happiness of children's experience, noting that if she has more children, "My family will be happy, by hook or by crook. I will have a big, happy family and every-one will be happy" (qtd. in Donath 148). These women, who self-identify as regretting motherhood, have internalized the essentializing cultural mandates not only to become mothers initially but to become mothers repeatedly by having additional children despite not having a desire to do so. The threat of the spectre of the doomed only child requires women to put their needs, desires, and self-knowledge aside in the service of protecting and nurturing their children.

The imperative to have multiple children is so pervasive that Donath lists regret about whether "to have or not to have additional children"

as one of the most common regrets related to issues of parenting and reproduction (55). So much of life generally, and parenting specifically, is calculation akin to that of the futures markets or of the nagging voice haunting travellers, asking "Is this the right time?" or "What if you miss this opportunity?" The voice repeatedly threatens the most unpleasant outcome, with the reminder that if a person neglects to do what convention requires you will regret it. Fear of missing out as a parent—whether to cultivate development, to protect, to establish bonds, to have any or additional children—permeates the lives of American parents as well as wider American society. Psychoanalyst Adam Phillips points out that "Much of our so-called mental life is about the lives we are not living, the lives we are missing out on, the lives we could be leading but for some reason are not" (xi). Given this cultural context with "an inordinate emphasis upon the many advantages attendant upon having children," which Jean E. Veevers describes as existing in both the US and Canada (3), pronatalist rhetoric propagates the belief that having children results in a unique form of satisfaction: "Children are thought to give life purpose and meaning and, especially for women, to be necessary if not sufficient for fulfillment" (Veevers 6). Pronatalism promotes motherhood by harnessing the fear Phillips describes. Spread through official government policies, as well as social construction and interaction,[3] this ideology encourages women to feel anxious about the possibility of not having a particular experience in order to threaten women that they will regret denying themselves and their families the opportunity to have at least one, and ideally many, children.

Persistent Stereotypes: The Mother is at Fault

The pronatalist threat of potential regret regarding procreation employs and thus normalizes common perceptions of only children. Despite scholarship challenging these views, the negative view of them persists in American culture, carrying enough credence to require frequent rebuttals in the popular press, such as the articles listed in the introduction to this chapter. What I suggest is a root cause of the continued persistence of these stereotypes is suspicion of a mother who has not been appropriately generative. As the regretting mothers in Donath's study related, they often encountered others who were

convinced that having more children would fix the cause of the mothers' regret; these efforts reflect how "to sustain the social order, a society often denies the existence and meaning of disappointment— the feeling that is awakened when something we expected, wanted, or hoped for was not realized" (Donath 154). Regret of becoming a mother is an emotion particularly unacceptable in pronatalist cultures, as these ideologies attempt to persuade women to make decisions in service of others. Pronatalism is promoted by people who are frightened by the possibility that women can discern what is best for them. This type of regret is taboo because it implies mothers are subjects, not objects. This distrust of women's knowledge about their bodies, needs, and desires reverberates across the world and in the US reflects the nation's history of reproductive injustice and substandard medical care, which disproportionately affects women of colour, particularly Black American women (Martin and Montagne; Solinger and Ross; Solinger).

Mothers who actually regret becoming mothers or appear to do so because of not having children in sufficient numbers upset the social order by flouting the expectations of pronatalism prescribing appropriate family size. They become objects of suspicion because they do not visibly perform certain aspects of the ideology of intensive mothering, specifically the natural self-sacrificing inherent to contemporary American understandings of good mothering. For many women, having further children or any children would entail a sacrifice of some sort—for example, in terms of physical, mental, or emotional health, socioeconomic stability, temporal resources, or professional goals. These women dare to engage their ability to analyze their distinctive context and by doing so demonstrate that they are thinking, discerning, and understanding subjects. If they have the privilege of selecting a family size and structure, they are able to act in ways that further their interests and goals. This recognition and pursuit of self-interest, however, do not align with the prevailing ideology of intensive mothering, which requires women to be "responsible for unselfish nurturing while men are responsible for self-interested profit maximization" (Hays 175). Engaging in a choice, rather than sacrificial motherhood, is what arouses pronatalist suspicion.

Women who dare to articulate that the single child they have is the result of a conscious choice risk being seen as not appropriately maternal. Their status as good mothers is suspect, as their choice marks

them as a woman first and a mother second due to their self-interest. Using Richard Weaver's concept of "god and devils terms," Lindal Buchanan theorizes a woman-mother continuum providing "rhetorical expressions" of familiar gendered and maternal stereotypes (8). "Mother" serves as the god term, associated with qualities such as "morality, self-sacrifice, and children" (plural), whereas the devil term, "Woman," connotes "self-centeredness, self-indulgence, and child-lessness" (Buchanan 9). Pronatalist and intensive mothering rhetoric draws upon this continuum by using phrases associated with the category of "Woman" when questioning the presence of a single child. Buchanan's continuum provides a powerful reminder of how language conveys social expectations: "The Woman and Mother are familiar to cultural insiders and, therefore, provide rhetors with opportunities to employ 'what everyone knows'" (8-9). Although they may not know it, what everyone certainly suspects is that mothers of only children are women first and mothers second, similarly prioritizing their needs over that of their child.

Resistance: Feminist Mothering and Matricentric Feminism

As I encountered the casual grocery-store inquires regarding the size of my family more frequently, I became more confident about how I wanted to handle them. When someone asked me, even in an offhand way, whether my daughter was my first child, I began to preempt the next question by asserting that she was "my first and only." I realize that I did not need to share my reproductive choices with random people in the grocery store admiring my charming child; however, I felt there were multiple advantages to being direct about my family's single-child status. Describing my daughter as "my first and only" destabilizes the questioner, who has to rethink what to say next. The most frequent response is "Oh," which is delivered in a range of tones, from surprised, to confused and polite, to disapproving. Then, I often follow up my comment with a statement about how much I enjoy her and some detail about her interests, as a way of diffusing the confusion from the subverted typical conversational structure. Although I started using this answer as a way to head off conversations I did not want to have, while simultaneously sharing something I am proud of and not

going to apologize for, I persist in using the phrasing "first and only," as I find it an easy way to perform maternal activism for mothers of only children and the single-child family. The more I am able to challenge the expectations of ideal family sizes by pointing out the commonness and pleasantness of multiple variants, the more exposure others have to positive experiences that destigmatize only children and their mothers.

My perception and experience of motherhood does influence my choice of number of children (Read, Crockett, and Mason 13). But in contrast to my acquaintance's belief that having one child implies that I do not love my child enough because I do not wish to have further children, I have made a conscious decision about how I want to mother and to live. My desire for my current family size is based on the positive experiences I have had with my one child as well as my reflection upon how I want to balance mothering with other commitments important to me such as my profession, extended family, and community as well as my health, self-care, and the pursuit of leisure interests. I am not alone; scholarly studies repeatedly have demonstrated many mothers' preference for a smaller number of children (Friedman, Hechter, and Kanazawa; Read, Crockett, and Mason; Margolis and Myrskylä) as well as the high rates of satisfaction and reports of increased well-being from mothers with only one child (Balbo and Arpino; Kohler, Behrman, and Skytthe; L. Newman).

Matricentric feminism and feminist parenting offer productive frameworks for satisfied mothers of one child to refute the stereotypes of only children and their mothers as selfish and self-interested. The type of casual yet pointed articulation of my decision to have one child as described above is part of my practice of feminist mothering, which as Fiona Joy Green asserts creates "a dynamic place for creativity" through feminist parents "placing themselves and not their children at the centre of their lives" in their interrogation of the constrictions of patriarchal motherhood (95). My intention in pointing out how much I love having one child and how it benefits my subjective situation—in terms of health, scale of commitments, temperament, and resources—is to facilitate interrogation of the conventional wisdom regarding the development of only children and the unquestioned benefits of sibling relationships. My central aim is to shift the focus of the conversation about the number of children in families from how sibship structures

affect children to how they affect parents, particularly mothers, who continue to do more childcare and housework than male partners in the US. This gendered division of labour has only been exacerbated by the global COVID-19 pandemic, with reports of 865,000 women leaving the workforce in September 2020 alone, some temporarily and some permanently (Gogoi). This situation has brought the effects of the expectations of intensive mothering and patriarchal motherhood into striking relief, emphasizing that American mothers' needs must be given serious attention. Matricentric feminism, as theorized by maternal scholar Andrea O'Reilly as "a mother-centred mode of feminism" (3), can provide the framework for serious attention to be refocused on the concerns and needs of mothers. As its key tenets include such goals as shifting from child-centred examinations of motherhood in scholarship and providing space for mothering to be activism (7), I conceptualize attempts to destabilize the received wisdom regarding only children and their mothers as a form of activism and a practice of feminist mothering. My practice includes informal strategies, such as speaking about my experiences as a mother of an only child by choice in a variety of social contexts as well as performing activism through scholarship and serving as a visible type of family structure in my community. It also entails cultivating a relationship based in mutual respect with my daughter, utilizing feminist mothering practices of creating space for discussion-based intersectional analysis of social contexts and systemic institutions, and offering a rationale for and inviting questions about the choices and constrictions that guide my life (Green 96). As Green points out, feminist mothering practices with "specific approaches to disrupting child-centric motherhood and dislodging sacrificial motherhood" benefit not only mothers, but also children, who may develop increased resilience, flexibility, and communication skills (97).

All too frequently, families face judgmental pronouncements about their structure—how they are too "something," whether too large, too small, too blended, too scattered, or too nonexistent. Families with one child encounter the stigmas surrounding only children—that these children, and by extension their mothers, are selfish, indulged, and lonely, stereotypes that pervade the perceptions of these children and mothers in American culture. Regret, "hegemony's watchdog," is employed by these pronouncements in an attempt to make these diverse

family structures more homogenous. However, American families with singletons may already becoming more common; my daughter is one of three only children in her extended family, and she was one of six singletons in her preschool class of approximately twenty children. My choice, made with my partner, to parent a single child reflects the choices made by numerous American families in the past decades, as demographic studies have shown. Pew Research Center reports an increase in the number of women who have given birth to only one child by the end of their childbearing years (considered forty to forty-four), from 10 per cent in 1976 to 18 per cent in 2015 (Livingston), and articles in the popular press are starting to point out the reasons for this trend, including economic concerns and starting families later in life (Gibson). Having a single child certainly is not the most popular family size in the US, nor does it need to be, but it should not be a stigmatized family size any longer. Mothers of only children should not be assumed to harbour regrets, merely because of how many children they have. No matter what size a particular family is, my wish for them, rooted in matricentric feminism and made with the utmost good will, is that that size and shape is the family they chose.

Endnotes

1. Annette Lareau's ethnographic research developed her theory of "concerted cultivation" to describe the parenting behaviours associated with the American middle-class parents who curate their children's experiences (specifically through organized activities) and encourage their self-confidence by conversing with them frequently, thereby assisting them in learning self-advocacy with adults in professional and institutional settings (1-2).

2. Other pronatalist cultures, particularly those similar to the US in many ways, share these essentializing assumptions about motherhood and, thus, mothers' expected behaviours and emotions. As my research, work, and personal experience are within the context of the US, this chapter focuses on this country's expectations, although I hope readers find commonalities with their own experiences elsewhere.

3. Although this article focuses on pronatalism inherent in social situations, many scholars have pointed out the pronatalist policies

and "cultural messages" (Lovett 2) employed by governments across the world (Lovett; Veevers; and Monach).

Works Cited

Balbo, Nicoletta, and Bruno Arpino. "The Role of Family Orientations in Shaping the Effect of Fertility on Subjective Well-being: A Propensity Score Matching Approach." *Demography*, vol. 53, no. 4, Aug. 2016, pp. 955-78.

Blake, Judith. *Family Size and Achievement*. University of California Press, 1989.

Bohannon, E. W. "The Only Child in a Family." *Pedagogical Seminary*, vol. 4, 1898, pp. 475-96.

Buchanan, Lindal. *Rhetorics of Motherhood*. Southern Illinois University Press, 2013.

Donath, Orna. *Regretting Motherhood: A Study*. North Atlantic Books, 2017.

Downey, Douglas B. "When Bigger is Not Better: Family Size, Parental Resources, and Children's Educational Performance." *American Sociological Review*, vol. 60, no. 5, Oct. 1995, pp. 746-61.

Falbo, Toni. "Only Children: An Updated Review." *Journal of Individual Psychology*, vol. 68, no. 1, Spring 2012, pp. 38-49.

Falbo, Toni, and Denise F. Polit. "A Quantitative Review of the Only Child Literature: Research Evidence and Theory Development." *Psychological Bulletin*, vol. 100, no. 2, 1986, pp. 176-89.

Falbo, Toni, and Dudley L. Poston, Jr. "The Academic, Personality, and Physical Outcomes of Only Children in China." *Child Development*, vol. 64, no. 1, Feb. 1993, pp. 18-35.

Friedman, Debra, Michael Hechter, and Satoshi Kanazawa. "A Theory of the Value of Children." *Demography*, vol. 31, no. 3, Aug. 1994, pp. 375-401.

Gibson, Caitlin. "The Rise of the Only Child: How America is Coming Around to the Idea of 'Just One.'" *The Washington Post*, 19 June 2019, www.washingtonpost.com/lifestyle/on-parenting/the-rise-of-the-only-child-how-america-is-coming-around-to-the-idea-of-just-one/2019/06/19/b4f75480-8eb9-11e9-8f69-a2795fca3343_

story.html. Accessed 18 Apr. 2022.

Gogoi, Pallavi. "Stuck-at-Home Moms: The Pandemic's Devastating Toll on Women." *NPR*, 29 Oct. 2020, www.npr.org/2020/10/28/928253674/stuck-at-home-moms-the-pandemics-devastating-toll-on-women. Accessed 18 Apr. 2022.

Green, Fiona Joy. "Practicing Matricentric Feminist Mothering." *Journal of the Motherhood Initiative*, vol. 10, no. 1-2, Spring/Fall 2019, pp. 83-99.

Hartmann, Corinna. "Is Only-Child Syndrome Real?" *Scientific American*, 21 Jan. 2019, www.scientificamerican.com/article/is-only-child-syndrome-real/. Accessed 18 Apr. 2022.

Hays, Sharon. *The Cultural Contradictions of Motherhood*. Yale University Press, 1996.

Kohler, Hans-Peter, Jere R. Behrman, and Axel Skytthe. "Partner + Children = Happiness? The Effects of Partnerships and Fertility on Well-Being." *Population and Development Review*, vol. 31, no. 3, Sept. 2005, pp. 407-45.

Lareau, Annette. *Unequal Childhoods: Class, Race, and Family Life*. University of California Press, 2011.

Laybourn, Ann. "Only Children in Britain: Popular Stereotype and Research Evidence." *Children & Society*, vol. 4, no. 4, 1990, pp. 386-400.

Livingston, Gretchen. *Childlessness Falls, Family Size Grows Among Highly Educated Women*. Pew Research Center, 2015, www.pewsocialtrends.org/2015/05/07/childlessness-falls-family-size-grows-among-highly-educated-women/. Accessed 18 Apr. 2022.

Lovett, Laura L. *Conceiving the Future: Pronatalism, Reproduction, and the Family in the United States, 1890-1938*. University of North Carolina Press, 2007.

Mancillas, Adriean. "Challenging the Stereotypes About Only Children: A Review of the Literature and Implications for Practice." *Journal of Counseling & Development*, vol. 84, no. 3, Sum 2006, pp. 268-75.

Martin, Nina, and Renee Montagne. "Black Mothers Keep Dying After Giving Birth. Shalon Irving's Story Explains Why." NPR, 7 Dec. 2017, www.npr.org/2017/12/07/568948782/black-mothers-

keep-dying-after-giving-birth-shalon-irvings-story-explains-why. Accessed 18 Apr. 2022.

Monach, James. H. *Childless: No Choice: The Experience of Invol-untary Childness.* Taylor & Francis Group, 1993.

Margolis, Rachel, and Mikko Myrskylä. "Parental Well-being Surrounding First Birth as a Determinant of Further Parity Progression." *Demography,* vol. 52, no. 4, Aug. 2015, pp. 1147-66.

Newman, Lareen. "How Parenthood Experiences Influence Desire for More Children in Australia: A Qualitative Study." *Journal of Population Research,* vol. 25, no. 1, May 2008, pp. 1-27.

Newman, Susan. *Parenting an Only Child: The Joys and Challenges of Raising Your One and Only.* Broadway Books, 2001.

O'Reilly, Andrea. *Matricentric Feminism: Theory, Activism, and Practice.* Demeter Press, 2016.

Oster, Emily. "Only Children Are Not Doomed." *The New York Times,* 27 Apr. 2020, www.nytimes.com/2020/04/27/parenting/only-child-siblings-emily-oster.html. Accessed 18 Apr. 2022.

Phillips, Adam. *Missing Out: In Praise of the Unlived Life.* Farra, Straus, and Giroux, 2013.

Polit, Denise F., and Toni Falbo. "Only Children and Personality Development: A Quantitative Review." *Journal of Marriage and Family,* vol. 49, no. 2, May 1987, pp. 309-25.

Polit, Denise F., and Toni Falbo. "The Intellectual Achievement of Only Children." *Journal of Biosocial Science,* vol. 20, no. 3, Jul. 1988, pp. 275-85.

Read, Donna M.Y., Judith Crockett, and Robyn Mason. "'It Was a Horrible Shock': The Experience of Motherhood and Women's Family Size Preferences." *Women's Studies International Forum,* vol. 35, 2012, pp. 12-21.

Sandler, Lauren. "The Only Child: Debunking the Myths." *Time,* 8 July 2010, content.time.com/time/magazine/article/0,9171,200 2530,00.html. Accessed 18 Apr. 2022.

Saner, Emine. "The Truth About Only Children: Are They More Insular and Confident?" *The Guardian,* 31 May 2018, www. theguardian.com/lifeandstyle/2018/may/31/truth-about-only-children-insular-confident-worry. Accessed 18 Apr. 2022.

Solinger, Rickie. *Pregnancy and Power: A Short History of Repro-ductive Politics in America.* New York University Press, 2005.

Solinger, Rickie, and Loretta J. Ross. *Reproductive Justice: An Introduction.* University of California Press, 2017.

Veevers, J.E. *Childless by Choice.* Butterworths, 1980.

Section II
Renunciations

The Children Leave: Maternal Abandonment in Two Alice Munro Stories

Laurie Kruk

In the official citation for the Nobel Prize in 2013, Alice Munro was dubbed "master of the contemporary short story." Quoting those words of praise, editor of *The Cambridge Companion to Alice Munro*, David Staines, begins his study by noting that she has devoted "her writing career to a careful exploration of the genre of the short story, questioning its boundaries, expanding its length (her early stories were ten pages long, her later stories up to seventy) and challenging the common understanding of its purpose and power" (2). Part of Munro's power is undeniably her clear-eyed, unflinching yet compassionate exploration of our human capacity for betrayal—through infidelity, abandonment, cruelty, and even murder. Lovers, spouses, friends, and family members are all shown to be capable of these acts of betrayal. Yet none is more painful and unforgettable, I argue, than the filial betrayal, experienced through the eyes of a mother, of her by her own adult child. This betrayal is seen, from different gendered perspectives, in two of Munro's later stories: "Silence," (*Runaway*, 2004) and "Deep-Holes" (*Too Much Happiness*, 2009). In "Silence," part of the Juliet "mini-cycle" (Weiss 84), a twenty-one-year-old daughter disappears from her mother's life, with no real explanation, after attending a "spiritual retreat." In "Deep-Holes," a grown son also mysteriously cuts ties with his parents and siblings, only to connect with his mother, years later, after his father's death. The reunion with this prodigal son,

however, is strained by his righteous attitude and motivated by desire for part of the inheritance. The son also seems to have undergone a spiritual crisis, precipitated by a near-death experience as a boy, a fall into one of the title's "deep holes" from which he is rescued by his parents. If the mothers in these two stories feel no regret about their choices to parent, it appears the children do, and thus "Silence" and "Deep-Holes" work to deidealize motherhood. As the protagonists reflect on their maternal careers, they are forced to confront the spectre of the "bad mother" in themselves and regret how their parenting chapters have concluded (if that is the correct word, in these typically open-ended Munro works). As Elaine Tuttle Hanson writes:

> Does a woman without a child simply become (at last or again) a subject, an autonomous self, free from the claims and contradictions of motherhood? Or does she suffer a tragic, irreparable trauma? The story of the mother without child addresses these questions and thereby brings us closer to that frequently stated goal of feminist study: seeing maternal points of view more fully, hearing maternal voices more clearly and vicariously, understanding maternal subjectivity more deeply and completely. (20)

I will argue that in these two disturbing stories, Munro disrupts the daughter-centric voice of much contemporary feminist criticism and invites us to witness the mother's trauma without death, except for that, perhaps, of the maternal voice and role. By speaking of trauma, and although I am familiar with Judith Herman's ground-breaking work *Trauma and Recovery*, I am referring not to the typical trauma inflicted upon women through history—from domestic abuse to political terror—but to intentional maternal abandonment as a traumatic wound in itself.

> Munro's subject matter ... is fundamentally elegiac in that an effort to control loss is often depicted in her work.

> —Karen E. Smythe 106

Taken from two of her later collections, "Silence" and "Deep-Holes" provide a contrast in child gender while sharing the theme of maternal abandonment by adult offspring. In both cases, the mother is revealed as a mature and widowed former wife: Juliet in the former and Sally in the latter. "Deep-Holes" treats the attempt to reconnect with an estranged adult son; "Silence," the unexpected separation from a twenty-one-year-old daughter who fails to turn up at a scheduled reunion after her stay at a spiritual retreat. In "Deep-Holes," a strained reunion takes place (although it may be financially motivated, as I indicated); in "Silence," the actual reunion remains elusive, out of reach, fictionalized. Juliet's own scholarly investigations in her maternal abandonment return her to her youthful classical studies vocation, but her research into the Greek myth of the Queen of Ethiopia, the "*Aethiopica*" of so-called Greek novelist Heliodorus, takes on a kind of Demeter-Persephone colouring. Juliet even rewrites the ending in a playscript developed with a friend to offer an emotional mother-daughter reunion instead of the original script: rescue by a lover, threatened sacrifice by the patriarch. Juliet "was secretly drawn to devising a different ending, one that would involve renunciation, and a backward search, in which the girl would be sure to meet fakes and charlatans, imposters, shabby imitations of what she was really looking for. Which was reconciliation, at last with the *erring, repentant, essentially great-hearted* queen of Ethiopia" (my emphasis, 152). Munro's familiar triplet of adjectives underlines her heroine's own struggle to acknowledge some fault, some aspect of the "bad mother" even as forgiveness is achieved. Yet after playing with her own revision of this story, Juliet is forced to confront the silence of her daughter's unimaginable life—now a mother herself, showing the wear of bearing five children, according to the quick report relayed during a chance encounter with her daughter Penelope's school friend, Heather, some fifteen years after the daughter's abrupt departure. This new information throws all of Juliet's suppositions out the window, as she realizes the daughter who rejected her as a mother has now taken on the maternal role herself. As Juliet digests the ramifications of the latest information, she thinks to herself "The Penelope Juliet sought was gone ... the mother who had brought her sons to Edmonton to get their school uniforms, who had changed in face and body so that Heather did not recognize her, was nobody Juliet knew" (157). As she

digests this new information, she comes close to her own madness of maternal abandonment ("she must not be so mad" [156]) as to envision flying up North to essentially stalk her daughter) and self-dramatizes an imagined confession of the story to her latest partner, Gary (who is oblivious), concluding bleakly that perhaps maternal failure has nothing to do with it: "*Maybe she can't stand me. It's possible*" (158). The daughter's rejection of the mother is personal, not political after all, leading Juliet further down the path of maternal regret.

To start with this earlier and longer story, "Silence" is actually the third in the Juliet "mini-cycle" as Allan Weiss calls it, which covers the life of a woman from her adventurous youth, an unexpected romance with widowed West Coast fisherman Eric ("Chance"), motherhood without legal marriage, a visit back to Ontario and her dying mother ("Soon"), Eric's sudden death in a storm at sea and maternal abandonment in "Silence." In "Soon," Juliet's mother, Sara, on what turns out to be her deathbed, actually articulates a kind of faith—loosely Christian—and the consoling thought of an afterlife reunion with Juliet. However, her daughter has become an argumentative atheist and rejects the minister's counsel as well as her mother's own plea. As the retrospective narrator reproaches herself in the closing paragraph of that story: "When Sara had said, *soon I'll see Juliet*, Juliet had found no reply. Could it not have been managed? Why should it have been so difficult? Just to say *Yes*. To Sara it would have meant so much—to herself, surely, so little. But she had turned away" ("Soon" 125). Ironically, this hope of reunion, in reality, will be revisited upon Juliet in terms of her own thwarted connection with her daughter. Thus, faith of some kind seems central to both older and younger mother-daughter dyads. Corinne Bigot also draws these two linked mother-daughter stories together:

> The reader is offered the possibility of accepting that Penelope [Julie's daughter] turns away from her mother because she was denied religious education…. Penelope's leaving the Centre before her mother arrives and her refusal to speak to her, eerily echo Juliet's silently turning away from her own mother at the end of "Soon" [125]—as if to suggest Juliet is being punished for having abandoned her own mother. (par 30)

The sins of the daughters are revisited upon them as mothers, as it were.

"Silence" opens with Juliet's happy anticipation of the reunion with her beloved daughter and only child, Penelope, at the Spiritual Balance Centre on Denman Island, BC. At this point, Juliet is a moderately famous television interviewer, and "what her mother would have called a striking-looking woman" (126). But instead, Juliet meets her unattractive maternal counterpart, Penelope's counsellor, an unfashionable middle-aged woman, who greets her as a celebrity but then delivers the bad news: Penelope is not there. Joan comments that Penelope came to them "in great [spiritual] hunger" and wonders if she was brought up in a "faith-based home." As we know from the earlier story, Juliet and Eric had decided "to bring her up without religion" ("Soon" 120). Now as Joan calmly relays the news that Penelope is not there—in fact has decided against meeting her mother, although she had sent a card and a map in the mail—Juliet loses her composure, perfected by years of television interviewing, and cries out, "What did she tell you?"(135). The obvious omission—"about me"—is all too easily filled in by the reader, especially a maternal one.

And thus begins the maternal abandonment of Juliet by the daughter she had formerly doted on for her strength and maturity. In her internal monologue that precedes the meeting with Joan, Juliet thinks, "*She gives me delight…. She has grace and compassion, and she is as wise as if she'd been on this earth for eighty years* (128). Birthday cards, sent on Penelope's birthday to her mother, by referring to her birth, are the only textual trace of the disappeared daughter. Of course, this story, in its context, predates the explosion of internet technology, and a younger mother might have had the resources to track down Penelope. But middle-aged Juliet is reduced to scrutinizing the postal mark (but cannot, in her pride, bring herself to take it to the post office) as well as waiting for phone call messages on her home phone at their formerly shared apartment. Inquiries from Penelope's friends are shrugged off with the excuse that she is travelling. Juliet delays moving out for years, waiting for contact. She shares her sense of mother guilt with her old friend (and Eric's former lover), Christa, lamenting and echoing Joan's implication: "I neglected her *spirituality*" (137). In the midst of this self-critique, Munro inserts a ten-page flashback dealing with the former major loss in her heroine's life—the death of her husband Eric, in a

storm at sea—when Penelope was thirteen. The death occurs while Penelope is staying with a friend and as a result, she never has to confront the actual loss or participate in Eric's casual cremation on the beach, as her mother does. In fact, they never return to the family home, a situation that perhaps delays Juliet's grief. One day, it hits her, when she is returning from work, and she thinks: "So this is grief. She feels as if a sack of cement has been poured into her and quickly hardened. She can barely move" (147). Penelope takes on the comforter role here, even as she is overheard earlier telling her teenage friends, to Juliet's shock, "Well I hardly knew him, really" (145). Is this teenage rebellion—or something more sinister? Juliet thinks of this comment as a means to dismiss the importance of someone who has filled her life. Is she now being similarly dismissed, the reader wonders?

Five years later, Juliet finally forces herself to move from the apartment they shared but keeps the contents of Penelope's room, the hidden shrine to her daughter's memory. She loses her old friend, Christa, suddenly, and forms other, seemingly more superficial relationships with men, which ultimately end. Juliet becomes more reclusive, returning to her scholarly career in classical studies but abandons her thesis for her own new obsession with the *Aethiopica* as a story of maternal longing for the lost daughter. Her fantasized reunion, however, comes not with her daughter but with her daughter's classmate, Heather, in a chance encounter on a street corner. Addressed by her former married name as "Mrs. Porteous," Juliet is returned to both past and present as she is informed that Heather is still in touch with Penelope. Indirectly, it is revealed that she lives far up north— north of Edmonton, possibly Yellowknife or Whitehorse—and is a mother of five children. Juliet, ever image conscious, does not let on that she is estranged from Penelope and participates in a social exchange expected of an otherwise casual encounter. She even asks after Heather's children, reminding the reader of the "mother talk," she has knowingly performed throughout her maternal career (127). Juliet accepts Heather's quick departure and an apology for not calling her with seeming aplomb. Only afterwards, in the privacy of her thoughts, does she rack her brains in an extended interior monologue (155-58). She parses their brief conversation in agonizing detail, wondering about Penelope's health, current family situation, and her own maternal assumptions. Far from having spent her life "in

contemplation," Penelope was living the life of a "prosperous, practical matron" (156). She now imagines them laughing together over this misreading but then corrects herself harshly, concluding "too many things had been jokes.... She had been lacking in motherly inhibitions and propriety and self-control" (156). She also wonders if Penelope had been secretly keeping track of her, at least by the phone directory. She refuses these comforts though and finally rejects the idea of actually travelling up north to seek her out in some fashion. The final rejection of her new partner, Gary, is tied in with her refusal to share this latest episode in her maternal abandonment.

The narrative then moves forwards into the present tense, the page break also suggesting that some time has passed. She continues her investigations of the Greek myth that has become an inverse reflection of her own situation. And despite Juliet's avowed atheism, the story ends on an odd note of faith, as she continues to hope for a word from her daughter: "She hopes as people who know better hope for undeserved blessings, spontaneous remissions, things of that sort" (158). "Undeserved blessings" carries a nondoctrinal yet clearly spiritual impulse; "spontaneous remissions" move us back to the world of medicine and science; and "things of that sort" vaguely gestures to an unnamed third possibility, probing the reader's empathy. Again, the triple listing works to undermine certainty, with the off-handed addendum "things of that sort" leaving us still waiting for Penelope's last word. Meanwhile, has Juliet moved closer to spiritual balance at last?

"Deep-Holes," the second story I consider, presents the abandoned mother, years later, with a reunion based upon a similar chance encounter with her adult child as rediscovered via some news footage stumbled upon by his sister. Kent, who has been out of touch with his family since leaving university, is spotted helping with a street fire in a dilapidated block of downtown Toronto. Savanna, who was a baby at the time of his life-changing fall into the cave, acts as intermediary and meets her brother first before her mother does, in an unfamiliar part of an increasingly unfamiliar city, Toronto. He instructs his mother to meet him downtown at a subway station, and Sally travels there, amid an increasingly multicultural crowd, ending up at an abandoned bank surrounded by seeming vagrants, one of whom steps forward and greets her with "Mom." This is where Kent lives—and works—as a kind of

self-taught social worker, or missionary, in a shelter for the homeless. Again, as with "Silence," there appears to be a spiritual aspect to his estrangement from the family, in this odd choice for a middle-class son. His father was a professor of geology; his sister is now a lawyer, his brother a doctor. Kent's chosen community includes homeless people and the mentally disabled, like the woman, Marnie, whom he greets affectionately in the kitchen: "Sally noticed a change in his voice. A relaxation, honesty, perhaps a respect, different from the forced lightness he managed with her" (110). Even his meeting with Sally is inspired by his reading of his father's death, half a year earlier, and his wondering if he is entitled to any inheritance. In Christian terms, Kent could be considered the prodigal son, and in their tense encounter, Sally quotes Jesus's rebuke to his mother, Mary, "Woman what have I to do with thee?" (John 2:4).

However, this story begins much further back, when the family is young—his sister is still a nursing baby—and on a family picnic. Yet because their father, Alex, is a geologist, their picnic spot, Osler Bluff, is also the site of his latest published research. The title, "Deep-Holes," is taken from the warning sign that greets them as they arrive at the parking lot; the grammatical oddity, noted pedantically by Sally, is preserved by Munro in the title as if to both mock human error and create a new portmanteau word, linking depth with absence, or the reality of an unfathomable loss. Theorist Jessica Benjamin's concept of "intersubjectivity" may be helpful here, as she argues that contrary to popular conception, the infant-mother bond is a reciprocal one and that the infant and mother are deeply connected in a wordless space where they "actively engage and make [themselves] known in relation to the other" (18). Patriarchal Alex objects to his wife's continued nursing and her casual naked breast. An Oedipal tension then appears to be raised with nine-year-old Kent, who comments on the sight with "Glug glug I'm thirsty too" (95). In fact, the dangerous "deep holes" themselves, some coffin sized, suggest womb and tomb imagery. It is into one of the deep holes that Kent falls, after running off to urinate, as if seeking his way back to the womb. Hauled up out of the crevasse by his father and heaved to an exhausted Sally, this event mimics a rough chthonic birth. Later, in his one written communication after he disappears, Kent refers to this as a "near-death experience, which had given him an extra awareness, and for this he must be forever grateful to his father

who had lifted him back into the world and his mother who had lovingly received him there" (102). Kent survives with both legs broken, leaving him with a permanent limp. The doctor blames Sally, as he scolds her: "Kids have to be watched every minute in there." She shrugs off his words and instead focuses on the "miracle" of Kent's survival, a telling word. The focalizing narrator reports "her gratitude—to God, whom she did not believe in, and Alex whom she did—was so immense that she resented nothing" (99). Even as a child, Kent frequently thanks his father, calling him "hero," embarrassing Alex. Alex himself shrugs off any special significance of this rescue to their relationship, saying *"Christ, I'd have saved anybody"* (my emphasis, 100)—a telling expletive here? Kent will later rename himself "Jonah," at the shelter (rather than the more obvious Lazarus) as if in recognition of a Biblical rescue from the depths.

After the accident, as Kent spends time at home recovering, mother and son in fact bond in imagination against the stern man of science that Alex seems to be. Sally involves Kent in her quest for undiscovered islands (again, preinternet and GIS mapping), "never telling Alex what they were doing" (99). Mapping is a key motif in Munro, as critics have noted. Coral Ann Howells refers to "alternative worlds [that] are positioned alongside in the same geographical and fictional space.... These stories make readers see that there is always something else which is out there unmapped, still 'floating around loose,' or partially figured in myths and fantasy" 95). Indeed, Kent's disappearance as a university student may be seen as an attempt to become an islanded or shipwrecked outcast. His long letter sent to them after he quits both school and job suggests it is more important to "explore the whole world of inner and outer reality" as opposed to becoming locked up in a "suit of clothes of an engineer or a doctor or a geologist" (102). His father blames drugs and also suggests that he is rejecting relationships, which is not normal. Indeed, Alex's depiction of nine-year-old Kent's behaviour at the picnic as sneaking a peek at his mother's nursing breasts hints at sexual deviance. On that fateful day, Alex declares "Kent was a sneak and a trouble-maker and the possessor of a dirty mind" (96). Alex dies before he can remeet his son Kent/Jonah and perhaps mend their relationship. The reunion is left to mother and son, some fifteen years later. And again, like the indirect reunion with Penelope via Heather, it leaves more questions than answers, as the

story concludes with what I would call a "double-voiced" open ending.

Outside the vacant bank, after Kent greets her distantly but intimately as "Mom" (later, he will revert to using her name), he leads her to his home and workplace, while assuring her that despite his thin, run-down appearance (he once had malaria), he is not sick and does not have AIDS, a common concern of the time. In fact, he claims he is now "neuter," uninterested in sex or relationships, as his father had once told Sally (102). After showing his affection for mentally disabled Marnie, Kent then leads her to his monklike sanctum of broken furniture. As she absorbs his minimalist lifestyle, of begging and living on the margins, their conversation turns to sparring as he appears to try to convert her to his way of thinking. Addressing his earlier letter, he now rejects it and his earlier self as "crap," insisting that instead of "spirituality" or "intellectuality," there is not "any inside stuff, Sally." (113). This is apparently what he means by "living in the present," as he told his sister he was trying to do. And he now confronts his mother with, "Don't you want a different life?" (114). Although he does not identify as Christian—or any other faith for that matter—Sally satirically puts herself in the Mary role, when she is pushed aside by her son the saviour, quoting from the New Testament. She has hit Kent/Jonah's Messiah complex. His resulting flare of temper ("Don't you get tired [of] being clever?" [114]) ends their encounter with no promise of another one, as he resists the comforting cliché: "Don't say 'We'll be in touch'" (114). Sally counters, with a wishful "maybe," and takes solace in the fact that he does not say no (or yes). On the long, lonely trip back to her home in the country, Sally wonders if she should try to placate him by partially responding to his request for money by writing "some sort of cheque ... not too big or too small." Still, she realizes, "He'll not stop despising her, of course" (115). Her bleak realization of this leaves her, like Juliet, still clinging to hope of communication with her own unanswered "maybe." The image of the fantasy island they once shared a passion for returns to her as she considers the alternative—that she will embrace a solitary old age, like others, "marooned on islands of their own choosing" (115).

Part of what makes Munro "master of the contemporary short story" are her open endings. "Deep-Holes," in fact, gives us two alternative endings, or two ruminations by the abandoned mother some time later. Separated on the page like two islands, the first is her

wistful consolation that she got through this long-awaited reunion "without its being an absolute disaster," but then undermining it with "It wasn't, was it?" (115). This is followed up by her clinging to that unanswered "maybe"—a deep hole in itself.

The second is her prophetic glance into the future where they do not meet again, where she could age into "somebody she didn't know yet." Sally's ultimate comfort comes from joining forces with "certain old people—marooned on islands of their own choosing, clear-sighted, content" (115). Like Kent/Jonah, she too can choose exile willingly. In both cases, the abandoned mother, Juliet and Sally, finds refuge in narratives of imagination—the Greek myth in Juliet's case, the fantasy of uncharted islands in Sally's—as some sort of resolution of their trauma and a recognition of the real possibility of lived maternal regret—if not in the becoming a mother, then in the rejection of that role by one's child and the rewards that should come with raising a child to adulthood.

Works Cited

Benjamin, Jessica. *The Bonds of Love: Psychoanalysis, Feminism, and the Problem of Domination.* Pantheon, 1988.

The Bible, King James Version. John 2:4. New Testament.

Bigot, Corinne. "Alice Munro's 'Silence': From the Politics of Silence to a Rhetoric of Silence." *Journal of the Short Story in English.* Spec. Issue: The Short Stories of Alice Munro, vol. 55, 2010, journals. openedition.org/jsse/1116. Accessed 18 Apr. 2022.

Hanson, Elaine Tuttle. *Mother Without Child: Contemporary Fiction and the Crisis of Motherhood.* University of California Press, 1997.

Herman, Judith. *Trauma and Recovery: The Aftermath of Violence: From Domestic Abuse to Political Terror.* Basic, 1992.

Howells, Coral Ann. *Alice Munro: Contemporary World Writers.* Manchester University Press, 1998.

Munro, Alice. "Deep-Holes." *Too Much Happiness.* McClelland and Stewart, 2009, pp. 93-115.

Munro, Alice. "Silence." *Runaway.* McClelland and Stewart, 2004, pp. 126-58.

Smythe, Karen E. *Figuring Grief: Gallant, Munro, and the Poetics of Elegy.*

McGill-Queen's University Press, 1992.

Staines, David. "Introduction." *The Cambridge Companion to Alice Munro*, edited by David Staines, Cambridge University Press, 2016, pp. 1-6.

Weiss, Allan. "Between Collection and Cycle: The Mini-Cycle." *Short Story*, vol. 17, no. 2, 2009, pp. 78-90.

Chapter 8

Love and Longing Buried under Silence and Strife

Jane Truro

The task of bringing up two intelligent and feisty daughters in Istanbul, even within a loving marriage, turns out to have surpassed my abilities. Both Willow and Heather are successful young women, but Willow never calls me, and I have not seen her for years. It seems that whatever a mother does, she is held accountable, whereas a father's faults are tolerated. Willow, now in her thirties, once told me that I don't listen. I replied that I do try to listen to her. "What about your father," I asked. "Him?" she said. "He never listens."

Although I was happy to bear two daughters as a young mother within five years of marriage and I loved my daughters as they grew within me, and still more when they were placed within my arms, my life has become a tale of grief. I am broken with helplessness, estranged from one of my daughters. I scarcely knew what I was getting myself into when I moved over a thousand miles away from my family in my early twenties to bring up my children in Istanbul without support. I am a loving mother and have always loved my daughters; my greatest fulfilment has been in experiencing the joy of interacting with their wonderful personalities, yet mothering has become the most daunting task of my life. Even here I can scarcely express myself freely, against the self-censorship that prevents a loving mother from critiquing her maternal tragedy. This chapter is an attempt to reflect on what went wrong in my loving family as mother of two powerfully exuberant daughters, focusing on the daughter who is self-estranged from me.

Although my marriage is successful, to the point that a friend once asked when I would write about my successful marriage, I find that my marriage also falls under judgment and the gavel as I ponder my maternal situation.

My narrative reflects the struggle mothers and daughters commonly experience, plus the difficulties of being a successful working mother while bringing up two daughters; these challenges are additionally exacerbated by a life straddled between Western and Eastern cultures, with negligible psychological partner support, as my husband assumed the role of material provider, while refusing to support me in my maternal role. My daughter Willow appears caught in an Electra syndrome of resentment against me, perceiving me as the powerful mother, even operating as "a domineering victim who manages to conceal her insecurity and yearning for motherly love beneath a great deal of noise [making] revenge on this detested mother her only goal in life" (Hendrika Freud 1).

What is the family heritage lying at the roots of my mother-daughter relationship? My own mother was tough yet emotionally repressed; she scarcely expressed her love for me or indeed for many other things. My weaker, affectionate father was unable to control my brother, of whose bullying my sister bore the brunt. I enjoyed interacting with father as daddy's girl, while I could never regard my mother as a role model. She was the proverbial doormat, overburdened for years with domestic chores; she returned to work in a part-time job beneath her capacity. She supported me and enabled me to achieve my dreams, including university study, which my father regarded as a luxury. She also supported me when I wished to marry a foreigner. But I undervalued this tenacious woman until her death, rebelling against her model of the "victim ... the unfree woman, the martyr," which I found unacceptable (Broe qtd. in Davidson and Broner, 219-220). Adrienne Rich quotes Lynn Sukenick in describing matrophobia as "the fear not of one's mother or of motherhood but of *becoming one's mother*" (Rich 235). I am afraid, Mother, that even as I discarded your status, I have succumbed to your female destiny.

My mother, like her mother before her, was often crushed by patriarchal restraints. My grandmother lost her teenage daughter tragically to scarlet fever and became bitter through the remainder of her life, under a domineering husband. My mother was a survivor, the

mistress of putting up with and making do. My father was traditional, holding the purse strings while attempting to assert authority; we used to tease him that Queen Victoria was dead. He beat me three times, returning once from work to administer what was surely mother's demand for punishment; her frustrated slapping was frequent and was then assumed normal. I recently recovered a piece of writing photo-copied from a book and placed in my diary when my daughters were young. Vividly apt at the time, it describes children's quarrelsomeness and shows two little girls pulling each other's hair while fighting over a doll. It states that "smacking is still inadvisable though difficult to avoid," indicating that it was not actually forbidden back in those days, whereas now it has become taboo. I was driven to smacking my children. Yet a mother's ability to manage her growing children while denied her own authority can be a daunting task.

I deeply sympathize with Sylvia Plath, yet my heart also goes out to Aurelia Plath, who has been blamed for her daughter's plight, especially by Sylvia herself. In her journals as well as through Esther, the protagonist of the semi-fictional *The Bell Jar*, Sylvia Plath declares that she hates her mother. Esther's therapist encourages her to express her hostility against her mother, applauding her when she dunks her mother's birthday roses in the bin, regarding this as a sign of liberation from the umbilical shackles of girlhood. Yet Aurelia supported her according to her own lights while enabling Sylvia to have the life she had lacked. She was there when knowledge of Ted Hughes's affair leaked through a phone call, as Sylvia furiously stoked a bonfire with her second novel, destroying the manuscript she had based on her love for Ted (Alexander 286). Aurelia witnessed her daughter's destruction by her husband's betrayal, as Sylvia lost her dream of family life while expressing herself through extraordinary poetry. Sylvia writes in her journals: "Why don't I feel she loves me? What do I expect by 'love' from her? What is it I don't get from her that makes me cry?" (Plath 448), admitting that her mother was a sad, pitiable old woman but not a witch.

On my children's paternal side, my husband Nuri's father was belligerent, his rages so terrifying that he scarcely needed to resort to violence. A scrupulously honest man, he had no experience of family life, never having known his father and losing his mother very young. My mother-in-law was given in marriage to this caring if severe

patriarch twelve years her senior at the tender age of twenty. Once he sent for his overcoat while working, but since he had locked her into the home for her security, she was unable to open the door, and she had to throw his coat from the window; he chopped to pieces a dress she had tailored, which he considered too attractive or too revealing. I once asked Nuri if he had never wanted to emulate his father, and he reposted that he could never wish to be like his father, even though rage has become his own automatic reaction under duress. His mother, under her husband's fierce grip, exerted an iron hand over her children. Nuri would be sent for a loaf of bread but become distracted by the boys playing football and join their game; hours later, he would return with his immaculate clothes muddied and dishevelled. On one occasion, his mother beat him with a leather belt, then put him to bed to hide the welts on his face, until his father spotted them, chastising his wife for daring to do such a thing. This beating became a family joke; despite his father's undermining this severe act of his mother, she exerted stringent authority over her children during the years he worked away from home. Forty years later, Nuri still follows all of the table manners and other rules she inculcated into him. But her model was a foreign one to me, which I could in no way emulate.

Mothers are still held accountable, even in these days when they need to juggle home duties with work and career. The clinical psychologist and psychoanalyst Bracha Ettinger suggests that the inevitable frustrations of life are always laid at the feet of the inadequate mother. Often the therapist, instead of bringing healing to such situations, may express hatred of the patient's mother because of her hatred for her own internal mother; Ettinger suggests this dreadful situation causes "God's womb to bleed" (127). She categorizes automatic mother-blame under three headings; the smothering or over-devotion of the devouring mother; maternal abandonment or negligence, and thirdly the apparently causeless yet inescapable "not-enoughness" of mother. The (female) subject so often "hates her first object mother/Other, fears her devouring tendencies and blames her for what [she] calls not-enoughness" (103). This "not-enoughness" gives the child a sense of abandonment, making them feel under protected. Adrienne Rich indicates these extremes in her own maternal guilt: "Am I doing what is right? Am I doing enough? Am I doing too much?" (223). In addition to the extremes of overinvolvement and distance, Ettinger's

third catch-all category implies that where there is no real cause for concern: "Semi-automatic mother-blaming and mother-hating is produced [whereby] a mother-monster readymade is offered to the patient qua the major 'cause' for almost any anxiety and psychic pain" (Ettinger 106). Thus, any problems of a growing child become reason to blame the available "mother-monster," who is unable to either protect her child, or arm her against every contingency in life.

My intention was to create a secure parental arch holding up the sky over my children, the image DH Lawrence uses in *The Rainbow*, which enables the young Anna to play safely underneath. My parents wrangled throughout my childhood, although I knew they loved me. When my daughters fought and tore at each other's hair, I wanted them to feel safe under the arch of our loving marriage. I also knew that they needed independence, unlike the children around me whom I saw as mollycoddled by their mothers. I wished them to grow up strong enough to assert their female rights in a patriarchal society. Nuri agreed that as the father of two daughters, he would have to become a feminist. Personable, friendly and charming, he exudes bonhomie while his sense of irony entails endless teasing and ragging, leaving his intent unclear. He enjoys putting people down, and then stating it was only a joke, although the joke is always directed against the other person in a compulsive power game. Highly reluctant to get involved when forced into a situation, he is a perfectionist, rigorously demanding the best while ruthlessly criticizing any lapses, even at times with physical force.

Halcyon Days

Against the opposition of both our families, Nuri and I married and created a home. Nuri resisted his mother's violent objections to me, loyally defending his marital choice of me against her complaints and tears. He insisted that now we were married, she would have to accept this situation as given; he has never been amenable to tears. Our position with my in-laws stabilized when I bore Willow within two years; we were a loving couple struggling to create our life together. Willow was a cheerful, affectionate baby, and she enjoyed nursing, which was an exceptionally intimate experience for me; drawing milk from my nipples set off nerve cells and healing all the way to my

postpartum womb, affording me considerable sensual pleasure. I would have loved to breastfeed her more but was pressured to wean her at eleven months, probably from Nuri's womb envy or his perceiving breast feeding as animalistic. Phyllis Rackin describes the Latin inscription made on Anne Hathaway Shakespeare's grave by her daughters: "Thou, my mother, gave me life, thy breast and milk; alas! for such great bounty to me I shall give thee a tomb" (38); at a time when wet nursing was common, and "maternal breastfeeding was regarded as an extraordinary sign of devotion" (Greer 343). It was over too soon for Willow and me; when a colleague mentioned breastfeeding her two-year-old son each night, I grieved my loss.

As a young child, my in-laws wanted Willow to stay up late for their visits, whereas I felt I should put her to bed early. Despite being obese, or maybe because of it, my in-laws insisted on plying her with food, smuggling her biscuits immediately before lunch, going against all I knew about spoiling a child's appetite. My mother-in-law advised me to let Willow hold a biscuit at all times, another impossibly no-no situation for me. On one occasion, which my mother never forgot, we were pushing Willow along in her stroller behind my in-laws, after I had refused to allow her grandfather to ply Willow with chocolate, until he could no longer contain his fury. He stopped and yelled at me in the street: "Why won't you let me love my grandchild? Why can't I give her chocolate?" I was suitable cowed, if perhaps not entirely repentant.

Willow was such a gorgeous, beautiful baby, she attracted admirers on the street who would pinch her cheeks and cluck her under the chin. She did not take warmly to such indignities and would stretch out her fingers threateningly towards strangers' eyes. Reluctant to be enclosed, she once wrenched herself from my arms, terrifying me by falling onto the fortunately soft carpet. She was a confident and cheerful girl. At nine months, I held her in my arms on the balcony while she repeated the words: "come Dada, come," tossing off this perfect phrase while we waited for his return from work. Her amazing linguistic skills soon enabled her to recite a huge repertoire of nursery rhymes, which I recorded. At my father's retirement party, he asked his colleagues to sing "Little Bo Peep" for his special granddaughter living abroad. Besides her linguistic ability and her retentive memory, Willow also has a strong will of her own; an early expression or hers was "Don't want." She only needed to gasp when she woke at night, for me to be out of bed

and by her side. But if Nuri chanced to return without his key, I would never hear him even if he nearly banged the door down. Willow was soon bilingual, speaking both English and Turkish. She expressed her sense of being split between two cultures by drawings enemy planes flying against each other overhead.

I was heavily pregnant with my second child Heather, busy in the kitchen, when Willow lashed out at me, biting my leg sharply. A girl of two and a half, how could I reassure her about the new play fellow who would soon join her? Who could I turn to for advice? This incipient sibling rivalry, before the birth of the sister who would encroach on and threaten her supremacy, may have ousted her from her paradisal security of parental love. In "Among the Bumblebees," Plath describes a girl kicking her brother under the table, as she looks into the blue eyes of her father while mother takes away the bawling child (259-60). One day Willow announced at the table that she would marry Daddy. She later wrote in her memoir that every daughter needs to feel the special twinkle of love in her father's eye.

Willow stayed with her grandparents while I was in hospital for the birth of her sister, and from the next day, when I was discharged, I singlehandedly juggled the care of a tiny baby with a determined toddler. Shortly after Heather's birth, when I left the room to fetch something, my visiting sister informed me how Willow poked her fingers threateningly at the eyes of the plump new baby; neither of us knew how to deal with this tricky situation. A couple of times I fell ill from exhaustion, begging Nuri to take the children out while I lay sick in bed. He sat by me, helplessly asking me what he should do, as I told him to take them out somewhere. Soon he returned, together with my responsibilities.

I shared many wonderful times with my children; we read stories and played games together, enjoying outings and activities; books remained our favourite. As my daughters became literate, we read together; bedtime was a pleasantly relaxing ritual. Willow became a great reader and having remarked that I had read *Jane Eyre* at the age of seven, she soon emulated me, reading the entire book in a few weeks. She would sit in my arms while I read or on her bouncer while I managed the housework, while chatting and singing to her. She played at being teacher at the blackboard, she played catch with a ball, skipped, and learned to swing and to cycle.

We enjoyed films and music. When she was twenty, some visitors turned up to our home, and I put Mahler on the stereo and turned to her, asking, "Which one is it, Willow?" She replied, "First Symphony, Mummy." My friends were rather impressed by this interaction. At other times, staying for the summer with my parents and enjoying the peace and freedom of their garden, the respite it offered from life in a cramped flat transformed our life into Eden. Such balmy times of mutual support of my daughters in a natural environment has to me become paradise lost. There we enjoyed harmony: "All the sun long it was running, it was lovely ... it was air/ And playing, lovely and watery/ And fire green as grass" through those idyllic summers (Dylan Thomas's "Fern Hill").

Willow had barely started primary school when her teacher reported that she had stolen an eraser from another girl, and I thought I should discuss this with her. However, she refused to admit what she had done, or discuss it with me at all. She never spoke about this, nor did she ever steal anything again. Silence became her defence weapon. Like her Turkish friends, Willow took cram courses to enter a good school, and after the exam, we checked the entry lists of the local schools, finally locating her name on an excellent school's list. Both parents danced up and down on the pavement with jubilation as we tried to cuddle and congratulate Willow. But she backed away from us and refused to be embraced, unable to enjoy her achievement at all. Later that summer, though, she announced to a group of my students at the camp I was running that she was going to attend a prestigious college, superior to their own one. There is little doubt this was a reaction to the academic stress she had undergone.

Terrible Thirteen

"No I won't! Back off! Leave me alone." Willow's voice exploded into the quiet room, asserting her own rights and refusing to budge or consider my request to pick up her mug and take it to the kitchen. I looked from her over to her father, who was studiously lifting his newspaper in order to bury himself behind it, pretending to read with great application. His actions spoke louder than words: "I'm not here for you. Your problem with your insubordinate daughter is yours for you to deal with alone. It's not my job to back you or give you any

support." He remained totally deaf on this issue, never giving a modicum of support to me with the girls, however much I reasoned with him in private. The girls learned to play us against each other. His sister informed me early on that he will always play at being the good police, never putting himself in the position of the bad guy; she said that you will always end up as the bad cop, whereas he will remain the good and innocent policeman, the clean guy.

In my early years of teaching, after being driven out of the class in tears by my students' refusal to take a quiz, I had learned through trial by fire how to control their insubordination. But now I was unable to manage my own daughter's rebellion. I had taken it for granted that parents support each other; my father never betrayed my mother. He would simply say: "Do as your mother says." I asked for my husband's support, but he never offered me even the slightest support, and under his patriarchal force, I was never able to betray or denounce him publicly. Direct and outspoken in other situations, I found myself utterly unarmed in domesticity, trapped in a powerless love. My teenage daughters later made fun of me: "Mummy a feminist? Haha. That's a joke, look at the way she acts towards Daddy." In our home, I was proud to raise my daughters unaided, in an exhausting labour of love, hence effectively teaching them that childcare was an unremunerated, unvalued task. Years later, I shared my frustration with a friend, saying the children were always encouraged to finish their homework but never expected to give a hand with the chores. With a sigh she said that there is actually a lot of time while children are growing up, plenty of chance for kids to do chores besides their own homework.

Facing my thirteen-year-old daughter's refusal to perform a simple task, with my authority totally undermined, was a devastating experience for me. Exposed to her angry retort and her father's complete withdrawal from the situation, despite being an articulate person professionally, I found myself helpless and speechless. Barely able to contain my choking sobs, I stuffed my blouse into my mouth to prevent an explosion of tears, as I flung myself into the bedroom, pulling the door closed behind me to release my sobs. What to do? Where to turn? Who could I even talk to? I had no family available, few contacts, and not even a phone, in a foreign country. After struggling to calm myself, I drove over to a friend living twenty minutes away to share my story, as she listened and sympathized, patting my

hand. What could she do or advise? We were expat wives and teachers, married to nationals, and we knew that if anything happened to our marriage, the chances of taking our children out of the country were slender. I later observed her bruises, as she hinted at abuse, reporting that her husband threatened to pursue her and shoot her if she tried to leave him.

Meanwhile, my fights with Willow continued; I would feel relief when going to school, as a respite from my home struggles. I was taken seriously by my students, unlike at home. An endless procession of evenings and weekends loomed before me as I struggled to be heard and failed to cope with my daughter's insubordination. Once when I went to school crying in distress after a fight with her, a friend gave me a bear-hug embrace I have never forgotten. I was loved by Nuri, who even praised me as something of a mascot before the girls, which I disliked, as I felt that his favouring me harmed my relationship with them and caused their jealousy of me, diminishing me into his pet. I resented it then; looking back, I feel that I have been guilty of basking in his attention. Meanwhile, they longed for his indulgence while often experiencing his sharpness. Willow idealizes her father, yearning for him to express his love for her. Lacking the firmness to control my daughters, I aimed to be their friend, even as they felt my position to be the preferred one. As they grew up, I became subject to their taunting and even mummy bashing. When visiting them, they would often act distantly; they would exclude me or diminish me in their own homes, leaving me to return to Nuri, who despite his faults expressed his love for me.

During their teens, it took us ten hours of shared driving to reach our summer house. I would arrive exhausted, clean the house, and prepare three meals a day while Nuri brought home the shopping. When I suggested that teenage daughters could share this work, I found I was wasting effort on a lost battle. Sometimes I would try to calculate the hours I spent daily on housework, after my teaching job. In the early days of marriage, I managed on two gas rings, and we bought a dishwasher when Willow was in her teens. When they were babies, before the time of disposable nappies, I washed all their nappies, largely by hand, while undergoing chronic water shortages. Like my mother, I became a mistress of making do and putting up with. Years later, Willow's partner exclaimed to me that she had no idea how to scour an

oven, complaining: "I hold a mother accountable for this." But how could I answer him? Should I confess that Willow had refused point blank ever to do a scrap of housework? Or did I prefer not to rock their relationship? During their visits to us, mugs would proliferate until they covered every surface.

There was an incident in Margaret Drabble's *The Garrick Year* that haunted me for years. A husband and wife are both on the brink of having an affair. The wife takes her children to feed the ducks along with her male friend. Suddenly her daughter falls into the pond and is completely submerged under the water in an instant. The mother immediately throws herself into the water to rescue her daughter, after which they go off to change their clothes. At home with her husband, she informs him of the accident, and he asks his daughter what she had been doing. She replies, "Ducks" then yells, "water, water." She starts to get excited, and in order to calm her rising hysteria, both mother and father immediately cut in with the same remark, expressed in almost identical words: "What a clever girl, fancy going for a swim with your clothes on" (153). They thus demonstrate their mutual accord while offering their daughter moral support. For years, this parental solidarity over their child in crisis haunted me; this was the arch in the sky to which I had aspired but had clearly not managed to achieve. In this novel, there is no question of the father blaming the mother. Both remain focused on the welfare of their traumatized daughter as their primary parental concern. However, I knew for a certainty what would have happened to me. I would have been asked: How did she fall in? How come you were so close to the water? How carefully were you watching her?

In Turkey, things were evaluated differently. Even for a young child, education was supremely important, with homework taking precedence over everything. Nuri enforced academic control, backed by warnings: "Study hard! You don't want to be a toll collector, do you?" But doing something to help me, like picking up dishes or washing up, was not on the agenda. Instead, maternal behaviour was held up to scrutiny. In *Of Woman Born*, Rich describes a summer she spent without her husband, in which she and her sons fell into a comfortable rhythm of living without hours or restraints. While we were on holiday once, my husband was recalled to attend his father's funeral, leaving the girls with me, on vacation with my sister and her husband. For those few

days, my brother-in-law made a point of supporting me with the children in small but decisive ways, becoming a surrogate father for them. As soon as Nuri returned, the usual slackness of my attempts to cope with the girls and his failure to back me and his lack of support continued. He preferred to be a populist father; he even used me to crisis manage, making me call friends to find out why the girls were late home or making me fetch them home. There is an insidious threat within such patriarchal pressure; this is what you will do or you may leave. It is difficult to explain the grip of control I felt myself held beneath throughout so many years; now I can shout back, but then I was young, lonely, and vulnerable. During a particularly bad marital period once, I heard him laughing with our teenage daughters and decided that whatever happened, I would never desert my family or sever myself from them; I felt I stayed with them on his terms. We had determined that I had the domestic role of minister of the interior, with him in charge of foreign affairs. However, we largely lived in a state of anarchy while he remained the supreme and absolute authority and judge, in charge of law and asserting any order.

The school campus and garden afforded a safe place while the girls were growing up and was full of interested and concerned people. I once emerged from a meeting and panicked when I could not find my daughters, running across campus in search of them, until a friend reassured me that they would be safe. The girls underwent the usual childhood illnesses, but when Willow contracted scarlet fever just after being sick with chicken pox and mumps, I became distressed and wept as we bought her medicine. Living in a place where my in-laws taught me to be terrified of potentially rabid dogs, I found it stressful to be among street animals; the girls even had some precautionary rabies jabs. I would go to bed fearful after any encounters with suspicious animals. Years later, I realized that as the girls had grown up, my maternal fear of such strange animals had simply evaporated. As a teenager, Willow would compare me with her friends' mothers, finding me second best; one friend's mother was a doctor, whereas I was only a teacher; one mother was a better cook and one was more attractive. I just managed to score second best in her various categories.

Struggles and Silence

Willow's paternal grandmother was lauded as a devoted mother, and when I inquired into the nature of her vaunted maternal love, something I had always taken for granted, they told me that when the children went out, she would sit behind the window waiting many hours for their return. On one rare occasion, my sister-in-law gained permission to attend a friend's birthday party and was due to return by a certain hour. When the hour arrived, the cake had not been cut, but she left anyway, rushing back home to relieve her mother's hysterical weeping behind the window; she admitted that she never had the chance to attend another party. When I showed how appalled I was by these stories, they stopped trying to impress me with such accounts of her as a smothering mother, stealing her children's rights.

Willow was about fifteen when her grandmother took her into another room, from which she emerged to announce that her grandmother had told her that I was not a good person. "Oh," I said, "What did grandma say about me?" She replied, "I won't tell you what she said about you, nor will I ever forgive her." Thus, her grandmother insulted Willow's own mother while leaving Willow resentful of this treacherous intervention between us. Reflecting on this memory, I note how I failed to protest this gross blackening of my name before my own child; at the same time, I wonder how I might have attempted to defend myself against such an attack. I suspect such undermining remarks were repeated through the years. Willow's grandmother loved her according to her own lights, and she also stated that she loved me, despite her frequent needling remarks to me. She died after being sick and immobile for a dozen years, cared for by her daughter. My sister-in-law confided to me after her mother's death that she had ruined her life in various ways. She had not allowed her to go on holiday with her friends even once, despite her father granting her permission on one occasion; she had not allowed her to study at her chosen university. Willow, her favoured grandchild, wrote in her memoir that her grandmother was evil. Willow wanted to dedicate this memoir, which stated that her grandmother was evil, to her sister, and was angry when Heather refused. Heather later shared with me that accusing her grandmother of being evil was a heavy judgment to pass against a dead woman, now unable to defend herself, and she refused to have her name added to the book's dedication.

Willow was very young when she sharply informed me that she was writing a report of everything I did in her diary, warning me that she would expose my bad behaviour when she grew up. I regret not taking this threat seriously back then. Years later, I saw a couple of leaves from this journal; it comprised a commentary on the day's activities, with remarks about her sister being naughty and monopolizing my attention. In her published memoir she describes a mother who failed to lavish attention on her. Once during my parents' visit, Nuri returned home and scooped Heather up, saying, "Isn't she gorgeous," after we had struggled with her climbing into everything and distracting three adults all day long. His mother instructed me to settle all domestic problems before he returned at night. He was not a hands-on parent, unlike my father, who had sat on the floor with me reading, or playing ball with me in the garden. When I asked Nuri to play with his daughters, he replied that he would play with them when they grew up.

One summer, I drove the girls to the local pool daily for swimming lessons, and Willow was reasonably proficient by the time we went to the in-laws' summer house. We were enjoying the cool of a lovely afternoon on a beach with fine sand, which could treacherously shift place in minutes. The girls were playing in the shallows, when they suddenly cried out in alarm, finding themselves out of their depth. We quickly jumped into the water to rescue them, as I plunged in, assuming we would swim out to rescue them together. But Nuri lacked confidence to even attempt to help, and he remained in shallow water, leaving the crucial rescue of our daughters to me. I struck out with my appallingly slow breaststroke, finally reaching them as they were valiantly treading water. I had to rescue Heather first, as the younger, immature swimmer, leaving Willow bravely keeping afloat, but it was heart wrenching to turn back and leave her there alone, treading water far beyond her depth. I grasped Heather and struck back with her, swimming and supporting her with not exactly a life-saving grasp. Leaving her in the shallows with Nuri, I swam out to Willow again, as she waited for my return in deep water. It took me forever to reach her, grasp her, and swim back supporting her, as I swam, gasping and struggling, while she calmly struck out beside me. We waded out of the water and cuddled each other, sitting on the shore in relief and exhaustion, not saying much. The experience had been demanding, leaving little energy for discussion. Returning to the in-laws' house,

Nuri determined we would say nothing because of the consternation it would cause. Failing to verbalize this experience, or treasure it as a family memory, this benchmark of family life became lost to us. And after my sister-in-law had her own daughter, we were no longer invited to their summer house.

A girl guide myself, I loved camping, and I arranged camps for the junior high school children I taught, using this opportunity to enable my own children to enjoy this experience. Willow was entirely independent of me during camps, joining the older girls in their dorms, classes, nature walks, and theatrical activities. She later showed great dramatic ability in a Shakespearean comedy at school. When we visited her at another camp, we found her sitting alone on the terrace, scarcely even greeting us. Besides attending camps in various countries, she also enjoyed holidays with her friends.

Willow underwent considerable trauma when she heard of a disaster occurring to her favourite pop group. She catapulted herself into bed with me, bathed in tears. Her beloved group had suffered a terrible accident; one was in a coma, and one was dead. She was devastated. She lay there in bed with me for hours, until she had sobbed out her pain and distress while I cuddled her and stroked her hair. The story, which later turned out to be false, a cruel attempt to tease her, caused her considerable suffering, through which she turned to me for comfort.

When she returned from tennis camp, she confided to me that her roommate had gone out in the grounds to sleep with a boy; she was only thirteen at the time, and I had not anticipated the need to prepare her for such an occurrence at such a young age. This situation while away from home had clearly shocked her. When I returned to my academic studies, leaving the girls for the first time ever for two whole weeks, she gave me a tremendously affectionate parting, kissing and hugging me. On her fifteenth birthday, two friends helped her prepare snacks for the boys who would join them from their largely male class. I was rather impressed by the three girls with long hair around their shoulders, jeans, and t-shirts, with not a lick of makeup between the three of them, preparing to enjoy the afternoon with their friends. Her yearbook called her the lovely English princess: "Why does Willow come to school? To teach us English!" One of her friends bumped into me the other day, and after chatting, she asked me: "What has happened to change Willow, Aunt Jane?" I replied, "I truly wish I knew what has happened to her."

Downhill in Teens

We thought we had found the best way to bring up our daughters, between affording them many opportunities without spoiling them, yet things deteriorated into physical and verbal fights, screaming and hair-pulling. Their behaviour escalated out of control. One argument occurred when Willow picked up a chicken bone in her hands to gnaw at it, just before she was due to go for a year's exchange to the United States. Nuri shouted at her: "What will these people think if you go there eating chicken out of your hands?" Mealtimes deteriorated into fights. I pulled him aside after he had berated her for a misdemeanour, telling him he should not yell at her like that, but he remained adamant. I always assumed the girls knew themselves to be loved, but actually many things were being left unspoken in our increasing domestic chaos.

Willow would confide in me at times, and I believe that we bonded as mother and daughter, despite our frequent rifts. She was also clearly infuriated by me, distancing herself and not talking to me for long periods of time. I wondered whether our bickering would ever end. Friends reflected that a daughter returns to her mother when she has her own boyfriend, or when she leaves home, or when she marries, but this situation has never come. She had a steady boyfriend before university, and that summer, after her studious efforts to get into university, she would sit listlessly all day, waiting for him to return from work. They both took me out one day to confide that since they had been together physically, they would have to marry. I said that what they had done was by no means binding, and a decision to marry was an entirely separate issue. She stayed with him for several months. When she left him, he threatened not to let her go, following her abroad armed with a gun. She rang me to inform me she had had to climb over him sitting in her doorway, as she eventually managed to break free of him. Colleagues once asked me if I would tell my husband if either of the girls came to me with a serious problem, such as an unwanted pregnancy. I said, "No way; if they come to me, I will respect their privacy and deal with their problem to the best of my ability by myself."

After Willow gained a university place in England, we corresponded through the then new, instantaneous email, although there were also many times when relations between us became strained. She would ask me to buy packets of cheese to take back to school with her; if I came

back saying they only had three and not four packets, she would reproach me, shouting angrily, and leave home without saying goodbye, sending me to Coventry. After a week or so passed, I would be the one to relent and write to her; she would never approach me to make peace, once she determined not to talk to me. On graduating, she gave me a copy of Frank McCourt's *Angela's Ashes*, expressing her gratitude for my support and encouragement through her university years, the most enjoyable years of her life. During her graduation week, both her boyfriend and her closest girlfriend deserted her, and so her graduation celebration ended up as a diminished, family occasion, as she started job hunting on her own.

In a later heart-to-heart, she confided many issues to me; both girls had always complained to me that I was not fair, which I always felt to be an indication that I had not favoured either one of them against the other. But she clearly felt that she had often been blamed for her sister's misbehaviour. Of the many fights throughout those years, I remember my total inability to understand which one was guilty of whatever injury. But her major bone of contention was my being unable to protect her from her father. I confessed that she was absolutely right about that; I had not been able to save her from the shouting or the putdowns. I added that I felt I had been an abused mother myself. Yes, maybe, she said, but still...

Before she married in her thirties, we had a splendid day together in London, taking in an exhibition, walking along both sides of the Thames and chatting. She expressed how much she enjoyed visiting art exhibits and museums with me. She made several visits home to have her wedding dress fitted, but something had gone seriously wrong by the time of her marriage. I could scarcely reach her over the walls she had bult around herself. Some of her guests made no attempt to talk to Nuri and me, as if we had been blacklisted by her. An orphan friend who had stayed with us over New Year and hence knew us made no attempt to greet us; he only waved from a distance when I called out to him. Willow's perfectly nice American mom from her exchange year arrived; thus, she had two mothers at her wedding, which left me feeling dreadfully crushed. Willow clearly no longer wanted anything to do with us, preferring to spend time with her friends. Although grieved to be pushed aside on this special occasion, we accepted her marital status and respected her independence. However, only months

later we were grieving again, as she informed us that they were separating. She refused my offer to come over and talk to her. Her calls became fewer, although we did visit her new home. She received a call while we were there once, and I asked if it was by any chance her ex-husband Luke. She admitted it was, adding, "Are you psychic?" Not psychic, maybe just sympathetic. On another visit, her birthday cards declared that you can choose your friends but not your family—a clear message made.

At some point, she made up her mind that I was to blame for everything that had gone wrong in her life. She projected all responsibility onto me, including everything that had gone wrong with her marriage. We made an attempt to stabilize family security by establishing a trust, which Willow had actually suggested and been in favour of, but this backfired in a nasty way, leading to her withdrawing from any participation in or management of the trust. Whatever misunderstanding occurred through this issue appeared to be the final straw that broke our always precarious but also loving relationship, and she has refused to speak to me ever since. I am thus left grieving for my beloved daughter, whom I can neither reach nor even talk to. Sometimes I dream of her. Will she ever regret this rift between us? Will I be able to talk to her again before it is too late?

Works Cited

Alexander, Paul. *Rough Magic: A Biography of Sylvia Plath*. Da Capo Press, 1999.

Davidson, Cathy N., and E. M. Broner. *The Lost Tradition: Mothers and Daughters in Literature*. Frederick Ungar Publishing Co, 1980.

Drabble, Margaret. *The Garrick Year*. Penguin Books Ltd, 1964.

Ettinger, Bracha. "From Proto-Ethical Compassion to Responsibility: Besideness and the Three Primal Mother-Phantasies of Not-enoughness, Devouring and Abandonment." *Athena: Philosophical Studies*, vol. 2, 2007, pp. 100-45.

Freud, Hendrika, C. *Electra vs Oedipus: The Drama of the Mother-Daughter Relationship*. Translated by Marjolijn de Jager. Routledge, 2010.

Greer, Germaine. *Shakespeare's Wife*. Bloomsbury, 2007.

Lawrence, D. H. *The Rainbow.* Harmondsworth: Penguin Books Ltd, 1915.

Plath, Sylvia. *Johnny Panic and the Bible of Dreams.* London: Faber & Faber, 1979.

Plath, Sylvia. *The Journals of Sylvia Plath, 1950-1962.* Ed. Karen V. Kukil. London: Faber & Faber Limited, 2000.

Rackin, Phyllis. *Shakespeare and Women.* Oxford University Press, 2005.

Rich, Adrienne. *Of Woman Born: Motherhood as Experience and Institution.* Virago, 1976.

Chapter 9

My Mother's Story

Kanchan Tripathi

I have this recurring dream that comes to my mind at inconvenient times, mainly, when I feel sad about my mother. In the dream, I get informed by either police, or a doctor, or, more recently, my boyfriend that something bad has happened to her. In the dream, I don't find out what happens exactly, but it almost always ends in my mother telling me that she is sorry for not being a good mom to us, for abandoning my sister and me when she felt lost and confused, and she tells me repeatedly that she tried her best. I have woken up to this dream for what feels like a million times now and have felt it throughout my day. I have seen it flash over my eyes, like snapshots out of a movie on the days I am my most anxious. I only truly feel the effects of this dream becoming real right after I have had an argument with my mother.

My mom comes from a family of self-taught artists; her mother was a weaver and owned a sari factory in India. My aunt used to make these massive embroidery and oil-painted canvasses, and my uncles were the culinary artists of our family. My mom was trained to sing classically since she was young, and she is an amazing singer. When we used to live together, sometimes I would catch her alone, and she would be singing away in the kitchen, cooking and cleaning and washing and repeating. Even when she was doing something menial, my mom would be walking around, humming the melody of a 1980s Bollywood song that was stuck in her head that day. It was only a few years ago that I finally clued into the fact that my love for sound and music comes directly from my mother.

She has experienced quite a lot in her short forty-six years of life. As far as I was told by her family, she contracted polio when she was

young. Girls like her, the ones considered broken and untouchable for having disabilities, were sadly undervalued and never received the attention they desperately needed. She is the oldest of four children, the eldest daughter and was usually the last one to get her parents' love. Why? I hate to think this, now that both my maternal grandparents have died, but they did not teach my mother to love and value herself. They didn't teach her that she was perfect the way she was or that her disability did not define her, nor did they instill in her that she deserved all chances life had to offer, such as education, self-sufficiency, and a loving, caring life partner.

My Mother's Marriage

My parents' marriage was an arranged marriage. Someone in my family's circle referred my dad who was completing his engineering degree in a nearby village as suitable to my grandparents. Because of my mother's disability, her family decided this was the best marriage proposal she was going to receive, and so within a few weeks, my parents married. As the culture in India would have it, she went to live in the same house as my father, along with his father and two brothers. Her mother-in-law had died when my father was young, and female independence was not really a thought for my dad's family, so it was no surprise when my mom was handed more roles than just that of a wife. She became the cook, cleaner, and maid, and all the men in the house made sexual advances towards her. I do not even consider them family, for being so disrespectful to my mother. Although she was spared from any physical abuse the effects of this emotional abuse were insurmountable.

My mother gave birth to me at nineteen, eleven months after getting married. Her life changed drastically in a matter of months and in more ways than one. My dad was not abusive towards my mom right away; it took a while for the anger and frustrations to build up for him before he hit my mom for the first time. My mom kept this private business and did not complain or ask for help in their marriage

I remember the first story I was told about my mother. Apparently when I was a year old, my house dog bit me on my face. According to my aunt, my mom did not stand up and run over to me as you would expect a mother to do. I distinctly remember sitting on the bed in my

grandmother's family room, with the air conditioning unit fan spinning round and round, using the water in the tank as a way of cooling down the hot Indian summer—when my aunt told me this story. I have the scar on my left eye to prove that I was bitten, but the most hurtful thing about that story was knowing that my pain did not affect my mother long enough for her to pry her eyes away from the television and come look after me. I do not know how much of this story is factual, but to this day, I have not been able to forget it, and especially not how it made me feel as a child.

I do not think my mom was able to connect with me when I was born. I spent my teenage years craving her love and attention. However, I now understand that she could not leave her marriage. In my culture, and especially in the early 1990s, it was not socially acceptable for a woman to ask for a divorce, even when it was to escape a physically abusive husband. When you got married and had kids with someone, you were stuck with them for life. It was an unspoken rule in my culture that it was better to have a husband that hit you than to try and raise your children alone.

When my mother became pregnant with me, she had no clue what motherhood would look like and was not given a choice in becoming a mother. You get married and have kids—that was what she was supposed to do. She gave birth to me and learned as she went just like all the mothers were expected to. To figure it out, make it happen, juggle the balls. I know all kinds of mothers, and although I am not a mother yet, I swear to god there is nothing like the love of your mother. I have had surrogate moms, foster moms, friends' moms, acting moms, and "trying-to-be-my-mom" moms, but there is nothing in this world that is comparable to a mother's love for a child. I know that because I have always yearned for my mother's love. Even when I hated her, I wanted her to love and acknowledge me. As an adult, I still wanted her to worry about me and to care for me.

My Mother's Children

Before we immigrated to Canada, my mother lost a child—a son. The son my dad wanted as an heir to his name died after surviving fifteen days in an incubator. My mom did not have the healthiest of pregnancies, and the at-home labour did not help her situation. My brother,

who went to heaven unnamed, was born at home in the middle of the night, after my dad chose to ignore my mom pleading with him to take her to the hospital. She knew she was in labour, as she felt like something was wrong. My mom gave birth to her second child in her own bed, without the help of anyone. She told me this story when I was young and cried like I had never seen her cry before. She was angry at my father for not listening to her, but more so with herself for not standing up to him when the time came. She dealt with the loss of her child alone, with nothing but a bloodied blanket and an incision scar to remind her of her loss. My dad was not nearly as affected as my mother. He healed rather quickly, but my mom never got over it.

My first fight with my mom that I remember clearly was right after my sister was born. We used to live in a quiet, suburban neighbourhood, and my sister was still a newborn. I do not quite remember what the fight was about, but I remember being cornered into a cupboard, hoping to hide away while my mom stood angrily in front of me, crying. She was exhausted and hurt—deep-down-inside sad. I did not see it then, but I think that she was dealing with postpartum depression. Unfortunately, no one knew or supported her. She had moved to Canada only a few years earlier. She did not have anyone to talk to or rely on, and, worse, her husband was not kind to her. My mom was married to a man who took his frustrations out on her. He was not the kind of person who would ask her how her day was, or if she had something to eat today. He would, instead, come home and say mean and hurtful things and beat my mom. Not every day though, some days he was nice. Sometimes we got to pick-up takeout, as on the weekends, he worked at his side job and would bring home leftovers. But if the expectation was to have a supportive, loving husband who would take turns watching the kids, my dad was not the one.

My parents officially separated in 2010, and it was my father who took custody of my sister. This was after I had left the house and emancipated myself from my parents. I was not happy that they were divorcing, but the alternative was a life full of resentment, hatred, and a toxic home environment for my sister. My dad had a steady income. He could support my sister emotionally and psychologically and was far more invested in her wellbeing than my mother was. My mother needed to mother herself. She needed to figure out her life without the rules and rigid routines of being a wife and a mother. She had spent her

twenties taking care of a husband and a child, on top of absorbing the burden of anger, frustration, and abuse of all kinds from my father. She could not raise a child again; she was not educated. She had never held a job in her life, nor did she have the resilience to become self-sustaining herself. She felt ashamed to ask for help, to tell others she was struggling to raise her children. But more than anything, I don't think she wanted to repeat the last fifteen years of her life caring for a human being again. She wanted to live her life, for herself, and on her own terms. She did not want to be a mother anymore. If she had the choice to start over, I sincerely believe she would not have picked motherhood for herself.

My Mother's Choice

When I was in seventh grade, my teachers brought me into the vice principal's office and asked me if anyone had ever hurt me, my mother, or my sister in any way. They had reason to. I came to school with a bruise on my face, and I was petrified, but I did not hesitate to tell them the truth. I told them all about how angry my dad would get when I didn't get an A on a test or when dinner was not what he wanted it to be, and how he would call my mom "fat" or "a cow" when she was about to eat her meal. I told them that my mother had a physical disability and was a stay-at-home mom, and that my father was working two jobs just to cover the bills. I think the teachers could tell we were new immigrants and that this kind of stuff happened in my culture a lot. Before I could stop myself, I told them about that morning, when my dad took away my mom's keys, left her in their bedroom with my sister, and blatantly told me that he was going to kill them both while I was at school. But what happened next was something even I could not have predicted.

My mother denied my story. When the officers came to see her at the house and take her to the station, she flat out told them that everything was okay and that I was making all of it up. It was not until one of the officers took a walk around our disheveled house that he realized that I was telling the truth and not everything was as okay as my mom said it was. Finding out that my mom tried to protect my dad over me felt like a betrayal and was heartbreaking. I used to stand in front of my mother when my dad would try and hit her with hangers

and belts. I used to do the laundry, clean the house, and watch my sister whenever I could to help my mom, in an effort save her from my dad's wrath. I would lie to my dad and steal from him for her and beg for him to hit me instead of her, yet here I was asking my mom to return the favour, and she chose not to. Was I braver than her? Was I stronger than her in some way for speaking out and putting up a fight against domestic violence and fear? How far would I have to go to prove my love and loyalty to my mother before she would turn around and do the same for me?

I remember the day I slit my wrists in front of my mom. It was the day I came home from camp, home to the same fight that I had had on the day I left. At that point, my dad had not been living with us for several months, and I was busy being a teenager, caught in a whirlwind of trauma and confusion. My mom was asking me why I was never home. She was wanting to know why I refused to stay home and help take care of my little sister. I told her I wanted to hang out with my friends and reminded her that there was a bottle of Merlot in the cupboard for her to chill out with. She got mad. We argued, and then I asked what I thought was a simple question to answer: "Do you love me?" I just wanted to know if she cared about me at all. Was she even aware of how much I feared my father? Did she realize the effects his anger and frustration were having on me? Did she even notice that her wanting to bring my dad back into the house was by far the most frightening thing I had heard thus far in my life? I was asking my mother to choose me, as I had chosen her. I was asking her to fight for me, as I had fought so hard for her.

While I was in foster care, I used to take the bus on the weekends to go and see my mom for a few hours. Sometimes I would not go for weeks, and then I would get a call from her saying that she missed me and she was sad that we were not living together anymore. She would say all the right things, which would fiercely tug at my heartstrings, so I would rush over to see her as soon as possible. After a while though, I started to dread going to the other side of town to visit her, and it was not the hour-long commute that made me feel that way. Whenever I would go see her, I would leave feeling sad and worthless. Even when my mom lived in a shelter close by, I did not have the strength within me to offer her my place to stay at. I wanted to take care of her, but I knew that if we lived together, we were bound to butt heads every

single day. Mind you, I had not been in therapy for long enough for me to build up my emotional tools and defend myself, so it was the easier choice for me to love her from afar.

Honestly, I was not aware of my anxieties and triggers back then, but if I were to guess now, my cutting, overeating, and depressive state were brought on by those visits. The visits when I would travel over an hour to go see her and bring her food and medications for her insomnia, yet she could not be bothered to ask me how I was doing, were difficult and detrimental to my mental health. She would forget my name and ignore me while I was there, as if I were nonexistent to her. She would tell me the same pointless, repetitive stories that I had heard in the past to try and start a conversation with me, but that would only leave me feeling more frustrated, annoyed, and sad. Oftentimes, we were not really talking to each other, just at each other. I would huff and puff and storm out of her place, yelling profanities and walk home, sobbing hysterically, snot and all. I did not know how to talk to my own mother, and I certainly did not understand her. I was not sure what I had done so wrong to be treated this way.

It was not until I was in my teens that I heard my mom tell me for the first time "I wish I never had you" and "I should've aborted you when I had the chance." I know now that she was battling with her own stuff, but as a kid, I felt like my mom did not love me and that she wished I had never existed. This inevitably resulted in years that followed with me dealing with suicidal tendencies and self-loathing. I have been resenting my life and being alive for years, thanks to my mother. I believed her when she told me she did not want to become a mother, pretty much my entire adolescence. Whenever life would get hard, or I could not see through the dark clouds in my head, I would try to give her what she wanted by undoing her regret. I was not sure if she was saying these things to purposefully hurt me, or if she truly believed what she was saying. If she really did believe it, that would explain why she could not care for me, even though it would be the harder pill for me to swallow.

For years, my depression was a part of me. Sometimes it still is. I spent years trying to end my life, destroying my body and sabotaging myself in more ways than I knew were possible. I slept with strangers to feel love and tried to spend my money on so-called friends to buy their loyalty, in an effort to get them to stay in my life, and I had serious

trouble understanding my worth as a person. I mean if my mother was saying she wished I were never born, then nothing could possibly help me to believe my life had an ultimate purpose. It took several years of going to counselling, PTSD therapy, talking in group sessions and journaling through my tears for me to understand that motherhood is really a reflection of oneself in their children. Motherhood is truly about sacrifices and selflessness, and the way in which a woman is raised is the foundation of the kind of mother she will become. My mother tried her best despite her trials; however, it was not within anyone's control to undo the damage done to her for my mother to break the cycle of hurt for her children.

My Mother's Guilt

Now imagine a woman who did the whole police investigation, lived without her husband for almost a year, and then decided that being a single mother was the harder choice. My mom allowed my father to come back home. The restraining order was lifted, charges were dropped, and my dad was given full access to the house and allowed to come home. Just the thought of having to live in the same house as my dad made me sick. I could not do that. I was the one who did this to him. I told someone about what was going on at home. I was in the house when he got handcuffed. How could I live in the same house with him, knowing him and his temper, knowing there was a great possibility he could take it back out on me and punish me for ruining his life? No thanks. I was out. I had a social worker assigned to my case after the arrest, so during a meeting, I told her I did not feel safe living in the house with him. I knew I would go back to being the girl with no friends, no plans, and no control over my life. I had to leave while I could. Some of the parents of my friends offered to take me in, but no one was like the foster mom that I got. She helped me to love my mother through the rough times and taught me to love her despite her flaws. If it had not been for my second mother, I do not know if I would have allowed myself to forgive my mother for her actions or survive the weight of her words.

Even to this day, a part of me wants to send my mom money whenever she asks for it and make sure she's eating on a weekly basis because I don't want to lose my mother to her own guilt—the guilt of

letting me leave to go live with another family, the guilt of not choosing to mother her youngest child, or the guilt she lives with daily for not being the kind of mother she knows she was capable of being. She did the best she could. I told myself this when I tried to figure out why she did not have the strength to try and give her children the best life possible, regardless of how hard it would have been to do so. It took a few years of counselling and therapy for me to accept that she only did what she could, and it was not her fault that she was not given the tools and resources to do better than she knew how.

I have seen myself repeat the patterns of my relationship with my mother with my boyfriend, who happens to be the best thing that has happened to my life. He is kind, gentle, and caring; he would never do anything deliberate to hurt me. But when I fight with him, I threaten to leave him. For the first year of our relationship, I was repeating and reliving my relationship with my mother with him. Every time we would fight, or he would say something to me that I didn't like or something that hurt my feelings, I wanted to feel like I had the upper hand in the relationship, just like I did so in my relationship with my mother. I could not risk her choosing over me again. She could not leave me, not again, because I would self-sabotage myself and be the one that left first. I had left my mother already; I could do it again with someone else, I thought.

My Little Sister

The days of my sister seeking the love of our mother are long gone. When she was still young, she would visit my mother on the weekends right after my parents separated and would leave my mom's place feeling sad, ignored, and lonely. My sister, who is about to become an adult now, is smart, funny, and outgoing as hell. As a child, she felt like our mother did not even notice her, even while the two of them would be sitting in the same room together. My mom would beg for her to come over and see her and order food for my sister, settle in, and watch the show she was watching before my sister got there. My mom wanted to do what she felt like doing, much like a single person would. My sister would eat her dinner alone, sitting in silence, and this was before she had electronics, so there was no other way for her to distract herself from feeling sad and confused. My mom could not have a conversation

with her little girl about how she was, how school was going—regular things a mother should be asking their child. My mom, instead, would have a short fuse with my sister and get frustrated with her quickly. Almost always, it was not that my sister had done anything wrong; she just happened to be caught in the line of fire, and my mom often used my sister, a six-year-old child, as her emotional dumping ground.

Caring for your children, doting on their little achievements and expressing how much you love them, is what I wished my mother had done with my sister. I wish my mom had spent more time healing through motherhood than healing from it. I really wish my sister would have known a loving mom instead of one that resented her. How do I explain to a young child that the reason why her mother cannot play with her or read with her is because her mom feels broken and undone inside? How do you explain to your little sister that mom's self-esteem is shattered, that she is struggling with her emotions and that has been, long before she was born? How do you tell her about how mental health works in an adult that has been through too much in a short amount of time? How do you tell her that the reason she does not know how to love her children is because she never learned how to love herself or her children the right way?

I know mothers who have full-time jobs and still make the time to talk with their children in a loving, supportive manner. I know mothers who have been through hell and come back to be better mothers to their children. I know so many moms that garner the strength to carry on and move forwards through the tough times in their lives for and because of their children. It was not as if we were wanting our mom to buy us things and help us with our homework; we just wanted her to be attentive to us and to care about us. She did not know how to be a good mother to us because she never really got to be mothered right herself. She was only repeating behaviour she knew: feed your child, make sure they are breathing, and ask them to help you out with chores. It was not my mother's fault that she couldn't be better for my sister, or me, but what followed were years of my baby sister feeling unloved and unworthy by a mother who chose to love herself over her own daughter. It was not wrong of my mom to choose herself; she just did not know how to love herself and her children simultaneously.

I tried to mend the relationship between my mother and sister; god knows, I tried my best. I remember one time during one of my own

rough patches with depression, I called my mom and sister on a three-way call to try and find some clarity and understanding between what my sister was feeling and to give my mom a chance to explain her actions. I was sick and tired of hearing my mom complain about how my sister was distant or that my sister was playing the role of a secret agent and bringing back information to my dad for him to use against her. My sister told me on that call that my mom would yell at her when she got upset and would not make the effort to apologize to her for the hurt feelings. As a teenager, she could explain her feelings while my mother was convinced that my sister and me were pawns in a plot my father had concocted.

I thought my sister would come around in time, but now it has been over five years since my sister last spoke with my mom. She does not want to have a relationship with her and does not feel as if she is missing a maternal figure in her life, especially not one who has hurt her enough already. Because it took some time for me to start talking to my dad again, I figured all my sister needed was time and space until she felt ready to do so. My mom does not know that I am cordial with my dad though. I have told her that I do not talk to him, that I hate him, and that I want nothing to do with him. I do not actually want to build a relationship with him, but by telling her that I resent him, to her, I am on her side, not his.

Is it bad that I feel guilty for wishing him a happy birthday or taking his recipes? I do not go out of my way to talk to him because I do not want to. I do not need to. I have outgrown the need to have a father in my life. I am okay with it. My sister lives with my dad now, and she does not talk to my mom, nor does she plan on changing her mind about it. I keep my relationships with both separate now and try my best not to get stuck in the middle of something that neither of them wants to fix. Sometimes I feel as if I am on a teetertotter of familial relationships, and I am barely hanging on.

My Right to Choose Motherhood

When I had to terminate my pregnancy at sixteen, my mother was one of the last people to find out about it. She did not ask me anything about how it happened or how I was feeling. When I told my mother about my abortion, she shamed me for it. She said that I was dirty, that I was

being a slut, and that I did not care for anyone but myself. The first person I did tell was my social worker at the time, who respectfully asked me what I was feeling and what I thought would be the right decision to make for me. I told her I knew I was not ready to have a child at the time and especially not with a man eight years older than me, who was not faithful. I did not have a support system, did not think I could give my child the life every baby deserves, and did not want to have a family that was broken and unfinished. I wanted my mother to help me, and I knew she was not going to.

My mom felt strongly about me making my own decision on the matter, so much so that she openly discussed this information with her other mom friends, with no respect for my privacy. A friend of mine asked me about it at school because her mom had talked to her about it. A part of me believed my mom when she slut shamed me, but I knew deep down inside that I was not ready to be a mother, not a good mother. I could barely take care of myself, let alone a tiny human. I was still in school, was in an inappropriate relationship for my age, and absolutely did not think I could take on the role of a mother. In truth, I did not want to turn out like my mom and regret having a child after the fact. I was just regaining control of my own life, and I did not want to bring another human into this mess that I had been born into. It was clear to me that I was getting the chance to make a choice that my mother only wished she had. I was the one who would get to decide when and whether I would become a mother. I did not then and will not ever regret my decision for a second.

Forgiving My Mother

For the last six years, my mom has thought about my sister every waking moment. She still sends me paragraphs of loving words she only wishes she could tell my sister in person. She says that she regrets not caring for her kids better, for being selfish in her decisions, and for not choosing her youngest daughter over herself. I still get texts once a week from my mom, telling me to pass on her message to my sister and remind her that she loves her. I do not take for granted the second chance I got to know my mother. I got the opportunity to become friends with her in her forties when she was divorced, living alone and finally living her life on her own terms. I got to see her as a woman

who had to admit to herself that choosing her husband over one of her children did not result in the easier life. As time progressed, more of her own personality came to the surface, and she is now becoming the person she wanted to be.

And I cannot blame her for her decisions. She was brought up differently than I was. She did not live in the kind of society where parents share with one another on Facebook how tired they are because of their kids. She did not grow up in a country that understands the reality of mom guilt. She was not even aware that one chooses to become a mother, that it is not something every woman who gets married must do. I had to learn to forgive my mother a while ago. Keeping my distance from her, staying disappointed with her decisions, and feeding into my own guilt for playing the role I did was too much for me to live with. I learned to keep my mother at a healthy distance by being available for her but not caring as much as I used to.

Of course, I wanted to build my relationship with her, but you can only love someone so much before it suffocates them. For me, it was easier to forgive her on my own, and for myself, than to try and help her forgive herself. I would use every opportunity to tell her I loved her, remind her that she tried her best, and even though life sadly, did not turn out the way she thought it would, forgiveness is better than regret. By keeping her at arm's length, I was able to care about her, and this was the only way I could look past her errors and see her as a person. I really tried to put myself in her shoes, and see the situation from her perspective, which helped me to let go of my bitterness and resentment towards her. I tried to walk myself through the major stops of our relationship and understand how she must have been feeling at the time in an effort to gain some clarity about her choices from her lens, not through mine. It was this way that I could face my fear of abandonment and neglect, but not absorb the things my mother had said to me in the past. This was my way, the only one for me, to undo some of the damage done by the both of us, to each other. I needed to heal, to move on, and to not remain stuck in a conundrum of regret, hatred, and hurt. I needed to forgive my mother, so I could love her again. Even today, I check up on her once a week to save myself a mountain of guilt in the future and show her that compassion and empathy are free to give and priceless to receive.

I hope my sister can one day forgive my mother, too.

Section III
Reflections

Her Response
(To Frost's Question)

Victoria Bailey

I overheard a question and looked up to the moon

Waiting for an answer from the mothers of this earth

If all the soul-and-body scars that start in womb

Were ever too much to pay for his birth

Chapter 10

Pernicious Narratives of Maternal Regret: Adoption and Disability Chronicles That Coarsen and Corrupt Their Readers

Martha Satz

The mother in Doris Lessing's novel *The Fifth Child* labels her child Ben even in utero, as savage and the enemy. And upon his birth, his parents term him a "troll or a goblin" (49), "an alien" (50), a "Neanderthal baby," (52), and "a nasty little brute" (54). Indeed, members of his extended family respond similarly, his grandmother remarking, "He may be normal for what he is, but he is not normal for what we are" (65). As it unfolds, the novel confirms the parents' initial belief: Their fifth child, Ben, is a foreign, damaging force who ultimately will destroy the family. The novel is, of course, a work of fiction and, strictly speaking, does not even concern adoption, although the work suggests that the difference between Ben, the malignant fifth child, and the other children of the family lies in his strange and foreign genetic material. However, this novel is one among a number of works—adoption narratives, disability narratives, adoption disability narratives, and works of fiction—that create a topology with similar dynamics: An alien creature infiltrates the family through birth or adoption, threatening it and its members and remaining impervious to the civilizing and nurturing influences the family can

offer. These stories represent the site of maternal regret regarding particular children—children that for some reason the mother deems unacceptable. These works either explicitly or implicitly raise philosophical and public policy issues. How does one resolve an issue when the nurturing of one sick or damaged child threatens the wellbeing of other healthy children within the family? Are some children so flawed that they necessarily remain untouched by the love and nurturance of the family? Are some children's problems so intransigent that they are beyond the hope of remediation? And, most chillingly, are some children and human beings so deranged and damaged that they simply lie outside the sphere of the human community and thereby the ethical treatment such beings warrant? The present chapter will explore the adoption narrative, Ann Kimble Loux's *The Limits of Hope*, and Lessing's *The Fifth Child* . The investigation examines how the narratives present and frame issues of disability adoption, motherhood, and the more sweeping philosophical and public policy issues that flow from such narrations.

This exploration falls within a particular philosophical tradition, moral philosophy, and is influenced by the work of Iris Murdoch and Martha Nussbaum. In her well-known article "Flawed Crystals: James's *The Golden Bowl* and Literature as Moral Philosophy," Nussbaum argues that traditional discursive philosophy is too simplistic to either convey the essentials of the moral life or engage its readers in confronting its complexity. She argues that literature, because of its complexity, density, and unclarity paralleling human life, can entice readers to grapple with the intricacy, difficulty, and murkiness of ethical decisions in a way that more traditional discursive philosophy cannot. Nussbaum suggests that for some moral positions, only literature can make the relevant sort of argument. She offers as an example the case of James's *The Golden Bowl*:

> The claims that our loves and commitments are so related that infidelity and failure of response are more or less inevitable features even of the best examples of loving is a claim for which a philosophical text would have a hard time mounting a direct argument. It is only when . . . we study the loves and attentions of a finely responsive mind such as Maggie's, through all the contingent complexities of a tangled human life, that the force of these ideas begins to make itself felt. (Nussbaum 41)

There are other moral benefits according to Nussbaum of reading narratives. Two, in particular, suggest their importance for her argument that literature may constitute moral philosophy: 1) Reading narratives of certain types where the reader must tease out for herself the nature of certain situations, where there is ambiguity and uncertainty, and where there is a necessity for interpretation develops certain faculties in the reader akin to moral attentiveness; 2) Narratives work against our moral provincialism as well as against the moral opacity of others. For example, the reader may not be able to imagine what it is like to be a male, a Hopi, or a longshoreman. However, they may approximate this experience in reading a narrative and, as in experience itself, reading, say a first-person narration, may not be reducible to a set of statements. For example, the recent memoir *The Distance Between Us* by Reyna Grande tells the story of undocumented immigration from the perspective of the abandoned Mexican child whose parents have left, lured by the reputedly better life of the United States (US). The child narrator eventually follows her parents but suffers a good deal in the process. Anyone reading this memoir would find it difficult to maintain a two dimensional view of illegal immigration, yet the new view might not be reducible to an argument.

Clearly, there are objections to Nussbaum's position. In particular, regarding her second claim, that literature works against moral provincialism, a narrative told from the first-person perspective of an African American male, such as that of Richard Wright's *Native Son*, or from the perspective of an early nineteenth-century woman, as in a novel by Jane Austen, may be more or less authentic and accurate depending on the skill and knowledge of the author and narrator. And even such terms as "authentic" and "accurate" are problematic. Nevertheless, reading *Native Son* or *Sense and Sensibility* may introduce some aspects of the life of a Black man in America in the 1940s or a British woman of a particular class in the early nineteenth century.

However, let us provisionally accept some aspects of the view— namely, that some works of literature offer a moral position and grounds for that position even when that position may not be an argument or reducible to an argument but consists of the reading of the narrative itself, and the knowledge obtained may be nonpropositional knowledge. As an example of such an effect, consider *Dirty Details*, a narrative in which Marion Cohen, a caregiver for her husband,

chronicles her unrelenting days and obligations and her desperate thoughts throughout the day. In reading her account, most readers became overwhelmed, depressed, horrified, and moved to work to make certain changes in the experience of the caregiver. Yet, arguably, what the reader learns from reading her narrative cannot be reduced to a propositional argument; rather, the position comes from a simulacrum of experience. We may also provisionally accept the view that reading certain narratives may itself develop the trait of moral attentiveness.

Now if one accepts the views above, it is relevant to offer criticisms of narratives on the basis of their manner of portraying reality, persons, or characters and their presentation of caricatures and simplicity in lieu of manifesting complexity and ambivalence, thereby fostering moral callousness and insensitivity rather than moral attentiveness. I would like to level this very charge against the works I am considering. This chapter will critique Lessing's *The Fifth Child* and Loux's *Limits of Hope* on the grounds that they present reality and their adopted and disabled characters in such a way that contrary to the examples Nussbaum cites, they have a tendency to coarsen their readers, rather than refining them, and promote a view of the world and human beings that alleviates the burdens of difficult moral decisions, ceding them to public policy decisions. In particular, they render the complexities of motherhood in a simplistic fashion and magnify the justification for maternal regret along certain lines in an unbridled fashion.

Regarding *The Fifth Child*, in a *New York Times* interview, Lessing admits that it is an absolutely horrible book (Sinkler 6). However, she appears shocked at the responses the book has evoked, claiming that it is a mere thought experiment, a novel that poses a moral and psychological question: what would you do if you had a child like this? In the novel, the Lovatts, an affectionate and generous middle-class couple, believe in the joys of domesticity and open their warm and welcoming house to family and friends. They have four exemplary children and then produce Ben, " a monster," as their fifth child. He is different in appearance and has preternatural strength. He is apparently destructive; as a toddler, he kills a puppy and breaks his brother's arm. He appears to be unable to learn the usual things in the usual ways. When he is quite young, five or so, the extended family together with the father convince the mother to send Ben to an institution. She reluctantly agrees. Eventually, she retrieves him from that institution,

horrified when she ventures to visit him and learns that he is near death. Eventually, Ben ruins the family life of the Lovatts and the lives of the four other children. Lessing maintains that her novel is an amalgam of three things: first, her fascination with the legends of the little people, gnomes and goblins; second, an essay by the anthropologist and poet Loren Eisely who ventures that he has encountered a genetic throwback; and third, a letter in a women's magazine (Sinkler 6).

Eisely's work apparently deeply resonates with Lessing's creative impulses. In his essay, he talks of walking up from the seashore somewhere in Maine at dusk. He had been thinking about the Ice Age, and he looked up and saw a girl. He said to himself, "There is a Neanderthal girl. I went up to talk to her, and she had the flaring eyebrow ridges and a funny shape to the back of her head." (Sinkler 6). Eisely speculated that the gene could have come down through the centuries.

Lessing finds a quotidian, contemporary source for her work as well. In a woman's magazine, she spies a letter from a mother who writes: "I have had three normal children. And then I had a baby, a girl, who from the moment she was born was evil. My family was loving and close and now is ruined. She is vicious and spiteful and only wants to hurt other people" (Sinkler, 6).

Perhaps, with this list, Lessing is forthrightly acknowledging her sources, and perhaps she is intending her novel only as a thought experiment: "What would happen if... ?" But since she is an author who in the past has quite deliberately manipulated the reading public's perceptions and who has throughout the twentieth century taken on the most profound moral issues of the time, we, as readers, may be dubious about the author's account of her own circumscribed sources and purposes.[1]

Indeed, this novel strikes close to the bone; its mirroring of reality and its psychologically and ethically provocative nature are reflected by its effects on readers. For these reasons, this work has its curricular uses in addition to its strong psychological effects. For example, it has been deemed pedagogically useful, often appearing on the reading list of the genetic counselling program at Sarah Lawrence, one of the top such programs in the US, because it explores some of the psychological and phenomenological experiences of a family who have a child with

severe disabilities.[2] In particular, the mother, Harriet, feels guilty, for she, like many mothers, believes that she is responsible for the impairments of her child. Harriet's views are consistent with those of many in society, acknowledged or unacknowledged: Parents are responsible for the disabilities of their child. She attempts to love the child and to balance the child's needs with those of the rest of the family and struggles with the decision to institutionalize her child.

Let me also say that having taught this novel and lectured on it, this work often provokes intense responses from its readers. Primarily these responses come from two different sources—one from people who believe that in their own family, they are the "monster child," the one who is irredeemably other, unlovable, and the other from mothers who feel that they have rejected a child and failed to love them.

However, I think beyond the therapeutic and psychological issues in the text are a series of moral questions. Can we love what is ostensibly unlovable? Should we try to ameliorate what we know to be intransigent? Can we assent to the death of someone whom we know will destroy everything we value? Can we embrace what we know to be inalterably other? However, beyond the moral questions the work poses, writing the work itself constitutes a moral act—but in my view, a highly questionable one. For although Lessing views herself as perpetuating the mythology of goblins and trolls, in fact she employs a mythology more powerful in the contemporary scene—DNA—as the embodiment of a deterministic biology.

But let us discuss the work in more detail. Part of the book's fascination is the textual ambiguity concerning Ben. The explanation of his alien, monstrous nature hovers among a number of contradictory interpretations: 1) a hostile, psychological projection of primarily his mother, Harriet, and, secondarily, the rest of his extended family; 2) a child adversely affected by the massive amounts of teratogenic drugs taken by his mother during her pregnancy; and 3) a child with an actual genetic recessive disorder (a "genetic throwback" in Lessing's language), who thus can be regarded as a member of an alien species born into an upper middle-class family in England.

Indeed, in multiple ways—psychological, biological, and philosophical—we may acknowledge the Lovatts' role in creating Ben's monstrous existence. On the psychological plane, we could diagnose Ben with attachment disorder. If a baby is regarded prenatally as an

alien by his mother and the rest of his family, can he form a loving bond with them? As early as the fifth month of her pregnancy, Harriet thinks of the baby as the "enemy," a "savage thing with hooves and claws" (41). And when he is born, Harriet imagines him as a "creature who had been trying to hurt her" (49) and terms him a "troll or a goblin"(49), "an alien" (50), a "Neanderthal baby" (52), and "a nasty little brute" (54). Other members of the family respond similarly. As a result, one may argue that Harriet and other family members cause Ben's behaviour rather than respond to it.

A parallel argument may be made on the biological level. Harriet, exhausted at the time of her pregnancy with Ben, conceives of herself early in the pregnancy to be at war with the fetus and consequently takes massive doses of drugs to quell it, addressing the fetus, "Now you shut up or I'll take another pill" (42) Quite simply, Harriet's ingestion of drugs during her pregnancy could fully account for Ben's abnormalities. And more grandly and metaphysically, as in Greek tragedy, one may venture that the hubris of the Lovatts, the belief that they can form the perfect loving community and family, brings Ben into being as an oppositional element.

In fact, The Fifth Child owes much of its haunting quality to reading it as a dark tale of motherhood and family life as well as a modern parable of the ineluctable emergence of evil in the most optimistic and loving of environments. However, the former reading, largely dependent on the view that Harriet and the other members of the Lovatt family bear responsibility for Ben's oddity, eventually becomes less plausible— overwhelmed by the evidence in favour of Ben's actual alien status, a position solidified by its sequel Ben in the World. Taken together, the books confirm that Ben is of another species and thus pose the dilemma of our relation to the Other in its purest form.

And indeed at the moral and artistic centre of the book, as critics and Lessing herself attest, lies the scene in which the ethical dilemmas undergirding the book present themselves in their starkest form. Against all advice and her own self-interest, Harriet rescues Ben from the nightmarish institution where he was meant to die with the complicity of his family and the institution's officials. (81). By rescuing this creature, her son—whom she does not love, whom she knows will destroy her family, her way of life, and everything she values—she asserts the sheer value of life or, if one wishes, affirms the Kantian

categorical imperative: to treat each person as an end and not as a means. As she says to her husband upon her return: "All right, I am a criminal. But they were murdering him" (97). Yet disturbingly coupled with Harriet's affirmation of the absolute value of life is her apparent acceptance of the insuperable divisions not only among her natural and nonnatural children (for she distinguishes between Ben and her "real" children) but between classes of people. For when she returns home from the institution with Ben, she cedes his care to John, who was a "part of the group of young unemployed, who hung about on pavements, sat around in cafes, went to the cinema, rushed about on motorbikes or in borrowed cars" (92). And this group, as the narrative makes clear, constitutes his clan, the people with whom he naturally belongs, where he is for the first time happy. Ben further demonstrates the identity of his natural peers by becoming quite successful as an adolescent in his environment: "All these schools have a layer, like a sediment, of the uneducable, the unassimilable, the hopeless, who move up the school from class to class.... Ben had become one of these" (120). And these members of the underclass Harriet conflates with members of an alien species: "Harriet watched Ben with his followers and tried to imagine him among a group of his own kind, squatting in the mouth of a cave around roaring flames.... Ben's people were at home under the earth, she was sure, deep underground in black caverns lit by torches.... Probably those peculiar eyes of his were adapted for quite different conditions of light" (122). Ben and his friends live a chaotic life, disrupting and eventually destroying the Lovatts' home life.

In summary, Lessing has portrayed Ben as a member of an alien species whose being is radically incompatible with contemporary Western civilization. Despite all of Harriet's efforts at educating Ben, he cannot be rendered acceptably human. This vision as a literary fantasy is disturbing, but Lessing's linkage of Ben with both a person with disabilities and the underclass makes her portrait politically abhorrent and dangerous. And Lessing is fully aware of the connections she has created, commenting in an interview: "If I had had Ben born into some kind of slum or a place where there are many deprived and difficult children, there wouldn't be any dramatic effect. They probably wouldn't even notice either. So I had him born into this very comfortable, successful family, and then the mere fact that he was what he was wrecked it" (qtd in Kellerman 6).

The Fifth Child is presently more frightening in its implications than it was at its writing in 1988. Today science has completed the Human Genome Project, and although empirically there have been very few definitive links to specific traits, many in the culture are adopting a thoroughgoing determinism that links intelligence, personality traits, such as cheerfulness and shyness, propensities, such as religiosity, and character traits to genetics. As a cultural matter, these scientific developments are infiltrating popular culture, even influencing that everyday mainstay of family life, the parenting manual. There are intrinsic limits to parental intervention, this literature suggests" (Nelkin and Lindee, 143). In this regard. Ben's anomalous behaviour is constructed as genetic in the novel. And since he is linked to the underclass, we may infer that their behaviour and nature may also be attributable to genetics.

In the nature versus nurture debate, even though Lessing takes full account of this in *The Fifth Child*, her narrative quite strongly suggests that some people because of their natural endowment are outside the human family and by nature are antagonistic towards it. Not only are their cognitive traits woven into their DNA but their moral traits as well. This is so for the enigmatic Ben and also for all his friends who gather in the living room of the Lovatts, spreading their trash, eating take out, and destroying the Lovatts' home and by implication their society. Lessing in this narrative conflates persons with certain impairments with those incapable of morality, persons of the lower classes, and the alien; she also affirms genetic determinism. She may have philosophically approved the value of and respect for human life, but she has also suggested that such respect will lead to the demise of civilized values. She has rendered futile not only the treatment of persons with certain disabilities but also the amelioration of class separation. She has metaphysically certified the othering of certain human beings. Because Ben lacks interiority in the novel and because all the characters who can find no sympathy for him participate in such values as love, community, and nurturance, it is difficult not to share their perspective. No sympathetic character exercises any creativity in establishing contact with Ben. To yield to this narration closes off the possibility of thinking about certain kinds of moral inclusiveness and fatalistically to accept the moral estrangement of certain human beings. Lessing's narrative sanctifies and validates maternal regret in the

circumstance of certain disabled children.

Lessing's novel is, in a sense, a fiction about an unwitting adoption, a couple that inadvertently gives birth to a child genetically different from themselves. They and the narrative as a whole conceptualize him to be so radically different from the rest of their family that he is of a different race and inevitably will destroy that family and play havoc with the society around him. His genetic difference renders him disabled in the society in which he lives, and as the narrative suggests, he is unworthy of the moral privileges human status would ordinarily accord.

Lessing's novel forecloses a certain species of human being, thereby bolstering a certain species of maternal regret and, as I would claim, morally coarsens its reader. In a parallel manner, Anne Kimble Loux's adoption memoir, *The Limits of Hope: An Adoptive Mother's Story*, presents what would seem the persuasive evidence of her own experience. Within it, she writes her adoptive daughters out of moral existence. Even in the preface to her book, she dismisses their moral worth. She apparently tries to write something redemptive about them, but the most she can summon is this: "In our sorrows, as a friend told me, we are fortunate. Although Margey and Dawn [the fictional names given her adoptive daughters in the memoir] may have been my sorrows, they taught me to include whole other worlds in my judgments. They brought the gift of a complicated life" (Loux xii). It is astonishing that Loux terms her daughters her sorrows and reduces their contributions to her life as their addition of complexity.

As in *The Fifth Child*, Loux in *The Limits of Hope* tells the story of a loving intact family with three children who out of idealistic motivations decide to adopt two sisters, three and four, who have been in the foster-care system. From the beginning, the mother narrator, much like the mother in *The Fifth Child*, cannot bond with these children. Indeed, she and her husband finalize the adoption with much trepidation and many doubts. And after recounting the initial stages of the adoption, the book continues to recount the difficulties she and the family have with these two sisters, who cause the family innumerable problems and who radically differ from their three original and achieving children.

At this point, I have to admit my personal negative bias against Loux's book. I, too, many years ago adopted a child, nearly the age of

Loux's, a boy who had been in the foster-care system. But my experience differed from Loux's. To speak in shorthand, that child is now the dean of a law school. Of course, we all have our stories, and they differ. But Loux's memoir, she over and over again makes clear, means to be not just her story but paradigmatic, though of what is a moving target. It appears at times that she wishes her story to be a parable for adoption, at others for the adoption of children older than infancy, and at others for the adoption of children who have been abused and neglected. Oftentimes she carelessly conflates all of these. And thus her memoir seems to be a parable of the devastating effects adopting a child has on a normal family. She assumes that adopted children are different and worse than biological children and ignores the fact that biological children are often troublesome, disabled, or mentally ill. She states over and over again that the best solution for such potentially adoptable children is that the state raise them, ignoring the particularity of her own situation and the complicity she has in their psychological damage. In her narrative, she constitutes these children as the Other even before they come on the scene. She relates her conversation with the paediatrician who questions the wisdom of mixing children with radically different IQs, his assumption being that the biological children will have high IQs and the adopted children low ones.

When her adopted daughters are adolescents, Loux records this extraordinary conversation between her and one of her daughters who is inquiring about her sister:

"Mom, do you wish Margey was dead?"

"No. I wish she did a lot of things differently though."

"Would you miss her if she was dead?"

"Miss her? I have to think about that one. What do you think I should miss?"

"What would you miss about her if she was dead?"

"That's what I just asked you. For sure I would not miss being so angry with her. What do you think I should miss?"

...

"Mom, do you wish you hadn't adopted kids?"

"I don't know. A lot of the time I feel like my adopted kids need a different kind of mother."

...

"Are you glad you did it?"

"Glad we did it? What do you think? Why are you asking all this tonight? Can't you see how these questions are making me feel?" (Loux, 56-57)

It's hard to think of a more rejecting exchange, especially during the psychologically vulnerable time of adolescence, between a daughter and a mother revealing herself to be supremely egocentric And this exchange is typical of much interaction between the parents, especially the mother writer in this family and the adopted children. Thus, as in *The Fifth Child,* for the astute reader, it is difficult to determine whether the extreme problems these adopted girls experience in adolescence and young adulthood stem from their genetic inheritance and early childhood abusive experience or the evident early failed attachment of their parents to them. However, Loux's narrative attributes all their difficulties to their adoptive status, and often it is unclear whether in her view simply being adopted is responsible for their failure to be assimilated into the family or the particular early experience of these particular children or some poisonous combination of both.

Where many adoption narratives proceed in a triumphant direction, demonstrating the healing power of love, Loux's project seems to proceed in the opposite direction, demonstrating why children like the three- and four-year-old little girls the couple adopts should not be raised in families. Whereas *The Fifth Child* is fictional and may not be taken in a seriously evidentiary way by its readers, *Limits of Hope,* an allegedly truthful memoir, has the same narrative arc—extremely optimistic parents imbued with supreme self-confidence and abounding faith in the preeminent power of nurturance lose their sense of self, security, family, and basic beliefs when children come into their lives, children apparently impervious to love and every other facet of what they had hitherto deemed the most potent human tools of intervention. As in the novel, the family's other children, the original children, flee from their once happy family, enraged by the unnatural and monstrous encroachers. The narratives, like the parents within them, hunt for, circle around, and obsess over a multiplicity of explanatory factors in search of the cause of the shattering incomprehensible fact: Their child lies outside of the human realm, at least as they had previously understood it.

Both works conflate genetic difference, disability, and in one case literal adoption with incorrigible moral depravity and the power to destroy the family. They implicitly recommend that incorporating such

beings within the family will destroy the family unit and damage each individual family member. Rather than refining the reader's moral sensibilities and attentiveness, the works coarsen those faculties, encouraging the reader to think in generalities and stereotypes. They are harmful to the reader's moral sense and faculties. Rather than encouraging moral sensitivity and subtlety, like the works Nussbaum considers, they reinforce gross prejudice against disability, genetic difference, and adoption, and encourage careless reasoning.

Endnotes

1. Consider the episode of *The Diaries of Janie Somers,* which Lessing initially submitted and published under a pseudonym. In *The Golden Notebook,* Lessing considers issues of feminism, communism, and mental illness.

2. Personal correspondence with Carolyn Lieber, director, Genetic Counseling Program, Sarah Lawrence College, April 16, 2013.

Works Cited

Cohen, Marion. *Dirty Details.* Temple University Press, 1996.

Grande, Reyna. *The Distance Between Us.* Simon & Schuster, 2012.

Kellerman, Henryk. 1989. "The Fifth Child: An Interview with Doris Lessing." *Doris Lessing Newsletter,* vol. 13, no. 1, 1989, pp. 3-7.

Lessing, Doris. *The Fifth Child.* Vintage, 1988.

Loux, Ann Kimble. *The Limits of Hope: An Adoptive Mother's Story.* University of Virginia, 1997.

Murdoch, Iris. *The Sovereignty of Good.* Schocken, 1971.

Nelkin, Dorothy, and Susan Lindee. *The DNA Mystique: The Gene as a Cultural Icon.* W. H. Freeman & Co., 1995.

Nussbaum, Martha. 1983. "Flawed Crystals: James's *The Golden Bowl* and Literature as Moral Philosophy." *New Literary History,* vol. 15, pp. 25-50.

Rothstein, Mervyn. "The Painful Nurturing of Doris Lessing's *Fifth Child.*" *New York Times,* 14 June 1988, section C, p. 21.

Sinkler, Rebecca Pepper. "Goblins and Bad Girls" *New York Times Book Review,* 3 Apr. 1998, p. 6.

Chapter 11

Time Machine

Jessica Jennrich

No regrets. Right? My children and I are playing a game of questions given to them at Christmas by their grandparents. My daughter points to a question: "If you could tell your twenty-year-old-self anything what would it be?" The cheerful query produced a chill.

Where was I at twenty? Standing, stupid and soft, ready to be destroyed for the next twenty years by a force whose hands I held in partnership, in love and in marriage, in homes and in harmony, in states of this country, and in states of disgrace. Whose hands delivered blows of violence over my body that she claimed as her own. Whose tongue spit rage that forever became imprinted on my brain, leaving me a shell, tumbling, on her drunken, sickly shore. I was, at twenty years old, offering my hand to the woman who would spend an equal amount of years as I had lived, trying to pound my bones to dust.

So who wouldn't shout into that time travel vortex at their unbruised self to run the other way, to gather themselves the first time she struck out viciously and run into a future unmarked by cruelty and violence? Yet I look at my three children whose eyes saw me lie and say "It's okay" over and over and cannot see my life without these extensions of my arms. They are my three hearts beating outside my body. What do I know about regret? This is the best confession I have to offer, a rumination on regret from a woman still sitting on the fence, wanting to change the past but keep the future. What would I say to my twenty-year-old self? I regret nothing. I regret everything.

Regret is a reckoning. The letters splash on the ceiling where once I lay below, thinking I was breathing my last breaths as she strangled

me. That was the time I finally had enough and left for real, for good. Regret is circles in the sand where she drank liquor at the neighbourhood beach and called me names in front of neighbours. Regret is tackling our dog to wrestle a chunk of glass from his mouth before he might swallow it and the wounded look in his trusting eyes at my unexpectedly rough grasp. Regret is listening to my heartbeat for hours, hoping she won't notice I've slipped my phone into my sock that night. Regret is staring at my phone knowing I have no one to call, that she's gotten rid of every friend I've ever tried to make. Regret is lying for the first time, and later the twentieth time, to my kids, telling them I'm not crying, I'm just happy, or heard a sad song, or am about to sneeze. Regret is knowing they know I'm a liar.

Are they damaged from the life they lived of chaos, screaming, and violence? Yes, certainly. Do I wish them out of existence by asking the universe to do it all over again? I cannot. But wait. What if I could do it better, save her, get her help for her the sickness that made her prone to striking out? Could I become a person less enjoyable to strike? Ready to retread my body under the soles of her shoes, I think back to my years of logging her every move, trying to massage her mood with varying amounts of alcohol, medication, music, or mannerisms. What strange bargains I struck with myself! Time wasted begging the earth not to spin, documenting the marks on my body, and trying to make sense of vile words. I regret my time was not better spent.

What about that night she almost killed me? Not the first time or the second time. The last time. The best time. Best? Wait, I regret saying "best." I mean something else. I mean the time it worked, and I felt myself change into someone else while pinned under her rabid claws. The life the previous woman I sailed past, and I live now without her. Do I really know the meaning of the word regret? Do I know how to live without it? I regret not having said goodbye.

Sylvia Plath was right: Dying is an art. It seems like I keep doing it, although I can't say I do it exceptionally well:

And I a smiling woman.
I am only thirty.
And like the cat I have nine times to die.
This is Number Three.
What a trash
To annihilate each decade. (lines 42-43)

This death, I am sure, was my final one. I mark that day in March of 2019 as my death and rebirth. Of course, you lose things when you lose your life. Whether ended in hatred or ground down by the disappointment of sunken years and deflated dreams, the death of self should require some thought. I didn't get the luxury. I regret not taking more notice of her leaving.

I surrendered to the rush of blood beating in my ears, to the pounding of my heart, to the odd gurgle in my throat. Shrieking in my head but silent on the outside, I urged myself, as my head thudded onto the wooden floor, to think about something important. Don't waste this. The pressure of her hands around my throat was impossible to escape. My side was already sore from being tackled off the couch and having hit the wood planks at an angle that left me unable to find my feet, which squirmed helplessly under her weight. My eyes swum with black dots like bugs. "No, not bugs," I demanded, "Planets, stars, think about something beautiful," my inner self screamed while my bladder struggled and later failed to hold. I regret not speaking a word.

I find myself wondering, do stars hold gravity for the planets so that they don't spin away into the dark cold night? Are the dead pin pricks of light anchoring my feet to floor so the room can't slip away? My vision can't hold the scene. My heart can't hold the beat; the ceiling is a drum on endless repeat. Am I the star to her planet or she to mine? Who's orbiting who? Could all this rage be explained by some planetary misalignment; she wastes her gravity trying to pull me in an impossible direction? I regret not thinking of something better, finding myself always thinking, even in the end, about what made her capable of such hatred rather than what made me think I deserved it.

In that last push of air past my lips, I stared through her hate-filled eyes and did not surrender. Or rather I needed peace so badly that I was willing to go to war to get it. The clatter of my cell phone hitting the floor brought me back to life, and I made it out of her grasp, pushed her elbow off my chest, allowing her hands to loosen from my neck. I found a way to pound air back into my lungs and see the numbers of my keypad enough to punch 9-1-1. My eyes, bulged and bruised, stared at me later from the mirror; I began to assemble my time machine.

The police came, and it was awful. I regret telling them to take her to a hospital instead of jail. Allowing her to appear at my bedside like the ghost of Christmas past later that night, rattling pill bottles and

rustling blankets, she found her liquor gone and my heart a stone. Regret is always a phone call away it seems, as I watch myself decline her calls from earlier that night while I frantically packed every legal document to prepare to run and hide them in our minivan.

And later I had her removed by the court, and it was still awful. I regret having tried to safety plan before so that she wouldn't be on to me, all over me, always two steps ahead of me. So there wouldn't have been Jessica's death. Round four. Every decision, every step I took was examined. I was a specimen under a glass, a beetle trundling over paperwork, and every desk attendant looked at me like I'd come to lay eggs in the cracks of their home. I regret not going it alone but found the one person I couldn't lie to and accepted when they held out their hand. Who am I to turn away from fate, from love, now? Didn't I deserve one soft heart to soothe all these years magnetized by misery?

Don't think me naive. I knew I'd have to leave one day. Driving, snow blind, through the polar vortex just a few months prior, I had shuffled the kids in the car after feeling the lumps on my head deposited by the uncanny aim of a well flung book that struck blood on my scalp the night before. I returned only thirty minutes into the trip, unsure of where I was going exactly. My parents house four hours away? It was January, unfathomably cold. I was fighting a losing game with the frost encroaching on my windshield and looked fretfully into the backseat at my three kids, who all bore dark circles under their eyes, reflecting so many sleepless nights. Seeking asylum would have to wait for a plan of action.

I regret not calling my mother for help then and for proof, as later the court would ask who I told, and I would say no one. It was a secret. I lied about this for years. Sometimes directly, when confronted by a friend, a coworker, a police officer eyeing a perfect rectangle stamped into the wall the exact shape of my phone and the exact red hue of its case. "No officer, I don't need help. People just misunderstand." Once I lost a job. And certainly I've lost my dignity. Near the end, a worried expression crossed the forehead of a Verizon worker when I showed up with her attached to my elbow and a phone leaking toilet water, she having destroyed it the night before. "Do you need help ma'am?" the employee asked as his coworker distracted her with blinking new electronics. "No, no, it's fine" I assured the employee, the police, everyone. Till it wasn't fine anymore. I regret never telling the truth

back then, the million times I had the chance.

Yet somehow later, after the secret was out, I realized everyone knew. Destiny felt like a destination that night with my three children in the car, deciding I had to get out. Stretched on a fixed point of latitude and longitude, I can plot my decision. I'm not sure if I regret coming back home that night, to do anything else seemed impossible. My son plucked at the seatbelt in the back of the minivan that night, sighing. Was this him losing faith in me for good? Could we unfasten the past and upend our present? I regret all the unspoken glances between us. I wait now to hear everything they have to say.

Pain is radically private in that it is mine and one of the few things that belongs to only me. As my pain became public, fought out in courtrooms where her lawyer questioned the validity of the scars she put on my arms, from the colour to the shape, I went from person to evidence. I floated above myself in the court room and watched the letters swirl on the pages of a document that began its life as my journal, trying in desperation to figure out this person who spent each day intent on destruction. Destruction of me, of herself, of anything and anyone in her path. It's a document that illustrated the tiny window of my freedom receding day by day, until its desperate pages record the contraction from weeks of stability to days, then hours, and finally the only mere minutes of safety that I could buy between her rages. The original was filled with reminders. Don't forget to leave her a note in the morning; it keeps her happier during the day. Place iced coffee in the freezer for twenty minutes (any longer and it would freeze, and she wouldn't be able to drink it or make it out of bed at all). Given all of the shapes I bent myself into, I marvel that my brain didn't vacate in protest.

I lived so long afraid to breathe. I couldn't move an inch without feeling her breath on the back of my neck. Claustrophobic in my own body, my skin began to hurt in the places it couldn't make room for her. But those kids' lives were mine to protect. I couldn't make up for the past, but maybe I could demand that minivan transform to a time machine. I travelled through space and plucked each memory and moment I was willing to bring into the future, losing years in the process. No, an ordinary eraser wouldn't really do the trick. We needed the creativity to cultivate a safe and free future but without the for- getfulness. Funny, once she was finally gone, we didn't know how to be

free. We lived a cardboard cut-out life. It didn't translate to reality; it only functioned to keep her still and shiny. Once gone, we don't know how to eat, sleep, or choose so much as a favorite colour without her heavy hand. I regret not learning how to live.

When the fall comes without her, I see the leaves change colour for what feels like the first time. This is what people always cared so much about. They were right to marvel at the miracle of mother nature; she has a way with magic. I've just been on her bad side for the last twenty years or so. Lugging branches from our lawn where storms threw them, I kick up piles of leaves, letting them accumulate across the lawn. Once we were foes, I recall hiding in my bedroom listening to her wield a leaf blower like a weapon for hours after she had blackened my eye and torn my shirt and bra right off my flailing body due to a long-forgotten disagreement. This year I throw piles of leaves in the air like a child, mystifying our neighbours, and drink in their soggy maple scent. I regret every fall I spent behind her bars.

But things still hurt now. Imagine my surprise after being burned by a hot pan on the stove. I held my hand up in frustration at the red welt, wondering how everyone goes through life in such constant threat of injury. Scratches become unbearable, the discomfort of a waistband unfathomable. Who knew how much you could feel when there wasn't so much at stake? When being numb wasn't your constant state? I regret not learning how to feel. Or, really, I regret having to forget.

When we finally vacate the house where the worst of it occurred, it doesn't feel right. My new partner finds me folded in on myself, weeping, gesturing to where my bed once was, pointing across a dust filled carpet and sobbing for the self I would leave behind those doors. Nights when I couldn't sleep after she was gone, I would visit my grave on our living room floor. Lying there, I watch my chest rise and fall as my lips curl in a grin, a genuine thrill at having made it, despite everything, despite being so close. Now I snap a photograph of that peace of wooden floor and pack it into the time machine.

Riddled with anxiety, I bring the kids to the house, let them say goodbye to what they might consider their childhood home. I wonder if this should be meaningful. They walk through its empty rooms, recounting incidents of childhood trauma. Its her last cruel vivisection, this court-ordered bisection of our home, my retirement; she is collecting wealth to fund her court room war against me while I gather

scraps to rebuild a life for myself and the kids. But no matter, we escaped, and the house, defrocked of its ragged furniture and décor, allows every smashed door and bruised wall to be exposed under unfiltered light. It looks like a prison; every colour is dull, every light-bulb dim. I wish the home peace to its new owners as I shut the door for the last time. I regret not having freed us sooner; the locks are so fragile and easy to break, what a flimsy incarceration.

We live across from a cemetery now. I watch the mysterious ritual of mourners. I assign them conversations and personalities. The widow who visits her husband's grave with a large Labrador in tow. The stuffy families on weekends making small talk on the annual visit to Aunt Betty's grave. The old, the young, all united by death. I feel a kinship. But then came the first funeral. The first was definitely the hardest. Death is romantic until it's fresh. Now it isn't unusual to catch a private graveside service through the kitchen window while making the kids lunch. I send them silent prayers over toast crumbs, hoping to imbue my domestic ministrations with a somber, respectful, grace. I want my silent silhouette not to offend but rather to attend to their grief. I regret not mourning the self I lost. I harvest pieces of her and scatter them into my current self.

On some days that old self is too alive for me to bear. I watch her body inhabit mine sometimes as I dance away from my partner across our kitchen, triggered by the sound of a dropped pot. I see her reflected in my partner's hurt eyes as I back away from them in fear should we ever disagree. That former self likes to sleep like a boxer, fighting off an invisible force night after night. Maybe she's angry I put her to death, and that's why she makes me relive that last violent scene whenever slumber pulls me towards it. Mostly I let her come and go as she pleases.

I am greedy now. Building giant vegetable gardens, I am certain I can coax into a life based on nothing but desire. My skirt, longer than is practical for yard work, floats above my fields and my lawn and then glides over my forest. I collect caterpillars as they flutters over the paths my partner forged in the woods for me, for the kids, for us. Selfishly, I lick the word "mine" off my lips, smiling at the taste of this freedom in ownership. I reign over this kingdom now. I open up my arms and gather the sunlight in bunches and touch the tips of every vegetable and flower I placed in the ground, children at my side. I plant my feet wide

and steady in the dirt, sturdy in my desire for this and this and this.

Would my voice sound as good bouncing off the brick of our side porch where I sing most mornings, had I not been allowed to use it in the darkness of that frozen kitchen? Would it still taste like joy to dance with our dog and harmonize with pop singers in freedom had I known the terror of those drunken nights? The time machine doesn't answer; it doesn't have to. Only regret for what is lost can make what is found feel like this. Now I feel like I can be free.

Is anything still possible? Probably not, but something is. And after nothing for so long, something feels like everything.

Works Cited

Plath, Sylvia. *The Collected Poems.* HarperCollins, 2008.

From Mourning to Greeting: The Predicament and Possibilities of Maternal Regret

BettyAnn Martin and Michelann Parr

An Invitation: Exploring the Threshold between Experience and Research

Traditionally, women have been conditioned to understand motherhood as a meaningful experience but also as a heavy weight (Martin); we are regularly reminded of the physical toll of mothers' work, the taxing quality of the double day, and the emotional labour involved in women's experience of motherhood. What we rarely hear about, or anticipate, is the degree of inner work that is required to engage maternal experience in a way that brings it into alignment with our own evolving identities as mothers,[1] women, and writers who crave continued growth, enrichment, and inner peace.

As autoethnographers, we make no attempt to theorize regret but instead show how, when "our stories arrive at a place where actions are required," we deal with "the predicament" (Bochner and Ellis 86) of regret, at once seeking emotional truth out of experiences and making knowledge that we hope others can use. We come to know regret as the inner work of memory; a monster that claws inside; unmet societal and cultural expectations that linger in our minds; a dwelling place for love

of self and others; conscious engagement with self; and a space for healing and resonance.

No different than human existence, maternal regret is riddled with inconsistencies and contradictions—a predicament that occupies the hearts and minds of many mothers. How we reconcile the contradictions, how we accept the full catastrophe of the dilemma of being human, and how we dwell in that liminal space is a story we both imagine and author—it is that story you find here. "What to do becomes severed from what to think" and our active engagement with regret is required (Bochner and Ellis 94). As Mark Nepo writes:

Regret is like striking a large bell in an empty field and then running through the wild grass trying to gather the sound of the strike back into the bell. It's impossible. All that's possible is to strike the bell again, to have the new sound layer itself over the old. All the while, our heart only needs the open air and the life-force waiting in the next moment to revive itself.

Numerous conversations and over two hundred pages of transcribed text capture our months-long journey through a three-dimensional space of living, thinking, and feeling as we consciously strike the bell that is regret, lingering in the sound of each layer. Dwelling in its melodies and discordant notes, simultaneously mourning what is lost and celebrating what is found, our work blends discontinuous fragments of our conversations, found word poems (centred on the page), reflective echoes and resonance (in italics), and academic insights (referenced the traditional way). The blend of voices and perspectives is intended "to convey the fractured character of contemporary life, and to bend and blend genres. [These] stories pay homage to ambiguity and the messiness and incompleteness of life in forms that reveal lived experiences as both tragic and laughable" (Bochner and Ellis 84-85).

Engaging feelings of regret is often a solitary journey—through secrecy, deep pain, and even shame. We mark the solitary and often urgent nature of regret in the first person singular: the ethnographic "I" (Ellis, *Ethnographic*). We reserve the connected "we" for our moments of resonance, where we act as empathetic witnesses to each other's stories (Levine), signalling the role of community and the power of collaborative autoethnography as mitigated risk, shared vulnerability, self-therapy, and process that we hope others will find useful.

In our uncertain trajectory (Goldsmith), we come to realize that regret often seems like a stuck place, an endless loop of tired narratives that leave mothers mired in a longing to go back in time to make or unmake decisions. In our process, we move through regret and back to ourselves and each other in the present moment where we find a home place (hooks) of actionable engagement and accept the potential gifts of dealing with regret as our maternal mandate. We come to understand that although regret can be a dwelling place of introspection and mourning, it is also a place of greeting (Nepo) and a threshold where we meet possibility with empathy for others, for our children, for our mothers, but mostly for ourselves.

The Inner Work of Memory

As a mother, I understand regret differently, its hold and nuance. It lingers. It sticks in deep places, difficult to excise. Steeped in thoughts of past transgressions, accidental missteps, and retroactive miscalculations, I find myself thinking of my mother, of our past together, and how she might have processed moments of regret and its potentially debilitating companion—shame. I remember a tea party when I was no more than four; she was making a special moment for us. I sit anxiously awaiting my tea; it is delivered to me—piping hot—in a fine bone china cup with matching saucer. We didn't have a set of these, only a random assortment that my father, who managed a jewelry store, brought home when less popular patterns were discontinued. That day, I had the cup with purple pansies. My mother was busy gathering cookies and cubes of sugar. I remember her walking away from the table. In my impatience to be a big girl—to hold the cup and sip the tea—I impulsively grabbed the handle. As I peered into the tipped cup, the hot liquid cascaded down the front of my body. I remember screaming, a desperate flurry of activity, and a futile attempt to remove my favourite yellow shirt. I remember little after that. For weeks, I would wear thick bandages, and the doctor would make house calls; there were always cracker jacks on the day the bandages were removed. I know now that my mother would have felt so much guilt—and regret. *Why did I leave that cup there? Why did I turn my back? Why did I use boiling hot water for her tea? Why didn't I put it aside to cool?*
Through reflection, we become keenly aware of the power to re-

frame, revise, retell, resee, rewrite, and relive our stories and, at times, the fictions we carry. We recognize reality as a construct in which meaning is made and unmade, created and recreated, and we understand that the stories we tell are not static maps, mirrors, or reflections but instead are "fluid, co-constructed, meaning-centred performances achieved in the context of relationships and subject to negotiable frames of intelligibility that change over time" (Bochner and Ellis 94).

We accept that the forces of life are grounded in continual creation, maintenance, and destruction... and that in order to create, we must accept mourning and letting go of regrets, for ourselves and others. It is in these spaces that we find reconciliation, healing, and sometimes forgiveness.

In our willingness to be silent and still, we come to understand: "Nothing is good or bad, but thinking makes it so" (Shakespeare's Hamlet).

We commit to rebirth.

What Claws Inside

[There's] no real cure for regret. Undoing what you've done is not as simple as a pill-a-day habit to regulate your swinging moods. What lingers, lurks, and claws inside. Monsters in the dark, under the bed, and in the ceiling. (Henderson)

In the dark. [Regret] grows like a fungus and takes on extreme forms. (Landman 18)

> an abundance of unbreakable patterns: anger,
> disappointment, remorse, repentance
> crises of identity: under duress, in turmoil,
> dead in the water, catastrophe
> devastation: agony, suffering, pain, callousness, misery
> dis-ease: tears, tightness, claustrophobia

I fear that my children judge the choices I made so many years ago when I lacked the ability to see the future. I imagine their words from the future settling on my soul in the present; I hear editorializing and narrating of my past. I perceive loud and menacing voices that hold me

hostage to the idea that I am incapable of growth. I'm stuck in emotional backlash, self-castigation, and doubt.

I don't know how I got here...

My deepest regret is feeling invisible, unseen, unknown.

I have a "dark thirst that can't be quenched" (Nepo), and so I purge; but then I regret "obsessively recycling, replaying, and rehashing mistakes, losses, and misfortunes" (Landman 15). Perhaps someday, I will write a memoir.

Why are children allowed to embrace estrangement, but good mothers are expected to love until it hurts and beyond?

I play and project the movies (Piver) of our lives: Was it my responsibility? What decisions did I make that put us here? What did I do or not do, say or not say? How do I undo the die-is-cast phenomenon? Do they watch the same movies I do?

We think we are guaranteed outcomes, but we aren't. And we judge ourselves by what is unmet. In terms of investments of emotional labour, mothering isn't about deliverables.

I regret if there's something I did that's getting in their way, interfering with openness in this moment. I regret things that my younger self, my unknowing self, did. I regret how I continue to let my children shape the way I imagine myself to be. I regret how I allow my perception of their judgment to tether me. I regret feeling that my children aren't in my corner and that I feel like we are often growing through resistance rather than connection.

"Faith is about opening up and making room for even the most painful of experiences, the ones where we 'take apart the chord' of our suffering to find notes of horror, desolation, and piercing fear" (Salzberg 118).

I resist the whole idea of revisiting the past, the lost opportunities, the road not taken, thinking the grass is greener on the other side. "I regret fear and being afraid of making other people afraid, not of me— never of me—but by me" (Henderson). I regret if my children's experience of motherhood with its perceived commitments, sacrifices, and responsibilities shapes their perception of me as a person and their decision to have children of their own. I regret that my fear has become widespread and contagious.

Does passage of time and hindsight create a deeper sense of regret? Is regret a continuous and necessary process? Does it serve any positive purposes?

When tangled in regret, we can fall into a storm of urgency, as if our future depends on whether we can unravel some knot in our past. And the grip of regret keeps us from the immediacy of life around us. All the while, we continue to suffer through our fears: that we're not good enough, that we'll never find love, that we won't be able to face our suffering or endure the loss of those we love. (Nepo)

I thought I was doing my best and loving my children the best way I knew how. The present is so far from what I expected. I imagine their memories as evidence that I wasn't good enough, and I wonder if that is what is holding us back now.

Perhaps the problem is that I fear that I wasn't my best ... which prompts a feeling of inadequacy rooted in self-loathing ... which is far from the unconditional acceptance and love I offer my children. And this fear becomes a real threat to my maternal identity and authenticity—my in-the-moment presence.

I can't take it back. I can't undo it. It feels a whole lot like I am paying for the past in my present. I regret the balance of care and regret that keeps me here, but I don't regret loving my children unconditionally and reminding them: "I see you. I know who you are. I care about you. I respect where you're at, even when you choose not to engage."

If they ask, I can say, "I'm sorry. But that's the best I can do."

Maybe regret thrives when we give way to imbalance, when we lose our faith—our way—in bewailing what is dead and gone. The reality is we can't undo the knot; we don't have editing rights to the story that our children are constructing and reconstructing about their past, about us.

What good is a memoir if this story is already written.

In those moments of comedy and tragedy, I was human. I am human. *We are human.*

In tackling regret—the monster under the bed—we come to know its pain as a product of our imagination. Indeed, it is our imaginative capacity that keeps us focused on what might have been, or could have been, had we taken the ideal road (Davidai and Gilovich). Decisions take on the weight of past pain or future anxiety when we allow ourselves to believe that a different choice might have been warranted or a different outcome achieved. We find ourselves stuck somewhere between the past and the future in an endless loop of rumination.

We are not alone. Many mothers create the same monsters: "Did I love them enough? Did I put myself first too often? Should I have taken a more laissez-faire approach to potty training? Let them eat dirt? Should I have used more Band-Aids? Fewer Band-Aids? Did I model strength? Should I have been more vulnerable?" The list is endless. And so we greet the monsters; play the "what if" game, share our fears, sadness, and anxiety; hypothetically walk the paths not taken; cry, laugh—but this time, we find we are not alone.

We recognize that "when packed to the brim with memories, wounds, worries, dreams, opinions, and schemes, we become limited in what we can hear or receive. With no room in our cup of being, less and less can touch us…. Sometimes, the only remedy is to empty ourselves and begin again" (Nepo).

We would like to begin again.

What Lingers in Our Minds

If not a many-splendored thing, regret is a many-faceted thing. Bridging past and present, interior and exterior, actual and possible, the cognitive and emotional, the individual and collective, regret calls for a wide-angle lens. (Landman xvii)

being with this feeling or state of mind

without emotional attachment

brings us to the brink of our own destruction

or to the possibilities beyond?

As we linger, we consider the weight of motherhood, the expectations passed down from one generation to the next, the ideals that establish the link between motherhood and selflessness, the impossible standards that are set for us, and the ones we choose for ourselves.

In our maternal mandate as the first first-responders, we engage a heroic quest in our call to be mother, teacher, nurse, coach, chauffeur, storyteller, best friend, multitasker, social convenor, domestic CEO, seamstress, editor, listener, monster killer. Motherhood messages and memos—swelling myths amid waves of feminism (Thurer)—began as we left the hospital: "This is the moment you have been waiting for your entire life; when the hole in your heart is filled and you finally

become complete. If, after I put this child in your arms, you sense anything other than utter fulfillment, seek counselling immediately" (Doyle 153).

We reach for understanding, not to blame, but to silence the doubt and uncertainty masked as should haves, could haves, wishes, and longing.

"The truth is that when we really begin to do this, we're going to be continually humbled. There's not going to be much room for the arrogance that holding on to ideals can bring" (Chödrön 3). When we begin to do this, we realize that while the pain of disconnection is real, our questioning, hurt feelings, suffering, and misery are choices borne in our imaginations, often sustained by the way we think things should be.

As mothers, we have spent many years pouring our hearts into our children—they ground our identities. But this is not their responsibility to carry, so we free them of that burden. In this liberation, there is a note of sadness. As mothers, we live the predicament, contradictions, and inconsistencies of being fully human—fully alive.

Engaging regret is like riding a roller coaster: There are intense moments of in-the-moment thinking, feeling, pausing, waiting, forgiving, and letting go.

We know that our children's distance is a critical part of growing up. We mourn the unconditional acceptance found in our children's eyes, long before they came into an understanding of their separateness —a knowing of their difference. We want our children close, especially when we feel the pain of them needing us less.

When they were little, dependence bred need. But as they get older, they're rightfully trying to dissolve that enmeshment. We know that they don't need us in the same way they needed us as babies, but sometimes, we're not quite ready to accept the process of them moving away from us.

Perhaps we were the first to distance, fearing rejection, not knowing who we were or going to be, if not in our children's eyes.

As we observe and reflect, we encounter ourselves, and we bear witness to each other—our power, confusion, rage, humour, sadness, fear, and pride. We commit to "Stay. Allow. Be with. *Look....* When you know how to stop, turn around, and look directly at yourself, you come into possession of a superpower. It is called kindness. Rather than protecting yourself at every turn by clinging to, blaming, or ignoring who you are, you can actually be right there, present, and accounted

for" (Piver 121).

"I did the best that I could with the tools and resources I had available to me" sounds like such a cop out, almost apologetic, and most definitely defensive. This is the very response that often gets us in trouble because our unpacking of what could have been done differently is grounded in the defense of not knowing then what we know now.

As we begin to divest ourselves, we realize that we often engage regret as a deficit: the paths not taken, the choices we didn't make, the things we didn't do. As mothers, we come to see that who we are, what we desire to be, the disappointments we face, as well as the regrets we hold are not just borne of our imaginations: They are grounded in a time and space rooted in colonized structures, in patriarchal institutions, and in feminist movements that did not fully engage motherhood (O'Reilly). As we linger a little longer, we find the crossroads where regret borne of idealism intersects with agency, and we understand that we have a choice; we have always had a choice.

And in that very moment, we made the best choice we could with the tools and resources we had available to us. Full stop.

We release the cultural ideals, the burdens, and our fears of our children's perspectives; we accept change as inevitable and progress as a conscious choice. We lean into our children's separateness and their desire to own their own stories. We lay down the Wonder Woman bracelets and all the energy spent in self-defence—trying to prove, trying to explain, trying to rewrite the story we think they carry with them. We reconstruct the movies of our lives instead of projecting past onto present. We ask important questions, such as "Do I want a relationship, or do I want to be right?" (Evans). We release the spectres of what a mother is supposed to be, how a mother is supposed to act, and consciously reframe the idea of motherhood.

We sit with the contradictions and inconsistencies of unconditional acceptance.

Lingering with regret is a long-term commitment, a daily meeting of the monsters; as mothers, we need to be willing to linger a little longer in the mirror as well as in the research, the memoirs, the media representations, our experiences of the past, the memories that shape our lives. Ultimately, we accept but not excuse: "We got a terrible memo. Our terrible memo is why we feel exhausted, neurotic, and guilty" (Doyle 155).

In this space of lingering, we stay with the pain, and we release

suffering. We endeavour to work with our thoughts and feelings so that we are no longer "at the mercy of preconceived notions, childhood woundings, outdated judgments, and bad habits—all of which [we unknowingly] project onto others who are also struggling with the contents of their own mind" (Piver 6).

We recognize that the experience of motherhood bleeds into other relationships and is influenced by other relationships. Maybe this is the problem. We judge ourselves through our relationships with our children instead of through our relationship with self. We allow this to happen, and then it bleeds out.

The longer we linger, the more we become aware that it is our neurosis that is having the real relationship with our children, not our hearts (Landman). It is not our children's job to rewrite us—cast us as more sympathetic characters. It is our responsibility to call forward the image of ourselves that we want to be seen. We take up the challenge, knowing that it is never too late to re/write our selves and re/right our relationships, taking comfort in the many opportunities for redemption that we meet through conscious awareness of our vulnerabilities—and our regrets. We learn that "regret need not be a ... waste of time, a failure of rationality, or a 'perilous slope.' Regret can also constitute a path leading onward and upward" (Landman 15).

We commit to change onwards and upwards.

What Dwells in Our Hearts

It is a strange karmic trick that at those times when we most want to harden our hearts and ignore others, what is called for is to soften, first to ourselves and then to everyone else. (Piver 121)

we show up, we are seen, we mirror

we find elegance in vulnerability

we cast and recast our selves in the stories of our lives

we undo and redo

we renounce past cages and that which doesn't serve:

a cup filled with regret leaves no energy for today's thoughts, words, and actions

we fill our cup with love and compassion

to mother is to care; to mother is to know regret

we question, we explore, we stay open

we resist the urge to conclude

we bear empathetic witness to ourselves and to our children

and we come to know this place tenderly as acceptance
of self and other

we come home—to a place of stillness, knowing, and love

This manifesto represents "a radically different worldview, one that runs counter to the spirit of much of the conventional advice we've received and internalized over the years. It prioritizes unending curiosity over conclusiveness," an open heart and mind that accepts the uncertain path of no agenda as a path to attainment ... where solutions to problems in the outer world are solved by making changes within (adapted from Piver 3-4)

We can't escape suffering; to be human is to suffer. Perhaps the reason that we suffer regretful thinking is that we allow ourselves to be more attached to our children and our monsters than to ourselves. Our children are born of us; they are part of us. Their independence calls our sense of security and wholeness into question, and so we question our belonging. And there is actually no way to get comfortable because relationships are, after all, alive and organic. Forcing rigid expectations or lamenting their stability turns the opportunity to love into a source of suffering. The path to liberation we've discovered is to accept all as it is and love more deeply; to ride the never-ending waves of connection/ disconnection, distance/closeness, dullness/pleasure and see them as neither good nor bad, pretty nor ugly, positive nor negative; to meet the instability together as love (Piver); to trust in the process of letting go; and to accept with faith that our children are not a reflection of who we are or were but evidence of who they are becoming. And that is a good thing.

Love does not insist on its own way; it is not irritable or resentful; it does not rejoice in wrongdoing, but rejoices in the truth; it bears all things, believes all things, hopes all things, endures all things. (1 Corinthians 13: 4-7)

Greeting regret as possibility is an act of loving and healing. In healing, we linger in the pleasure of the past, in gratitude for our children's affection and experiences that might have been shadowed by our regret. In loving, "we dwell awhile in the space of memory, urging memory to speak" (Bochner and Ellis 252). We bring the tangible and concrete artifacts into the light: the home movies and the photo albums that capture moments of life in process; the sticky notes left on the bathroom mirror; the countless birthday cards, letters, and notes; and the lovingly constructed gifts—the macaroni necklaces and clay structures—which call to mind the innocence of love. We open ourselves to receiving, hearing, and appreciating the past through a wide-angle lens that encompasses regret as a potential site of pain as well as an opportunity for love and healing:[1]

When I was little, I loved to watch you blow dry your bangs in the bathroom mirror.

There have been so many times when I wished I could slow down the world for you and remind you how much you are truly loved and cared about..

You have shown me the meaning of what it means to love deeply, of what it means to be selfless and empathetic.

You have endowed me with the skill sets and traits necessary for me to develop as an independent individual—one who doesn't see any barriers standing in the way of progress and personal development— one who takes control of her own destiny.

I know we have our differences, and it's not always easy living in close proximity to each other, but I really respect you as a woman and as a mother. You always bring your determination and positive attitude to any challenge you face.

As life provides me new opportunities, I realize that it is all just "flash and distraction" outside of the people you care about.

Thank you for supporting me, for being there in good times and bad, for giving me life (twice!), and for being a model of strength and ferocity—even when I didn't deserve it.

You are awesome. You look nice. Stay positive. I love you.

Dwelling in our hearts, our journey moves beyond abstraction to self-discovery that feels like promise and has real potential to shape our perception and relationships in positive ways. We become more faithful in our capacity to take ownership of our choices and our fears; we begin to intuit our sometimes-obsessive longing for connectedness with our children as a function of fear of judgment for past transgressions, decisions, or projected regrets. This place, though emotionally intense, is filled with the lightness of being inspired by the compassion and tenderness we bestow on ourselves, on each other, and ultimately our children.

We are open to expanded levels of consciousness through loving.

What We Make Conscious

be still and know, live this moment:

tender of heart

abundant with gratitude

compassionate with self

gracious with consciousness

courageous in thought

clear in word

authentic in deed

faithful in direction

open to change

willing to grow

In our emergent consciousness, we know that although our children make us mothers, we ultimately experience motherhood through agency and imagination. To love and care fully for our children, decisions are made, and paths are left unexplored. There is an acceptance that there are days when the grass is, in fact, greener on the other side. In feeling our way through regret, we have examined our consciousness and greet ourselves with faith in our intuitive knowing: We "burn the memo presenting responsible motherhood as martyrdom." We decide "that the call of motherhood is to become a model, not a martyr." We unbecome "a mother slowly dying in her children's

name and become a responsible mother—one who shows her children how to be fully alive" (adapted from Doyle 75).

And in this consciousness, we accept, with humility and integrity, our role as writer, maker, creator, and architect of our own stories: "It's like entering a nightmare with conscious awareness that [we're] in charge of what happens and telling the monster, 'Begone!' comforting [ourselves], and righting the situation easily and confidently" (Cohen 207). How do we want to experience regret in the present moment? What kind of person do I want to be? What kind of world do I want to live in? Where should I begin?

When we become conscious, when we exercise our free will (Cohen), we respond and act accordingly. We understand why this is so and that integrity means staying true to ourselves. It is here that we find ourselves deep in authenticity, tenderness, vulnerability, and humility (Brown).

Being conscious in regret is an act of mindfulness, of understanding with tenderness the difference between the experience and the story (Gornick). It is an act of lingering with what arises rather than running or escaping. It is here that we consider cognitions, sensations, and feelings with generosity of spirit, greeting them as old friends or strangers (Nepo) and asking what we have to learn from them. It is here that we accept the power of our adult awareness and make conscious choices to act differently, setting aside worn patterns and no longer reacting from a position of fear (Cohen). It is here that we find "the more beautiful place our hearts know is possible" (Eisenstein).

We receive, hear, and listen in a more authentic place.

In this consciousness, we shift our energy, accepting that we are accountable and responsible for how we deal with the predicament of regret. We are capable of creating a loving world within ourselves, and our maternal lives are opportunities to create relationships of genuine caring. This doing brings great joy and "generate[s] healing energy that radiates outward from us in all directions, affecting not just our family but our peers, our friends, and even strangers" (Cohen 210).

When we give way to fear, the monsters from the past overtake us in the present and grief enters, an experience that takes place entirely in our minds. Reconstructed memories and thoughts take over, masquerading as facts, hijacking our present. But we have the power to pay attention and engage life through the persistence of the possible (Landman). We can greet each experience of regret with a beginner's

mindset: What is it that we have to learn? How can we see this differently? How might we advise a friend? Our children? We can tune into our experiences of regret, recognizing that the physical sensations, immediate reactions, and guilt are all distractions from the ever-present challenge and opportunity to rediscover ourselves.

I think I've become a better mom through regret. I think I'm far more conscious of regret, and it forces me to keep my heart open when it would normally have a tendency to close.

In the past, I spent a lot of time thinking that if I could rewrite my story, I would eliminate all my regrets, leave no stone unturned. That was the me stuck in looking at life through the rear view mirror. I once heard that there's a reason why the rear view mirror is so small. It should only take up a small amount of your energy; constantly looking back instead of forward will make you crash.

I can't stop regretful thoughts, but I can relate to them differently. I can build new evidence, and I can recognize that this is not currently happening.

We have come to accept the experience of regret, and the opportunity to engage it mindfully, through our lives, our research, and writing as a great privilege. We reflect consciously on the power implied by agency and imagination in our lives. We accept the gift of choosing how we carry regret in this present moment—as burden or as possibility? How can, and will, we make our consciousness of regret actionable in our futures?

We exercise the power of our imaginations to create a gentler experience of regret, a tender approach to ourselves through the experience of motherhood. We know that our faith in this vision and our willingness to engage skillful doubt (Salzberg) have implications for our stories, ourselves, our children, our world.

We are Here.

We are Now.

A time and space of absolute acceptance.

We experience what is.

Past and future lose their power.

This inevitable moment is possibility.

We are possible.

A Space of Resonance and Healing

Moving through regret, we have dwelled in those places that beckoned us to linger; we experienced the layering of sound as we struck the bell, listened for its echoes, and moved on. We moved back in time and greeted the spectres—our self-created monsters—those fears and anxieties borne of imagination. In the act of unburdening, we emptied our cups and divested ourselves of this weight, paying homage to those experiences, and witnessing ourselves and each other.

When we accept the fundamental reality that the past wound or knot of regret must be mourned, forgiven, and released in our present, we find a conscious awareness that our past *unconscious* experience of regret is our only real regret. Letting ourselves off the hook through loving kindness, we hear the final chime: the healing that comes with the elegance of embracing our vulnerability (Piver), welcoming self-acceptance as a precondition for faith, and moving beyond the boundaries and restraints of our own perception. As fellow travellers, we experience and witness this site of connected-consciousness through each other and now with you, our reader. We humbly offer this gift—our journey into knowing—and invite you to join us:

> Consider how partial, tentative, and incomplete our stories and memories can be; how throughout our lives we constantly revise, reframe, reinterpret our lives, and yet feel a desire to view our life as a continuous and coherent whole. Revision allows us to expand and deepen our understandings of the lives we have led and the culture in which we have lived, offering alternatives to staying stuck in the same old interpretations. We can seize opportunities to compose a story for ourselves that continues to be worth living. (Ellis, *Revision* 12-13).

Sharon Salzberg defines faith as "the ability to offer our heart to the truth of what is happening, to see our experience as the embodiment of life's mystery, the present expression of possibility, the conduit connecting us to a bigger reality" (100). Striking the bell yet again, we find "the open air and life-force to revive ourselves" (Nepo) and a more beautiful world with possibilities to be present for ourselves and for our children in ways that are both attentive and tender. We embrace the harmony that is peace borne of expanded consciousness, empathetic

sharing and witnessing, and gratitude for both the pleasure and pain of mothering.

When we, as mothers, have faith in ourselves and allow possibility to persist, we typically do our best work. We love lightly and with an ability to hear and receive the love that is freely given around us. We accept our confrontation with the predicament of regret as "the work of love: to give, to empty, and to make room for life.... The more we are emptied of our personal echoes, the more we can be present to what is alive before us" (Nepo). As we have, we invite you to strike the bell: linger in the spaces that need healing; welcome the monsters as room for growth; dwell in love of self and other; release the pain of the past; witness and reconcile reality in the present; and embody a liberated consciousness that greets the predicament of regret with all its inconsistencies, contradictions, and possibilities for growth within ourselves and throughout the world.

Now, as a mother I would want her to know that it wasn't her fault, that I love her, and that I don't remember any pain.

I just remember the cracker jacks.

Endnotes

1. We are mothers and grandmothers. BettyAnn has five children ranging in age from thirteen to twenty-eight. Michelann has three children, ranging in age from thirty-three to thirty-seven, and two grandchildren, aged ten and almost fourteen.

2. Our children's words are unedited and presented in their authentic form. While we considered a poetic arrangement, we gestured toward honouring their voices.

Works Cited

Bochner, Arthur, and Carolyn Ellis. *Evocative Autoethnography: Writing Lives and Telling Stories.* Routledge, 2016.

Brown, Brené. *Braving the Wilderness: The Quest for True Belonging and the Courage to Stand Alone.* Random House, 2017.

Chödrön, Pema. *When Things Fall Apart: Heart Advice for Difficult Times.* Shambala Publications, 1996.

Cohen, Doris Eliana. *Repetition: Past Lives, Life, and Rebirth.* Hay House, 2008.

Davidai, Shai, and Thomas Gilovic. "The Ideal Road Not Taken: The Self-Discrepancies Involved in People's Most Enduring Regrets." *Emotion*, vol. 18, no. 3, pp. 439-52.

Doyle, Glennon. *Untamed.* Penguin Random House, 2020.

Eisenstein, Charles. *The More Beautiful World Our Hearts Know is Possible.* North Atlantic Books, 2013.

Ellis, Carolyn. *Revision: Autoethnographic Reflections on Life and Work.* Left Coast Press, 2009.

Ellis, Carolyn. *The Ethnographic "I": A Methodological Novel About Autoethnography.* AltaMira Press, 2004.

Evans, Louise. *5 Chairs, 5 Choices. Own Your Behaviours, Master Your Communication, Determine Your Success.* Create Space Independent Publishing Platform, 2016.

Goldsmith, Daena. "Narrating an Open Future: Blogs by Mothers of Autistic Children." *Writing Mothers: Narrative Acts of Care, Redemption, and Transformation*, edited by BettyAnn Martin and Michelann Parr, Demeter Press, 2020, pp. 109-25.

Gornick, Vivian. *The Situation and the Story: The Art of Personal Narrative: New Edition for Writers, Teachers, and Students.* Farrar, Straus, and Giroux, 2002.

Henderson, William. *The Progression of Regret*, 2012, goodmenproject. com/featured-content/the-good-life-the-progression-of-regret/. Accessed 23 Apr. 2022.

hooks, bell. *Yearning: Race, Gender, and Cultural Politics.* South End Press, 1990.

Levine, Peter. *Healing Trauma: A Pioneering Program for Restoring the Wisdom of Your Body.* Sounds True, 2008.

Martin, BettyAnn. *Narratives of Becoming: Maternal Identity as An Evolving Intertextual Mosaic.* Nipissing University, 2017.

Nepo, Mark. "Regret." *Spirituality and Health Magazine*, vol. 21, no. 1, 2018, Gale Academic OneFile, https://link-gale-com.roxy.nipiss ingu.ca/apps/doc/A520460090/AONE?u=ko_acd_can&sid=AO NE&xid=17f58374. Accessed 23 Apr. 2022.

O'Reilly, Andrea. *Motherhood Hall of Fame Keynote*, 2014, mother hoodfoundation.files.wordpress.com/2015/05/procreate_andrea_ oreilly_july_1_2015.pdf. Accessed 23 Apr. 2022.

Piver, Susan. *The Four Noble Truths of Love: Buddhist Wisdom for Modern Relationships*. Lionheart Press, 2018.

Rich, Adrienne. *Of Woman Born: Motherhood as Experience and Institution*. Norton, 1976/1986.

Salzberg, Sharon. *Faith. Trusting Your Own Deepest Experience*. Riverhead, 2002.

Shakespeare, William. *The Tragedy of Hamlet, Prince of Denmark*. Washington Square Press/Pocket Books, 1992.

Thurer, Sherry. *The Myths of Motherhood: How Culture Reinvents the Good Mother*. Penguin Books, 1995.

Chapter 13

Minjinaweziwin: Anishinaabeg Women's Teachings on Maternal Regret

Renee E. Mazinegiizhigoo-kwe Bedard

Maajtaadaa[1]

In Anishinaabeg[2] culture traditions, maternal regret is considered a natural part of Anishinaabeg life, occurring as we move through our lives as adult women and as mothers. As we try new things and face new experiences, maternal regrets are the evidence of our growth on our life path as human beings: Anishinaabeg mino-miikana-bimaadiziwin (good path of life as a human being). Maternal regret can come as a result of some negative outcome or decisions that take place due to reasons relating to infertility, pregnancy, loss of pregnancy, termination of pregnancy, pregnancy complications, birthing, parenting, loss of a child for any reason (e.g. death, adoption, or removal), body image, parental decisions, or the actions of a child. In this chapter, I want to share with you specific Anishinaabeg teachings on the origin and contexts of maternal regret through an Anishinaabeg women's centred paradigm. First, I share the Anishinaabemowin term "minjinaweziwin" as an intellectual anchor for understanding Anishinaabe-kwewag (Anishinaabeg women's) ethics, philosophies, and cosmological teachings about the complex nature of maternal regret

221

within the lives of our women. Anishinaabeg concepts within minjinaweziwin about maternal regret offer a gentle and nurturing perspective that seeks to teach women about the complexities of womanhood, motherhood, and mothers' cultural traditions. Second, I explore how Anishinaabeg beliefs of maternal regret are recognized as a natural state of being and as a site of both Indigenous women's agency and self-governance. Third, I share with you a traditional sacred story as the origin of the knowledge I carry and how I contextualize that sacred knowledge as instructions related to the ways Anishinaabeg women view, embody, and utilize the embedded teachings to navigate contemporary maternal realities. Last, I offer some concluding thoughts and a poem expressing my own positionality on maternal regret as an Anishinaabe-kwe (Anishinaabe woman).

Furthermore, I recognize those who describe themselves as Anishinaabeg mothers, those who assume a maternal or mothering role within the Anishinaabeg family and community, and those females and individuals who identify as 2SLGBTQQIA+. I write for both Indigenous and non-Indigenous people who identify on the female spectrum or as mothers, including cisgender women, niizh-manidoowag (Two Spirit), and LGBTQIQQ2SA+ or queer/trans women. Inclusivity of the spectrum of femininity that embodies motherhood and womanhood further highlights the value of Indigenous perspectives on maternal regret. My objective here is to share my people's language, stories, and traditional women's teachings on maternal regret to nurture the resurgence of ancestral grandmothers' wisdom for our women and those women who need these words.

Anishinaabeg Maternal Regret as a State of Being

When our kwezensag (girls) begin their paths to becoming oshki-Anishinaabe-kwewag (young women) at the time of puberty, we give them teachings on womanhood and motherhood. They are taught to situate feminine regret as a natural state of being and living as adult women. My mother, Shirley Ida Bedard-ban,[3] who was Anishinaabeg, used to say, "The more you, the more you come to regret things along the way!" As I became a mother, I had to sort through Western concepts of maternal regret I had absorbed by just living in Canadian society that competed with the traditional knowledge I had learned

from Anishinaabeg women Elders and traditional stories.

Specifically, I felt the effects of Western culture on my own maternal regrets. In the last few years, I began to feel regret that I was not going to have more children because I was now in my forties and felt that I was no longer in the stage of life to keep having children; however, my own grandmother had children up until her fifties, so I know my concerns are not rooted in my own cultural values. Instead, they are rooted in the fact that doctors will label me a "geriatric mother," which I experienced in my mid-thirties during my two pregnancies. Western labels of motherhood loomed over me and shaped my mindset. How do I process my feelings of maternal regret through an Anishinaabeg lens? The start of the process begins in embracing my maternal regret as a space of cultural opportunity and not as a deficit. Furthermore, it is also a site of my political agency—my inherent right as an Anishinaabeg woman.

I reject Western culture norms on the nature of maternal regret that shames Anishinaabeg mothers for any maternal regret and steals our agency away from us, corrupting our sacred relationship with our womanhood and mothering roles. The complications of hetero-patriarchy, heteronormativity, and transphobia that settler colonialism has generated in North America targets our Indigenous maternal bodies, minds, and spirits because of the power Indigenous women have to create and hold together our Indigenous nations. Anishinaabeg maternal identity is still strategically targeted for assimilation, acculturation, and extinguishment policies by the Canadian govern-ment because the Anishinaabeg nation embodies matriarchy in ethical formation, practice, and process (Kairos Canada). When we let Western culture continue to displace our traditional Indigenous values and mores related to maternal regret, we allow the colonizer to perpetuate the violent extinguishment of our maternal cultural traditions.

The violence by colonial heteropatriarchy, heteronormativity, and transphobia on Anishinaabeg maternal identity has harmed Anishinaabeg maternal ontologies, epistemologies, and axiological understandings of a woman's role as mother. Through colonization and the introduction of Christian norms about female bodies, sexuality, and agency, Indigenous cultural norms were almost extinguished. Maternal regret is in fact a site of maternal agency. As regret arises from decisions we make, Anishinaabeg recognize that it is the inherent right of every

woman and mother to make decisions that sustain her life, the lives of her family, her community, and her nation. Our regrets are felt inside our maternal bodies. We feel them in our bones, our muscles, and deep in our hearts. We ache from them in both our bodies and minds. In Anishinaabeg contexts, maternal regret is not abstract; instead, it is real and manifests as physical, emotional, psychological, and spiritual states of being. By altering the Indigenous women's relationships with maternal regret, Indigenous women's agency and sense of self-governance is threatened with erasure. Anishinaabeg agency and governance lies in the mother's decision-making power; maternal regret is her opportunity to analyze her decision, change, improve, grow, heal, and transform as a human being. Without maternal regrets, we do not become better women and mothers. Therefore, colonizing our Indigenous minds with Western ways of understanding maternal regret steals away our traditional axiology for female self-improvement and self-governance.

In Anishinaabeg culture, maternal regrets are to be embraced as well as listened and responded to in a state of self-directed kindness (gizhewaadiziwin), unconditional love (zhawenjigewin), and humility (dibaadendiziwin). So when I think about my maternal regrets, I try not to let Western cultural thoughts about maternal regret get too far into my mind, especially heteropatriarchal and heteronormative ideas. I state to myself one word as my mantra: Nimaamaa-Minjinaweziwin! Nimaamaa-Minjinaweziwin! Nimaamaa-Minjinaweziwin! This word means maternal regret or mother's regret, which is my right and my shield against the cognitive imperialism that seeks to extinguish Indigenous maternal ways of knowing and replace it with a mindset that disempowers mothers from the pollical agency regret can represent. Nimaamaa-Minjinaweziwin is my mantra for the reclaiming, revitalizing, and rebuilding of Anishinaabeg women's and maternal intellectual traditions I repeat the word "Nimaamaa-minjimaweziwin" as a weapon of decolonization and indigenization.

Minjinaweziwin

The Anishinaabeg language allows our woman to root our identities in the natural world and the Manidoowag (Spirit Beings) that guide us. Language is described as "gaa-izhi-zhawendaagoziyang: that which is

given to us in a loving way by the spirits" (W. Geniusz 10). Through it, we can express ourselves to each other and show gratitude to all-of-Creation. The Anishinaabemowin word "minjinaweziwin" translates to a condition or state of regret or disappointment. "Minjinawezi" describes a feeling of regret or disappointment and "win" translates to the state of being or condition of being ("Minjiawezi"). Anishinaabeg see the state of regret as an emotion related to sorrow or remorse for an action or disappointment to an undesirable situation or decision made. The intensity of emotions connected to regret vary over time after the situation or decision has been made. Specifically, feelings of regret may lessen or intensify in regard to action versus inaction. Anishinaabeg worldview also recognize regret as a natural condition of human life.

In settler-colonial cultures, regret is often considered something to be avoided; it is a source of guilt for the person who experiences regret. I once read a quote from the New Zealand writer Katherine Mansfield about regret: "Make it a rule of life never to regret and never to look back. Regret is an appalling waste of energy; you can't build on it; it's only good for wallowing in" (qtd. in Hendrix, "I Don't Believe in Regrets"). For me, the settler-colonial worldview and perspective runs contrary to the teachings of Anishinaabe-kwe mino-miikana bimaadiziwin (Good Path in Life as an Anishinaabeg woman), which teaches us to recognize our past experiences, build on those experiences, and use them as we traverse the challenges we will meet on the road of life. We move forwards carrying our regrets lovingly and with gratitude. Anishinaabeg believe that maternal regret provides valuable teaching experiences that allow us to emerge and transform with knowledge that we need to enact life changes, evolve, make wiser decisions, and understand that every lived experience of a woman is an essential part of our identity formation and Anishinaabeg path in life: miikana-bimaadizi. Furthermore, the teachings of the life path are called the mino-miikana-bimaadiziwin ("good path" of life as a human being), which instruct us that the experiences that cause maternal regret can be signposts that alert us to times in our life where we must stay true to or return to our "good life path" and address the consequences of decisions or outcomes in order to best understand how to better live Anishinaabe mino-bimaadiziwin (living well/good as a human being). To veer off and stay off the good path leads to great pain in life. When I felt maternal regret for not having more children, I was

getting a reminder to be grateful for what I have and to know that my life is changing as I grow older. My role of motherhood is evolving, and I need to remember that with humility and unconditional love. My maternal regret was a signpost for changes that are coming in my own life; it reminded me that my life path as an Anishinaabe-kwe is a transformative process as I move through the parenting stage of my life.

In our Anishinaabeg teachings, the path of life is depicted either as an arrow or four hills marking the stages of our life (infancy and early childhood; late childhood and youth; adulthood; and old age) with diverging paths off the main road. In the Figure 1 below, I have combined both the arrow and four hills of life teachings.

Fig. 1. Anishinaabe mino-miikana bimaadiziwin

The divergent paths on the hills of our life indicate our many lived experiences. Those lived experiences can sometimes be difficult and challenge us as human beings, such as things that cause us to feel regret, but they also represent opportunities to gather valuable knowledge (gikendaasowin). The teachings of miikana-bimaadiziwin tell us that we must always return back to the main path and go forwards and to not let ourselves get lost from the main path of our lives on earth.

Within Anishinaabeg intellectual traditions, the condition of maternal regret flows from learning to be a woman and learning to be a mother. The path of motherhood is not easy and has many challenges. Motherhood, mothering practices, and fertility are dynamic experiences that do not always go as planned. Furthermore, fertility, pregnancy, birth, and parenting cause women to deal with serious

issues related to cognitive wellbeing and agency over both their bodies. For instance, women can have unplanned pregnancies, be infertile or become infertile, face choosing to have an abortion, suffer miscarriages or stillbirths, or have pregnancies that destroy their reproductive organs. Births can go awry or not as was planned. Women can have difficulties breastfeeding or be completely able to feed their babies. They can suffer postpartum depression or feel they are not prepared to take on the role of mother, so much so that they give up their children. Children can be born with medical challenges that cause a mother to regret her actions during pregnancy; they can also die, leaving a mother heartbroken. A mother cannot control the lives of her children or the decisions her children make, good or bad. Day-to-day decisions and challenges can also stir feelings of maternal regret. Women do not have to regret any of these instances; however, the stresses of these events can cause regrets naturally and that is a healthy positionality. Over the years, I have had my own maternal regrets related to motherhood, and many Anishinaabeg women I know have had a range of regrets, but we are taught not to attach shame or guilt to them; instead, we embrace these emotions as sites of growth, change, and opportunities for understanding our own evolving femininity.

Where do I find my peace with my own regrets? I find peace through my Anishinaabe-kwe izhtwaawin—that is, Anishinaabe women's cultural traditions. It is wintertime while I am writing this chapter, the traditional the time of storytelling when we share with our children and community the aadizookanens (sacred stories) of my ancestral grandmothers. It is within the sacred stories that our instructions on maternal regret can be found. We listen to and reflect on those teachings and situate them in the contexts of our lives.

The original Anishinaabeg teachings of maternal regret are rooted in sacred Creation stories about the formation of our universe, the earth, and human beings. There are several stories that I draw from for understanding the dynamics of Anishinaabeg maternal regret. For Anishinaabeg women and mothers, our ancestral grandmothers' stories represent a cognitive space and time that train our women in feminine-central intellectual thought and feminine-centred theories developed over thousands of years, shared from generation to generation between women. Anishinaabeg Elder and scholar Edward Benton-Banai writes that stories are shared between us for a variety of

reasons:

> Anishinaabe can see that if he knows his creation story, if she knows her creation story, they know how all of life moves. They can know how life comes to be. All life is a creative process that began in this original way and continues in the same way in all aspects of our life. In all places and all facets of creation, and creative activity, these seven stages are reflected. (Toronto Zoo, "Ways of Knowing Guide" 30)

Creation stories are told and retold in our families and communities, in our lodges and around kitchen tables. They are told throughout a woman's life to remind her that she is important to her people and give her the knowledge she needs to follow mino-bimaadizi. In order to cope with maternal regret, our ancestral grandmothers left us the Creation stories to guide us through these emotions. The grandmothers and women Elders share them with women at times of puberty, pregnancy, at the birth of our children, and in postnatal care to prepare us for the rigours of motherhood.

For me, discussions and teachings of maternal regret began with the specific Creation story relating to the creation and destruction of the first human beings, the children of Gizhew-Manidoo (The Great Mystery; Creator). In the next section, I wish to elaborate on this story and share the specific teachings on maternal regret that all women (both Indigenous and non-Indigenous) might find useful to understand and contextualize the nature of Anishinaabeg women's perspectives on regret related to mothering. How the Anishinaabeg women intellectualize this Creation story provides a unique look into the specific cosmological, ontological, epistemological, and axiological understandings of regret in motherhood as a wholistic approach to maternal education and philosophy.

The Creation and Destruction of Human Beings: The Original Story of Regret

In Anishinaabeg cosmology, Gizhew-Manidoo is recognized as the original maternal source of life in the universe. All wisdom on the creation and destruction are interwoven into the ancient sacred stories of Gizhew-Manidoo. In these stories are lessons on the dynamics of

female energy, creativity, fertility, and maternal roles and responsibilities. Our Creation stories are our first source of maternal knowledge, as they contain instructions on women's ontological and epistemological ways of being. Embedded in these teachings is a recognition of maternal emotions, specifically regret. Regret is recognized as a negative feeling and outcome that can arise from maternal experiences of taking on roles and responsibilities. Most importantly, we learn that regret is natural and acceptable within an Anishinaabeg women's worldview. From regret can come creativity, change, and growth. Regret can force us to reexamine our situation and improve our actions so that we achieve mino-bimaadiziwin.

When I was thinking about writing on the teachings of maternal regret, I turned first to the Creation story of Gizhew-Manidoo's creation of the first human beings. I want to share my retelling of this ancient story honouring the knowledge shared with me by Anishinaabeg Elder Edna Manitowabi (Wiikwemikong Unceded First Nation) during the time I was her teaching assistant at Trent University. I have also studied her written account of the story in *Dancing on Our Turtle's Back* by Leanne Simpson (35-39). I draw on the version of the Creation story as told by Terry Dokis (Anishinaabeg, Dokis First Nation) my first university professor in Native Studies at Nipissing University. Further, I have studied the written versions of Basil Johnston (Johnston, 12-17) and Elder Edward Benton-Banai (Toronto Zoo, "Ways of Knowing Guide" 25-30; Benton-Banai, *The Mishomis Book*, 2-4). What I share here is a version inspired by all my teachers listed above and my own understanding of the story through the perspective of both a woman and mother.

In the beginning, before the beginning of everything, there was only darkness and silence, but in that darkness dwelled something; someone was listening. That someone was Gizhew-Manidoo,[4] who was born out of the darkness, carried forth on the song of their own heart beating. Gizhew-Manidoo was born with both female and male energies. They brought with them gifts of light, sound, creation, and dreaming. Gizhew-Manidoo's first thought was a dream/vision. The first dream was of a universe filled with all things and all creatures: galaxies, suns, stars, planets, and Aki (Earth), with her waterways, mountains, prairies, plants, and living creatures. Inspired by these images, Gizhew-Manidoo sent out their ideas into the darkness, but they went

on forever because there was nothing in the darkness for them to take root.

Gizhew-Manidoo had to create something for their dream/vision to reside in. Being both male and female spirits, Gizhew-Manidoo decided to conceive, grow, and birth a space for the dream/vision to manifest. Out of the nothingness, Gizhew-Manidoo created the raw elements upon which all life would grow. Each element was given an essence of what the Creator called the jichaag (soul-spirit). First was waawiyekamig (the universe), acting as a womb where the Gizhew-Manidoo's thoughts could make real the dream/vision. In waawiyekamig, the thoughts took root and formed into countless galaxies, stars, comets, suns, and planets. The planet Earth, whose name is Aki, was formed with mountains, prairies, lakes, rivers, valleys, deserts, and islands. Next, the seeds of organic life on Earth were distributed across the lands and waterways to grow into fungi, flowers, trees, food, and medicines. Using the raw elements of the Earth's body, the seeds of life grew into animals, reptiles, birds, and insects. Weather, like the rains and winds, cleaned and nourished Aki and her children. Everything had its place and purpose on Earth; everything was beautiful, and every living thing on Earth was imbued with a soul-spirit by Gizhew-Manidoo.

And last were the human beings. A favourite of Gizhew-Manidoo, human beings were given the most care and gifts. Yet these creatures were also the most dependent on other living creatures in order to survive. The tree does not need human beings to survive. The wolf does not need a human being to ensure its existence. Water is not created by human beings, but it is needed by human beings for survival. Human beings were created with this dependence because they were given the greatest of gifts: dreams/visions. Every human being was created in the image of Gizhew-Manidoo; however, these first human beings had one failing: They were given spirits without the same soul essence as the other creatures on Earth. This was a decision Gizhew-Manidoo would regret.

As a final act of creation on Earth, Gizhew-Manidoo gave all their creations the Gchi-inaakonigewinan (Great Laws of Nature, The Great Spirit Laws, or the Great Binding Laws) to maintain harmony, balance, and wellbeing among the creatures of Earth. The laws instructed everything on Earth that there was a place and purpose for all things

and all life. These laws were to be respected, cherished, and obeyed, or the complex web of relations would collapse. Every creature on Earth must follow these laws due to our soul connections to them.

Human beings were taught by the other creatures of Earth to follow the natural laws; however, human beings did not feel the same connection to the laws as the snake, eagle, or buffalo. So human beings began to neglect the natural laws and failed to protect the natural order of Creation. The first human beings brought great destruction and cruelty without a soul to temper their human spirits. Gizhew-Manidoo grew upset and concerned for the balance of the whole of their creation. Disappointed and resentful towards the human beings for failing to live up to their sacred gifts or to value the Earth, Gizhew-Manidoo responded to protect their creations on Earth and the delicate balance on Aki and throughout waawiyekamig.

Gizhew-Manidoo recognized that these first human beings jeopardized their body, their other children in the universe, and their sacred dream/vision, which resulted in Gizhew-Manidoo's state of maternal regret. Gizhew-Manidoo made the difficult decision to terminate human life on Earth. As if cleansing the womb of life that is waawiyekamig, a great flood was sent to cleanse the body of Aki. Great storms spilled water from the clouds and flooded the lands below. Human beings died, and the earth was made new again. Gizhew-Manidoo came to know regret from the loss of their human children, but the decision had to be made to protect all creatures of the Earth and to uphold those Sacred Laws of balance and harmony that bind together the universe. All the universe existed as parts of the body, mind, and soul-spirit of Gizhew-Manidoo. Through their creations, Gizhew-Manidoo witnessed, felt, and experienced life as an extension of their whole being. Therefore, through destroying human beings, Gizhew-Manidoo expressed agency over their own body, mind, and spirit. After the destruction came the healing, growth, renewal, and rebirth of life, including human life. The presence of regret became a space of self-reflection, growth, and wisdom for Gizhew-Manidoo. Regret did not undo the life purpose of Gizhew-Manidoo; instead, it was part of their journey, story, and identity as a living spiritual being.

For each generation of women, traditional cultural teachings on womanhood and motherhood include knowledge on the complex nature of woman's regret and maternal regret. These teachings have

been embedded by our ancestral grandmothers in the Creation stories of destruction, creation, life, birth, and death. This particular part of the Creation story teaches Anishinaabeg women to understand their agency over their physical and spiritual bodies. Indigenous scholars Kim Anderson (Cree/Métis) and Brenda J. Child (Anishinaabeg) have both noted that women's fertility and reproductive agency was prioritized as a maternal right (Anders 40-46; Child 16). The Creation stories tell us that our women have sovereignty over the nature of conception, pregnancy, birth, birth control, abortion, postnatal life with children, and raising children. Women are responsible for providing a good life for themselves and their children; therefore, if they cannot provide as such, they should not bring children into the world where they would suffer or die. Furthermore, Anderson, Child and Mary Siisip Geniusz all note that women maintain a working knowledge of plant medicine to maintain control over their body's reproductive health, including whether to ensure or terminate a pregnancy depending on what the needs were of the woman or her family's stability (Anderson 40-46; M. Geniusz, 43, 110). Our Creation stories tell us that our decisions involving fertility are ours to make as women, as creators of life; and equally so, our regrets are ours to manage, heal, or overcome, since we know that we maintain sovereignty of our body, mind, and spirit. In summary, maternal regret is a part of our cosmological legacy from Gizhew-Manidoo because it is part of what it means to grow as living beings, as kwewag (women), and as maamaayag (life givers; mother; one who gives birth to you) in this universe. The original Creation story on the first destruction is a reminder that maternal regrets are an integral aspect of womanhood, parenting, and motherhood. We all have to make difficult decisions that sometimes have negative consequences and result in great loss (physically, emotionally, psychologically, and spiritually) for either us or others or make us wish we had done things differently. Anishinaabeg mothers are taught that this is part of our learning journey and women's path of life teachings: Anishinaabe-kwe mino-miikana bimaadiziwin.

These teachings from Gizhew-Manidoo not only reflect political acts of Anishinaabeg cultural agency but also in contemporary contexts Indigenous feminism. Sharing these teachings is a political act for me as an Indigenous/Anishinaabeg feminist scholar because it is an act of

decolonization. Menominee poet and activist Chrystos writes as follows: "I also believe that everything is political—there is no neutral safe place we can hide out in waiting for the brutality to go away" (129). I recognize my political agency as a mother in relation to regret as a source of my motivations to get better and do better as a woman, mother, and community member. As Anishinaabeg mothers, there are no neutral spaces, not even motherhood, because we are protectors of our children, families, communities, and nations. As Anishinaabeg mothers, we understand that we birth the nation into existence and must work hard to keep it afloat so that it may survive for the next seven generations to come.

Our traditional example of this is Gizhew-Manidoo as one of the First-Mothers-in-Creation, who had many difficult decisions and outcomes they would come to regret, but they accepted their responsibilities to balance their Creation: family, community, and nature. There was no neutral space for Gizhew-Manidoo as mother. If Gizhew-Manidoo had not decided for the destructions of the first human beings then everything on Earth and all life would have been jeopardized. The balance of Creation on Earth would have been damaged forever. The community of beings living on earth—the family of relations among animals, plants, insects, birds, water, and earth—would have been hurt. These are good lessons to learn. We face many choices as women and mothers in our day-to-day life, but we must see them in the context of making decisions for the betterment of our lives, our family dynamics, and our community. If we have to move to find work, we do it. If we have to buy second-hand clothes instead of new clothes so that our children have food on the table, then we do it. Sometimes we even give up our own food so that our children have full bellies to bring them to school in the morning; this is the sacrifice we are willing to make. If we have to pull our children out of school to avoid COVID-19 spreading to ourselves, our Elders, and our Indigenous communities, then we do it. We may have regrets, but we also have to walk boldly forwards on the path of life. We are taught as Anishinaabeg that regrets are teaching experiences and opportunities to learn who we are and who we can become.

Concluding Thoughts

When I look at the Earth, I know that Gizhew-Manidoo is responsible for its existence and that Spirit energy of Gizhew-Manidoo supports all life around me in a maternal embrace. I share my knowledge of this maternal culture and wisdom so that other Anishinaabeg and Indigenous women, youth, and girls do not take on the worldview of our colonizers and erase the wisdom of Gizhew-Manidoo. Settler-colonial culture in North America makes taboos of maternal regret instead of coming to understand it as a natural expression of human understandings. However, I am not here to expound the details of the colonizers mindset because I am sure that others within this text will share their opinions on it and its burdens on contemporary North American women. Indigenous voices on maternal regret are non-existent because until now we have had little space or agency to come forwards to share alternative views. My views are political because Indigenous women's perspectives have been brutalized by colonization, so it is my role as a mother to protect my maternal body and that of my daughters. I speak for those girls who deserve to come to know regret through the perspectives of their ancestral grandmothers.

For my concluding thoughts, I would like to end with a short poem about maternal regret through the lens of an Anishinaabeg maamaa (mother) and doodem (mother who breastfeeds her children). Maternal regret is a topic that I am grateful for being about to delve into because it is a facet of Indigenous womanhood and motherhood that I get to reclaim for Anishinaabeg women and share with others so that they may think of maternal regret in a different way. Indigenous women's ways of knowledge offer vital perspectives developed over thousands of years of learning and from following the ways of our ancestral grandmothers. Miigwech (thank you) for allowing me to share my maternal knowledge.

Gimaamaa-Minjinaweziwin: Maternal Regret

maternal regret is stored in ... our stories
moving through time
between women, mothers, grandmothers
daughter.

maternal regret is stored in ... our bodies
buried in our bodies
that are tattooed in stretch marks, thick thighs, dropping
breasts, pregnant bellies, infertile wombs, miscarried little ones,
or in children we chose to send back to the Spirit World.
we learn to accept, heal, and grow.

maternal regret is stored in ... our mothers
they are loved and accepted for their journeys into motherhood
she is changed, wise, and is better for it.
she is her grandmother's ancestral wisdom.
miigwech to my nimaamaa!

Endnotes

1. "Maajtaadaa" in Anishinaabemowin (Anishinaabeg language) means "Let's begin!" and is used to start a conversation, discussion, or activity.

2. Anishinaabeg is a term for those nations that are rooted in the same root linguistic dialect, cultural teachings, and intellectual traditions. Those who use the term to describe themselves as Anishinaabe (meaning "human being") is comprised of the following nations: Anishiniwag (Oji-Cree), Ojibweg, Odaawaag, Bodéwadmik, Odishkwaamagiig (Nipissing), Misizaagiwininiwag (Mississaugas), Omàmiwininiwak (Algonquin), and Leni Lenape (Delaware). The Anishinaabeg peoples inhabit the Great Lakes region in both Canada and the United States. In Anishinaabemowin (Anishinaabeg langauge), "Anishinaabeg" means the original human beings. Benton-Banai, *The Mishomis Book*; "Anishinaabe," *The Ojibway Peoples Dictionary*.

3. "ban" in Anishinaabemowin is a marker attached to the names of someone who has passed away or died.

4. Gizhew-Manidoo is a great mystery that Anishinaabeg do not seek to define; therefore, we also believe Gizhew-Manidoo has no fixed male or female gender, but all genders exist within the creative energies of this Great Spiritual force. As I have been taught, I refer to Gizhew-Manidoo as "they," "their," and "them."

Works Cited

"Anishinaabe." *The Ojibway Peoples Dictionary*, ojibwe.lib.umn.edu/main-entry/anishinaabe-na. Accessed 23 Apr. 2022.

Anderson, Kim. *Life Stages and Native Women: Memory, Teachings, and Story Medicine*. University of Manitoba Press, 2011.

Benton-Banai, Edward. *The Mishomis Book: The Voice of the Ojibway*. Red School House, 1988.

Child, Brenda J. *Holding Our World Together: Ojibwe Women and the Survival of Community*. Penguin Books, 2013.

Chrystos. *Fire Power*. Press Gang Publishers, 1995.

Geniusz, Wendy Makoons. *Our Knowledge is Not Primitive: Decolonizing Botanical Anishinaabe Teachings*. Syracuse University Press, 2009.

Geniusz, Mary Siisip. *Plants Have So Much to Give Us, All We Have to Do Is Ask: Anishinaabe Botanical Teachings*. University of Minnesota Press, 2015.

Hendrix, Meredith. "I Don't Believe in Regrets." *Medium*, 4 May 2017, medium.com/100-naked-words/i-dont-believe-in-regrets-6776fe53a366. Accessed 23 Apr. 2022.

Johnston, Basil. *Ojibway Heritage*. McClelland & Stewart, 2008.

Kairos Canada. "John Rice & Waubgeshig Rice (38:37)." *YouTube*, 2015, www.youtube.com/watch?v=hxZKzU39dVU. Accessed 23 Apr. 2022.

"Minjinawezi." *The Ojibway People's Dictionary*. ojibwe.lib.umn.edu/main-entry/minjinawezi-vai. Accessed August 28, 2020. Accessed July 30, 2020. Accessed 23 Apr. 2022.

Simpson, Leanne. *As We Have Always Done: Indigenous Freedom Through Radical Resistance*. University of Minnesota Press, 2017.

Toronto Zoo. "The Ways of Knowing Guide, Ways of Knowing Partnership Turtle Island Conservation." Toronto Zoo, 2010. www. torontozoo.com/pdfs/tic/Stewardship_Guide.pdf, 32. Accessed 23 Apr. 2022.

"(How) Can We Speak of This?" Opening into the Dark Spaces of Maternal Regret, Choice, and the Unknowable

May Friedman and Jacqui Gingras

What choices would we make if we weren't worried about risk and accountability? How would we parent? Would we parent? How do these questions fit into a broader politic of gendered, raced, classed, and heteronormative expectations? Put differently: Why do we do what we do, how do we know what we know as mothers, scholars, and queer ciswomen, and how do these truths factor into discussions of maternal regret?

This became our relational and scholarly imperative—to unpack some of these unknowable questions as they emerged through a pandemic. Through dialogue and collective auto/biography, we call to each other with an ethic of care while considering the epistemology of choice. What decisions have led us to live as mothers in the present day and what complications and considerations have brought us to be the specific mothers that we have come to be? As mother-scholars from working-class roots, we situate our relationship to motherhood into existing ideas about personal responsibility, which draw from neoliberal imperatives that demand we make the right choices as dutiful and productive parents. We seek to interrogate the complexities of both

maternity and regret, leaning into the messiness of our varying subject positions. We consider the intersectional implications of our lived experiences through queerness, racialization, class, and beyond. In the context of an iterative reflexive script, we aim to foreground both our individual experiences and the complicated truths that live in the space between our words as we come together to expose this hidden and painful terrain.

In this chapter, we aim to consider the ways we orient ourselves to maternal regret. We consider how motherhood has come to define us and consider regret in relation to the impact of classed and cultural expectations.

We begin with an exploration of our pathways to motherhood as well as the birthplace of our connections to one another. We then discuss the impacts of connection and rupture and the embodied stickiness of motherhood. This is followed by an analysis of the impact of expectations of mothers in contemporary societies. We consider the ways that neoliberalism, blame, and shame are imposed upon us externally and are also held within our own sense of ourselves. We close the chapter by considering the possibilities for future directions, for ourselves, and far beyond ourselves.

How Did We Get Here? Situating Ourselves, Separately and Together

This work sits restlessly at the intersection of intimacy and academia—in the corners that inspire our most fervent intellectual curiosity paired with our deepest reluctance to reveal ourselves. Simply put, this is the conversation we wished we could have witnessed when we first became parents or even before. We have had to ask ourselves why this is simultaneously a conversation that we were so reluctant to undertake.

As professors at the same university, we have been in each other's orbits for many years. In the past, we met continuously but briefly through academic commitments and revelled in the sparks that flew each time we shared space, but until very recently, we did not have the time or take the time to really know each other. When we began to share our stories over lunch one winter day, we were stunned: despite significant differences in the ways we live and parent, differences in our approaches and entry points to academic life, we found some deep

resonance and connection in our shared feelings about maternal choice. Inspired by this project, we began to engage in raw and difficult dialogue about parenthood and all the decisions, whims, and strokes of fate that brought us to our present lives. We were moved and inspired by the power and deep connection that emerged. We were also aware that many of the stories we shared were about things we had not spoken of before. There was an aspect of secrecy to these conversations that we anticipated might be experienced by others (inside and outside of academia). Specifically, acknowledging that our choices to parent might be tinged with regret and ambivalence was forbidden territory—simply sharing this revelation immediately made us lean into intimacy while shivering with discomfort. For those reasons and others, we decided to keep going. Deeper.

Before we describe what emerged from our time together, however, we want to ensure that we situate ourselves and our complex entry points, separately.

May

I am a reluctant academic, but I always knew I would be a mother. To say that I "knew" is perhaps disingenuous, since in my racialized immigrant family of origin, not parenting was never presented as anything other than a tragic mishap. After marrying a man at a young age, I was primed for family and had my first child in my mid-twenties, followed by more children over the next decade. My experience of motherhood occurred in lockstep with my path through academia, which has often made each both better and harder. Despite spending much of my academic life examining motherhood, this deepest darkest corner of regret has stayed outside of my gaze—too much shame and too much fear to expose this pain and difficulty completely. Connecting with Jacqui has allowed me to begin to ask questions I didn't dare to consider until now and has allowed me to shift my gaze on motherhood (and academia for that matter) to consider my own agency and autonomy and rage in this often romanticized space.

Jacqui

I am a reluctant mother but knew very early on that I would be an academic. I did not have any desire to have children until I held my

newborn nephew, Luke, and felt my heart split open. I was astounded by my love for this amazing being. I was instantly spellbound and caught completely off-guard by my reaction to him. And in my mid-thirties, I suddenly started thinking seriously about actually having my own child. I was in a lesbian relationship at the time, and we proceeded with IVF. Unlike me, my partner had always wanted kids, so things progressed quickly, and in June 2004, we had our daughter, Evyn, while I was just beginning data collection for my doctoral studies. We had a second baby in January 2008 that my partner carried. Parenting fit awkwardly and precariously alongside academia. I wanted it to be more seamless, but I mostly failed. Two years later, as I joyfully dedicated myself to my first academic position, my parenting suffered as did my relationship. I couldn't make both work well. And I have deep regret about what I lost and what I gave away when I became a mom.

Creative Process and Beginnings

Our inquiry process began with us spending an hour each week for several months over the pandemic summer of 2020 writing via iMessage and then in a shared Google document. We knew we wanted to explore what maternal regret meant to us, separately and together, and we knew we could not lean into this sticky and raw terrain through sterile academic processes. Importantly, this process was continuously interrupted by both the pragmatic work of parenting and also by the emotional impact of being mothers. We were either upset at our connection or disconnection with our children or by our niggling worries about their wellness, especially in the midst of this over-whelming pandemic time. We wrote in stolen moments, before kids awoke or as they ran around nearby, in early morning light and in corners of the house trying to avoid the very matter we had shown up to discuss. There was no avoiding the obvious significance of our mothering from our inquiry on mothering and our ambivalence towards it. We gave ourselves complete permission to have it be as it was, a surrender to the source of the dilemma—the heart of our complex experiences of mothering by immediately centring the for-bidden and considering our orientation to maternal regret and our early lack of autonomy and diminishing sense of self.

May: OK, diving in: When was the first time you regretted motherhood? (assuming you did...)

Jacqui: It wasn't until I had to begin focusing again. I was just about to start data collection during my PhD. I finished the comps, had the baby, and then felt sheer joy and deep love. I was undone by my love for this sweet baby girl. Then my other intellectual desires started tugging and I couldn't resist them.

May: So it was a good start for you.

Jacqui: Yes, it [the regret] wasn't immediate. I recall that particular three months after Evyn's birth (wow, only three months) to be the happiest I have ever been. It was the actual impossibility of attending to both my own self and my children that tore at me.

May: It's almost like regret for having lost the rest of yourself as distinct from regret for having them. As they've gotten older, I'm able to pretend to have both better, but it's always imperfect.

Jacqui: The literature mentions those regrets as distinct: regret towards the children and the mothering. The mothering is what was made impossible, not the children.

May: I wonder if we'd experience less regret if we could still be us. Are there conditions that mitigate regret?

Jacqui: I don't know if I can even fathom that. My self, my desires for a certain kind of intellectual life, had to die for me to become a mother. That is pretty awful to admit.

May: For me, there was a lot of kicking and screaming. Perhaps the real problem is that I wasn't willing to not do the things I had done before.

Jacqui: I didn't want to feel encumbered. I saw other women doing that so much better than I. I started to just not go anywhere with my infant daughter.

May: Whereas I went everywhere with my infants, slowly, laboriously, and with resentment. I refused to give things up, but I lost parts of myself anyway.

We realized at the outset of our dialogue that so much of our regret was bound up in our grief at the loss of self that motherhood had spawned. Although we experienced those losses differently, we found that we

were similarly unprepared for the deep losses that motherhood entailed—the ways that we had passed through a door that had slammed shut behind us, leaving us bereft of the lives we'd had and people we'd been. In this sense, we found that we did not immediately regret what we had gained—children—so much as we regretted all we had lost.

On Building(s), Ceramics, and Cells

We quickly found that it was impossible to consider motherhood and regret without resorting to metaphors. The emotional landscape of motherhood is so overwhelming and so complex that it often feels as though additional linguistic resources are required to try to unpack the affective dimensions of this experience. The emotional terrain of motherhood sits like nesting dolls, with each revelation breaking apart to reveal another.

Specifically, we note that themes of upheaval are central to our identities as mothers and that the general theme of change and distortion is indissoluble from our analysis of maternal regret. Our lives are so unutterably altered that it is impossible for us to consider regret without exploring metaphors of breaking and building, connection, and rupture.

Jacqui: Has parenting broken us and put us back together again?

May: On my good days, I think we're like that Japanese ceramic technique where the breaks are highlighted in gold and scars have beauty. On my bad days I feel like a lamp glued back together by a five year old.

Jacqui: I want my children to see those lines, "Look what parenting did to me."

May: I want mine to know it, so they are clear sighted about the costs and benefits of parenting, which kind of leads me to my next question. What would you tell someone who asked you if they should parent?

Jacqui: I wish more people would ask me this question. I never get this question! I don't think women want to hear the answer. Maybe they don't need to ask me because I am explicit about my feelings around it.

May: How can we be honest given how intersected and variable the experience is, even with regard to different kids in the same family

configuration? I feel like I can't describe parenthood because it's so clear that its defining characteristic is uncertainty and chaos.

Jacqui: What I would say is "Let's think through this together. What do you love about your life now? What do you think it will look like with children at various ages and stages? What are your vulnerabilities? What is your life's work? What do you dream of healing in yourself?" I want this woman to join me in a circle of other women and be absolutely breathtakingly honest about this. I want our chapter to be the start of that circle.

Through this dialogue, what began to settle through the dust of our complicated impulses was how we wanted and needed to further explore the visceral meaning of regret further. We realized that we wished we had read theories or stories about mothering that questioned its place in our lives. Given that we did not previously encounter those revelations (BK: before kids), we became preoccupied with providing our own critical stance towards motherhood for others to consider— these adamant invitations into the dark heart of being a mom. Even though we felt a conviction to speak our truth as a means of overture, we continued to be tentative about speaking publicly about such seemingly forbidden topics. However, through it all, we recognized the anguish caused by the silence permeating our maternal regret, and we could not continue to abide by that. We chose not to be complicit in the withholding of our own truth for another single day despite the affective challenges to follow.

Motherhood as Sticky Affect

Thinking through rupture and regret, Orna Donath skillfully teases the notion of regret of motherhood apart from the notion of regretting specific children. This idea is tremendously healing in a culture where eschewing motherhood may be held as a failure of femininity and in which ambivalence while parenting is equated with a lack of love for one's children. We are unhesitating and resolute in our love for our children, yet our experiences of motherhood involve unending churning ambivalence. As we puzzle through the regret and ambivalence, we consider the ways that motherhood has stolen into us (and from us?), even as we sometimes seek to reject it in the most embodied of ways.

May: I've been thinking of how apparently pregnancy leaves trace DNA in your blood—they're literally in me (although I appreciate how much that privileges biology, which is not what I mean to say here). How do we feel about maternal ambivalence at the cellular level?

Jacqui: Wow. Yes, not only are they in us and of us, the hormones of control and trauma (cortisol, adrenaline) become them. We are in them, which seems more obvious, I suppose; I have not thought about them being in us. It seems funny and scary to think about that. It could be seen as the most beautiful thing, the most intimate. How does that sit with you? This notion of them being in you?

May: I suppose on some level, I'm relieved that the change is real. If it is so obvious that I'm a different person than I was before, how wonderful to find that this is literally true. On a less romantic level, though, perhaps this is akin to the bittersweet relief of having colonization recognized rather than having a new country valorized? It pushes on my ambivalence when I think of the magnitude of what is changed by having children. We can never go back. They are in us forever, no matter what.

We tended towards the iterative as a solace from regret; mothering had changed us cellularly, and we had left the imprint of that change on and in our children's own bodies. These shifts occur whether or not children are biologically borne—the affective dimension of maternal labour is absolute, no matter the method of family building. The relentless inseparability between our children and ourselves had offered us another view towards maternal regret; we had been biologically marked by our children and our children by us through the hormones of that indelible and often emotionally wrought connection. In other words, the affective had obviously marked us, but it had also marked and bound us even more intimately to our babies. We were in the struggle together and that struggle became our collective experience. In decentring ourselves, we aimed to disrupt and reject ideologies that would have us otherwise being to blame.

Whose Fault Is It Anyway? On Neoliberalism, Blame, and Shame

Understanding that our children are of us and within us could be seen as liberating, but it also speaks to the immense responsibility of motherhood, both pragmatically and in societal expectations—what Andrea O'Reilly terms "patriarchal motherhood." Overwhelmingly, mothers are seen as the agents of their children's lives with little acknowledgment of the enormous range of conditions and contributing factors under which parenthood takes place. Also unrecognized is the immense variability of the humans we parent (sometimes in the same child from moment to moment). Parenthood sits in a fundamental tension: Children are in and of us but ultimately distinct. Motherhood, in particular, sits in this corrosive discomfort between our connection and our bifurcation. Problematically, however, social reproduction is often presented as a straightforward and linear process by which the application of love and nurturance will guarantee predictable outcomes. We explore the ways our regrets are seeded in rage at this disconnect between our lived experiences of motherhood and the formulaic expectations placed upon us.

May: I think I believe that on some level that this is an exam, and if we do it right, we end up with what we need from it.

Jacqui: Yes. I believe that, too, about my role as a parent. How to produce the right child? Teach them to be good citizens. Moral beings, not a burden to the state! Neoliberal parenting.

Even as we acknowledge the impact of structures and expectations ironically, however, we note the extent to which we have uncritically internalized these ideas and hold ourselves deeply accountable. Parenting outside of the current systems of mother-blame and overall neoliberal self-regulation is literally unfathomable.

May: If we weren't held so horribly accountable, would we like parenting more? How much of our ambivalence is about the conditions of neoliberal parenting and how much is about the labour itself? Are those things even separable in the current moment?

Jacqui: How much shame and guilt do I have when someone calls me out on my parenting because I believe I did do something wrong? It feels so

tightly bound up together that it is impossible to see how to untangle it all.

May: I literally don't know what parenting—mothering—would be without shame. I keep thinking about the people we hold accountable when buildings fail—was it the architects, was it the builders? Who didn't follow which rule? And how mothers are held accountable similarly, but that there are actually no rules, or contradictory rules, so it's impossible.

I presented materials on fat and reproduction to a bunch of OBGYN residents, and one story was about stillbirth. These doctors immediately wanted to figure out what had happened and couldn't grasp that stillbirth is always a possibility. And I said something like "How many of you have attended a stillbirth?" and they all raised their hands, and I thought why can't we accept that loss is actually just inevitable sometimes? Because to do so, as scary as it is, would lessen the shame, at least. I think for me the biggest question remains: How would I parent if I didn't fear social sanction of reprisal? What would I do differently?

Jacqui: And who is asking these questions of us? It seems to me that I have been judging myself from the moment I chose to return to my academic work, and my milk dried up, and it was only three months, and I should have been breastfeeding for at least six and and and...

May: I was raised to believe that femininity and martyrdom were synonymous. I literally don't know how to be a woman or a mother without it—to ask what I would do differently renders me speechless because it feels like asking how I would enjoy being a cat or a bird.

Sometimes I believe this is universal, but then I realize how rooted this is in gender, race, and class. I had a meltdown the other night and started enumerating the ways I am worried I'm a bad parent, and my partner looked mystified, and I realized he doesn't ever think of this. It was stunning and overwhelming in its own right.

We are constituted by the intensive parenting discourse that has us falling short, messing up, seeking forgiveness, and most of all believing that there must be something inherently wrong about who we are as the evil, shameful source of our maternal regret. We did not make it up. We did not create these conditions. We have accepted this means of constituting our subjectivity by staying quiet and hanging on by fine lines, fraying threads. We sat down across from each other that wintery day and took a risk to be seen, to be heard. In that fierce courage, we

decided our regret could be otherwise. And our ways of being, or what we had internalized as our ways of being, began to shift outwards.

From Internal to External Expectations

Fundamentally, discerning the spots where internalized discourses yield to externalized expectations is as challenging as defining the distinction between mother and child. These, too, are slippery and interrelated schemes, powerful in their impact, held tight in the grip of patriarchy and racism, gendered expectations, and homophobic frameworks. We do not mother in isolation, and we do not have access to the control group in this rogue experiment to consider the choices we would make—the alternative ambivalence we might feel were we parenting in a supportive environment that held our hopes and dreams alongside those of our children. We do not want regrets that we would have in an alternate reality. Instead, we parent in this world, in the midst of a sea of churning assumptions and conjectures:

May: If we're not the architects, what are we?

Jacqui: We are the... I want to say support beams. We are necessary, but not seen.

May: Maybe more like gardeners. But there's a lot of weather that is bigger than us, and we didn't choose the seeds we planted.

Jacqui: Gardening is a form of control, though. My mom loves to garden, has a prolific garden because she can control much of what happens. She produces the garden through the storms, through the droughts, through the pests. Just by sheer will.

May: Maybe we're farmers? I think about all the farms that got wiped out by acts of god. But now in the era of factory farming all the outcomes are meant to be predictable. Maybe contemporary parenting is presented like a factory farm when in reality it's more like that old time farmstead.

Jacqui: Yes, where we give ourselves over to the storms, winds, hail, and hell's fury and just ride it out, leaning on our neighbours, crafting our experience into wisdom every day we stay alive. When are we parenting with or for, instead of always against?

May: Maybe that is the problem with all the expert discourses. They

describe parenting as though in a void and in the meantime we're all ensnared.

Jacqui: Ensnared, entrapped, entangled.

May: Enraged.

The rage-parenting that we witness in ourselves, yet rarely wish to acknowledge to others, is a reaction to the resentment of not being able to speak freely (with notable exceptions of Kingston and Heti) of how utterly we have been unprepared by our own expectations of becoming mothers. We regret all the things we did not know; we regret that our consent to mother was never informed. More than that, we react with rage to the immense difficulty of becoming a mother in relation to the other subject positions we take up, especially in this moment of pandemic where the workplace has pushed us back into our homes and kitchens, thus pushing our fight for equality back decades. Perhaps we were never meant to be there (academia) either.

Professor + Parent = Conundrum (Or, What Is the Equivalent of Parenting Tenure?)

As mother-academics, we see a corollary between our mothering and our academic trajectories; we did not know better, yet here we are taking on too much (intensive professoring) and feeling resentful, feeling angry, and feeling depressed by the perceived lack of choice. Becoming a mother is not a given; Jacqui used IVF to become pregnant with her daughter, and May struggled through a series of devastating pregnancy losses before having her last child. We hear those voices: "You worked hard for your babies, so you should be grateful and submit to all else." In the same way, we know that we worked hard for our academic careers, so we should be grateful for the stable employment of the professoriate, taking all its indignities in our stride. Where is the liminal contested space in which we can take up being wholly ungrateful? Loving our jobs, but hating some of their politics, their toxicity? Loving our children but being endlessly frustrated by motherhood?

Jacqui: As I take forty-five minutes to draft a section of this paper, I'm aware of how on edge I am by the possibility of being interrupted by my

kids. *I love the work that we are doing together to explore maternal regret, and I want to give myself over to it. I have never been the person who moves effortlessly from task to task, calmly accepting the interjections of a preteen son who is refusing a shower and a sixteen-year-old daughter who wakes up at 1:30 pm on a Sunday afternoon wanting a waffle breakfast. Don't come at me with your admonitions of just letting them take responsibility for their own lives and enjoy the natural consequences of living with someone who doesn't shower for ten days or leaves the kitchen in complete chaos. These are not choices I was prepared to have to make. I desire compliance more than I care to admit.*

May: I have enjoyed specific aspects of my children's young childhood. There's a lot of sensual pleasure there, but I also wanted an After where I wasn't so endlessly indispensable. While I'd be happy if they continued to live with me for a long time, there's no question that parenting my seventeen-year-old isn't the same as parenting my five-year-old. My eldest is growing into responsibility, even as that often makes parenting him even more difficult.

Jacqui: And I just feel so seen in reading what you wrote. It is like the murky water cleared in my heart. It is your truth, yet I see myself there. And that is where the ambivalence lives. We were promised the kids would eventually leave. Part of the social contract.

May: Parenting is always presented as a season, not a life sentence.

Jacqui: I accept that. There have been so many promises with parenting that have been broken (for me), such as I am very open with my kids, and I had always thought we could be open together, but that promise didn't materialize. My kids do not like talking with me about relationships, sex, social justice, existential questions. That is just one promise (again, made in my mind, made up by me). I worry about the promise of a season vs. a sentence will also be broken. I slip into full martyrdom at that point: "No, you were supposed to leave. This is not what I signed up for. I want to focus uninterrupted on my writing now."

We accept our privilege and our courage to be able to speak of maternal regret. We understand that our positionality as tenured professors affords us this luxury, but we equally understand that this is not at all easy work. Often when we mention maternal regret as an aspect of our research program, we are met with silence or widening eyes, perhaps a

raised eyebrow. We know that we might have had similar responses ourselves had we heard another so casually mention that which has never been spoken. Yet we reject that the attitude of regret is as inappropriate as others offer (Greasley; Schaubroeck and Hens). It is precisely because these feelings remain unspoken and invisible that we demand the space to expose them. We are here to mark that space, cultivate that dialogue regarding regret, and prepare our children for their ability to parent differently than we have. We see this demarcation as a political project of truth telling. And without truth there is no justice.

Where Do We Go from Here?

As we sat in dialogue, there were many moments of stunned revelation, both at the words we caught from each other but also at our own words. This process allowed us to access feelings and ideas that we had not ever given ourselves permission to name or to know. As we began to excavate layers—of longing, of regret, of pain and discomfort from our lives as parents and as children—we kept realizing that the conversation was not over. Instead, the dimensions of the massive iceberg of maternal regret continued to grow and come into focus.

We realized that we wished we had stumbled upon a dialogue like this early in our own parenthood and that such frank discussion would have served as a balm to our battered psyches as we began the difficult work of understanding ourselves in the new space of separate/together with these new beings. We also realized that we continue to need that balm and that although the specificities that make parenting painful may shift over time, there continue to be wounds that need tending. Yet in the academic enterprise, the chapter must be concluded; the piece must be done. How could we possibly put such a tidy cap on something as bloody and messy as our experiences of motherhood?

We came to understand that the process of conclusion is the antithesis of the difficult and revealing labour we aim to do here. As a result, we offer our dialogue here as an imperfect artefact, a moment in time, a glimpse into our lives, with more questions emerging than answers. We also came to understand that we are not done and will never be done questioning and scheming to understand ourselves in the context of our maternal identities. As a result, we have decided to keep

connecting several times a year as our lives and families grow and change to document the ways that our feelings and identities may alter as parenthood morphs from its present acute state to a (maybe?) altered future. We see this prolonged work as essential to the documentation of maternal regret; a way to avoid the rosy amnesia that keeps us from having difficult conversations with the people who come after we have moved on. We invite others to join us in this work, to consider the impact of these difficult conversations, and to map the landscape of maternal regret in all its savage beauty.

Works Cited

Donath, Orna. "Regretting Motherhood: A Sociopolitical Analysis." *Signs* vol. 4 no. 2, 2015, pp. 343-67.

Greasley, Kate. "Abortion and Regret." *The Journal of Medical Ethics*, vol. 38, 2012, pp. 705-11.

Heti, Sheila. *Motherhood*. Knopf Canada, 2018.

Kingston, Anne. "'I Regret Having Children': In Pushing the Boundaries of Accepted Maternal Response, Women Are Challenging an Explosive Taboo—and Reframing Motherhood in the Process." *Macleans*, 1 Feb. 2018, www.macleans.ca/regretful-mothers/. Accessed 24 Apr. 2022.

O'Reilly, Andrea, editor. *Feminist mothering*. SUNY Press, 2008.

Schaubroeck, Katrien, and Kristien Hens. "Parental Choices and the Prospect of Regret: An Alternative Account." *International Journal of Philosophical Studies*, vol. 25, no. 5, 2017, pp. 586-607.

Notes on Contributors

Juliana Buriticá Alzate is the departmental lecturer in modern Japanese literature at the Faculty of Oriental Studies, University of Oxford, a literary translator, and a research fellow at the Center for Gender Studies at International Christian University (ICU). Her research brings together queer and feminist theory to explore representations of mothering and related embodied experiences in contemporary Japanese fiction. She has translated Aoko Matsuda's *Where the Wild Ladies Are* into Spanish (Quaterni, 2022) and is currently working on a collection of poetry by Hiromi Itō (Insensata, forthcoming 2023).

Lorin Basden Arnold is provost and vice president for academic affairs at Kutztown University. A graduate of Purdue University, her education had a split focus in interpersonal and organizational communication. She has taught across the communication studies curriculum, with attention to interpersonal, family, and organizational communication, as well as qualitative methodology. Arnold's research has primarily addressed issues related to family, often with embedded critical and/or feminist analytic frames. Her most recent scholarly work has been devoted to mothering and how cultural expectations of motherhood frame and restrict the experiences of mothers.

Victoria Bailey is currently completing a PhD in Creative Writing and has a Master's in Women's Studies. She is co-editor with Dr. Fiona Joy Green and Dr. Andrea O'Reilly of the upcoming Demeter Press collection *Coming Into Being: Mothers on Finding and Realizing Feminism*. Her poetry has been included in a wide range of feminist-focused

publications including other Demeter Press anthologies. She is also a feminist mother of three.

Renée E. Mazinegiizhigoo-kwe Bédard is of Anishinaabeg (Ojibwe/ Nipissing/ Omàmiwininiwag), Kanien kehá:ka and French Canadian ancestry. She is a member of Okikendawdt Mnissing (Dokis First Nation). She holds a PhD from Trent University in Indigenous studies. Currently, she is an assistant professor at Western University in the Faculty of Education. Her areas of publication include practices of Anishinaabeg motherhood, maternal philosophy, and spirituality, along with environmental issues, women's rights, Indigenous Elders, Anishinaabeg artistic expressions, and Indigenous education.

Alesha E. Doan is the associate dean of the College of Liberal Arts & Sciences and professor at the University of Kansas. She holds a joint appointment in the School of Public Affairs & Administration, and the Women, Gender & Sexuality Studies Department. She has published numerous articles and five books: *Managing Sex in the Military: Gender, Identity, and Behavior* (co-editor, 2022), *Abortion Regret: The New Attack on Reproductive Freedom* (co-authored, 2019), *Opposition and Intimidation: The Abortion Wars and Strategies of PoliticalHarassment* (2007), and *The Politics of Virginity: Abstinence in Sex Education* (coauthored, 2008).

J. Shoshanna Ehrlich is a professor in the Women's, Gender, and Sexuality Studies Department at UMass Boston. Professor Ehrlich's interdisciplinary scholarship and advocacy focus on the legal regulation of reproductive and sexual rights. She has written extensively on the subject. Her most recent article is "The Body Borderland: The Abortion (Non) Rights of Unaccompanied Teens in Federal Immigration Custody" (UCLA Women's Law Journal, 2022). Her books include *Abortion Regret: The New Attack on Women's Reproductive Freedom* (coauthored with Alesha E. Doan, 2019); *Regulating Desire: From the Virtuous Maiden to the Purity Princess* (2014); and *Who Decides? The Abortion Rights of Minors* (2006).

May Friedman is a faculty member at Toronto Metropolitan University. Much of May's work explores issues of fat activism and weight stigma in a range of different settings. Drawing from her own experiences as a fat racialized mother, May thinks through themes of body instability in relation to appearance, nationhood, race, and beyond.

Jacqui Gingras, PhD is an associate professor in the Department of Sociology at Toronto Metropolitan University in Tkaronto. Her research explores social health movements, fat studies, radical democratic pedagogies, and decolonization of health professions within the entanglements of colonial neoliberal economics and intersectional feminisms. She has published in the *Fat Studies Journal, Journal of Sociology*, and *Critical Public Health*. She is an associate member of the Communication and Culture graduate program, a Joint Program between Toronto Metropolitan University and York University. She is the founding editor of the *Journal of Critical Dietetics*, an open-access, peer-reviewed journal at https://criticaldieteticsblog.com.

Jessica Jennrich has three children and lives in Saugatuck, Michigan, with her partner. She is the director of the Center for Women and Gender Equity at Grand Valley State University. Her essays have appeared in *Paradigm Magazine*, and most recently her scholarly work has been published in *The Journal of Progressive Policy and Practice* and *The National Women's Studies Journal*.

Karla Knutson is professor of English and former director of the Women's and Gender Studies Program at Concordia College in Moorhead, Minnesota. She teaches courses on feminist literature, women and children in literature, the English language, ethnography, and first-year writing. Her research explores the rhetoric of lactation production and academic motherhood.

Laurie Kruk is full professor of English Studies at Nipissing University. She has published *The Voice Is the Story: Conversations with Canadian Writers of Short Fiction* (2003) and *Double-Voicing the Canadian Short Story* (2016). She has also published three poetry collections: *Theories of the World* (1992), *Loving the Alien* (2006), and *My Mother Did Not Tell Stories* (2012). Her grown daughters have given her no cause for maternal regret—one is a biologist with/for First Nations, the other an aspiring social worker.

BettyAnn Martin is a narrative scholar interested in the reconstruction of experience through story and the manner in which creative engagement with memory transforms individual consciousness. She rediscovered the therapeutic aspects of storytelling and writing while completing her PhD in educational sustainability from Nipissing University. In addition to several peer-reviewed articles and book

chapters, her recent publications include *Writing Mothers: Narrative Acts of Care, Redemption, and Transformation* (2020) and *Taking the Village Online: Mothers, Motherhood and Social Media* (2016). Through her own experience of mothering and through a growing literature theorizing motherhood, BettyAnn continues to research and write about motherhood and its implications for identity and healing. She currently resides in Brantford, Ontario.

Andrea O'Reilly, PhD, is full professor in the School of Gender, Sexuality and Women's Studies at York University, founder/editor-in-chief of the *Journal of the Motherhood Initiative*, and publisher of Demeter Press. She is coeditor/editor of twenty plus books including *Feminist Parenting: Perspectives from Africa and Beyond* (2020), *Mothers, Mothering, and COVID-19: Dispatches from a Pandemic* (2021), *Maternal Theory, The 2nd Edition* (2021), and *Monstrous Mothers; Troubling Tropes* (2021). She is editor of the *Encyclopedia on Motherhood* (2010) and coeditor of the *Routledge Companion to Motherhood* (2019). She is author of *Toni Morrison and Motherhood: A Politics of the Heart* (2004); *Rocking the Cradle: Thoughts on Motherhood, Feminism, and the Possibility of Empowered Mothering* (2006); and *Matricentric Feminism: Theory, Activism, and Practice, The 2nd Edition* (2021). She is twice the recipient of York University's "Professor of the Year Award" for teaching excellence and is the 2019 recipient of the Status of Women and Equity Award of Distinction from OCUFA (Ontario Confederation of University Faculty Associations).

Michelann Parr is professor in the Schulich School of Education at Nipissing University. She currently teaches in the PhD program. Primary research interests include narrative forms of inquiry, identity as lifework, sustainability as relationship with self, other, and all our relations, and family engagement through community partnerships. She has recently taken a deep dive into the pedagogy of care and what that looks like, sounds like, and feels like in higher education, particularly in online environments. Recent and upcoming edited collections include *Writing Mothers: Narrative Acts of Care, Redemption, and Solidarity*; *Tales of Boundary-Busting Mamas*, and *What the Pain of Mothers Must Never Expose*.

Tracy Royce is a feminist poet and writer living in Los Angeles. Her account of caring for her mother with dementia was recently featured on the "One-Minute Memoir" episode of the Brevity Podcast.

Martha Satz teaches at Southern Methodist University and uses her background in philosophy and literature to publish essays on such diverse topics as Jane Austen and genetics and the disability community. The adoptive mother of two biracial children (African American and white), now adults, she has written frequently about this experience in a variety of periodicals and anthologies. She coedited an anthology on Toni Morrison and motherhood.

Kanchan Tripathi was born in 1992 in Allahabad, India, but was raised primarily in Ontario, Canada. She holds a bachelor of arts in sociology from York University and a postgraduate certificate in public relations from Toronto Metropolitan University. Kanchan considers her personal ethics, her friends, and family to be most important to her. If she is not spending time cooking spicy meals or reading articles regarding media, entertainment, and celebrity culture, you can almost always find her lounging with her partner binging crime documentaries. *My Mother's Story* is Kanchan's first non-fiction piece of writing.

Jane Truro is a professor of English and American poetry in Istanbul, where she has taught and researched for many years, working on poets from both sides of the Atlantic, including writers like T. S. Eliot. Sylvia Plath, Ted Hughes, D. H. Lawrence, Margaret Atwood, Emily Dickinson, and Anne Bradstreet. She enjoys the pleasures of literature, poetry, music, and nature with her family.

Rachel Williamson is an academic and educator based in Christchurch, New Zealand. Her doctoral research investigated representations of maternal ambivalence in contemporary literary and visual texts. She has published on maternal regret, the impacts of neoliberalism and colonisation on indigenous motherhood, and mother-daughter relations. Rachel's current research continues to explore the intersections between representational forms and embodied gendered experiences, especially as they pertain to motherhood. Rachel has taught at both secondary and tertiary levels and is a senior trainer for a domestic violence specialist agency.

Deepest appreciation to
Demeter's monthly Donors

DEMETER

Daughters
Rebecca Bromwich
Summer Cunningham
Tatjana Takseva
Debbie Byrd
Fiona Green
Tanya Cassidy
Vicki Noble
Naomi McPherson
Myrel Chernick

Sisters
Amber Kinser
Nicole Willey
Christine Peets